NEW YORK SCHOOL
THE FIRST GENERATION

NEW YORK SCHOOL
THE FIRST GENERATION

PAINTINGS OF THE 1940s AND 1950s

Foreword by
MAURICE TUCHMAN

20 color plates
111 black and white plates

NEW YORK GRAPHIC SOCIETY LTD.
Greenwich, Connecticut

This book is a revised edition of the original Los Angeles
County Museum catalog of an exhibition during July–August 1965
called *New York School*

INTERNATIONAL STANDARD BOOK NO.:
PAPER EDITION: 0–8212–1111–0
CLOTH EDITION: 0–8212–0389–4

LIBRARY OF CONGRESS CATALOG CARD NO. 77–86265

PRINTED IN ENGLAND

CONTENTS

BIBLIOGRAPHY

LIST OF ILLUSTRATIONS

FOREWORD

In the five years since the *New York School* exhibition at the Los Angeles County Museum of Art, the significance of this art-historical movement and the individual contributions of the fifteen artists included in it have taken on added dimensions in the context of the art of the 1960s. This short span of time has allowed a new perspective on the extraordinary contribution of this core of abstract expressionist artists, especially in the light of two recent exhibitions, the Museum of Modern Art's *The New American Painting and Sculpture: The First Generation* and the Metropolitan Museum's *New York Painting and Sculpture, 1940–1970*. Both exhibitions reaffirm the fact that it is against the background of the first generation of New York School artists that all current American art must be viewed. Only very recently can one begin to fully evaluate the effect and follow the complicated paths of influence stemming from the work of these artists in the 1940s and 1950s. Indeed, the choice of 'New York Painting and Sculpture' by the Metropolitan for its mammoth show, broadens the hitherto restricted term to include the 1960s, and serves to strengthen the position and emphasize the continuing relevance and fecundity of the initial group. Virtually every important American artist to have emerged in the last fifteen years looks to the achievement of American abstract expressionism as a point of departure, in the same way that most European artists of the 1920s and 1930s referred in their work to the inventions of cubism.

The title of our exhibition and the criteria behind the choice of artists were based on historical considerations: the first generation of New York School painters were those whose activity centered in New York City after 1940 and who had achieved by 1950 a mature and distinctly individual style. The term 'New York School' as a geographical indicator is more valid in application to the first generation than in relation to its followers, for the proliferation and dispersal of the achievements and ideas of the earlier group of artists make it impossible to impose such localized restraints on the younger generation. The

7

dates of our original exhibition were confined to the 1940s and 1950s to bring clearer recognition to the essential contribution of American abstract painting, focusing upon that body of work which marked such revolutionary advances during those years and has generated so much inspiration (and reaction) since then.

Since the 1965 catalog was designed to illustrate and document the best available work of these artists during the two decades of the inception and development of abstract expressionism, we purposely included more writings by the artists themselves than by critics. With the basic exception of some early writings by Harold Rosenberg and Clement Greenberg, critical acclaim of the movement came relatively late, and, from the beginning, the artists were often their own best verbal exponents.

In the present, revised edition, an attempt has been made to preserve the spirit of the 1965 catalog. A few omissions in the bibliography and reference notes were corrected, and reproductions of key works from the period, which, for one reason or another, we were not able to borrow for the exhibition, have been added. The main revision is the addition of new writings to the bibliography, bringing it up to date through October 1969, including, as in the original listing, all important reviews, articles, books and exhibition catalogs.

I would like to thank Mrs Gail Scott for her assistance in compiling the new material for the bibliography and Mrs Jane Livingston for her helpful suggestions.

MAURICE TUCHMAN

WRITINGS BY CRITICS

Lawrence Alloway

The twentieth century is full of art-as-an-object theory and practice which usually means severing connections with 'the world outside' or introducing materials from 'outside' (sand papier collé) not sanctioned by earlier technique. The scale of intimate easel painting persisted, however, and it is a common reaction upon seeing early concrete works to feel suffocated by the cabinet scale. Newman's and Pollock's early big pictures, however, made it possible to create works of art which are objects because they are large enough to affect our perception of them in relation to their surroundings. They create space by occupying it literally. Heads and figures in front of small paintings or detailed paintings are interruptions, as upsetting as a tall man in front of you at the cinema. The paintings of Newman, however, survive overlapping by people. What happens is that the figures become related to the ambiance of the picture. Introduced between the picture surface and ourselves, 'the others' are simply some of the permissible variables in the reading of the work of art. Newman's pictures with their stretching fields of colour, some wide, some narrow, always continue above or beside the spectator and reappear. Their redundancy is such that it survives a changing relation to its witnesses: his art is a massive defeat of noise. This, combined with the spirit of gravity and momentousness which is Newman's reason for working, justifies such ambitious titles as *Concord*, *Abraham*, *Adam* (as well as the *Onement* series). His art is like a rock.

The paintings of Rothko (who was close to Newman and Still ten years ago in the heroic phase of surface as space) do not admit us to mysterious precincts, as Giacometti does: they face us. Rothko's clouds with the weight of oceans or suns, dyed into rather than laid on the canvas, vibrate, advance, and expand. He prefers his pictures to be hung in groups, not spaced out in conventional good hanging: their united effect stresses their environmental function. The space of Still also starts at the surface and rises from it, but the unexpected distribution of his colour-flashes and torn edges give the spectator less freedom than Newman's or Rothko's easily learnable forms, because there

is less redundancy in his economical forms. The colour organization of *No. 2* (1949), though the forms are scattered, is organized by a firm system of containment: red surrounds brown, brown surrounds blue; orange within black, black within brown, brown within red, an order which holds good for each appearance of any of the colours. Like the colour code of a map, the colours occur only in certain relationships. The painting is like a map that is turning back into a substantial reality; not a key to somewhere else, but itself a land. Another visual effect, which depends basically on the creation of an expanding surface, occurs in *No. 3* (1951), where a blazing yellow plane is ripped by erupting blues and oranges, mineral hard within Still's amazing surface.

In 1941 Gottlieb 'adopted the term Pictograph for my paintings, out of a feeling of disdain for the accepted notions of what a painting should be'. He was strongly influenced by Torres-Garcia's paintings of the early thirties and, in his turn, he influenced other painters, such as Tomlin. For artists in the early forties who were dissatisfied with cubism's by then mannerist iconography, with geometric abstraction's denial of signification, and with the spookiness and sexiness of late surrealism, but who regarded art as a means of communication, primitive arts were useful. Sign language, as Torres-Garcia and Klee showed, combined an eloquent power of making references with a profound respect for the picture surface (that constituent fact); sign language was, in fact, a semantics of the surface, close to the wall. Gottlieb's compartmented space carried symbols of varying referential power. Accusations of privacy, once levelled at these works, are, like so many twentieth-century attacks on modern art, a symmetrical inversion of the truth. These rows and tiers of symbols can, perhaps, be called 'information painting', as Gottlieb's pictographs dramatized art as a means of communication.

His ribbon forms influence Tomlin who took them further in the direction of calligraphy; however, his pictures typically keep a chunkiness which, for all its elegance, echoes Gottlieb's compartments and never dissolves into a fluid continuum like Tobey's calligraphy. Tomlin's calligraphy is haunted by symbolism, whether we can decipher it or not. The display of marks, though esthetically governed, projects a lyrical pretence of antique messages, the challenge of symbols not yet decoded. His play with mystery triggers curiosity and makes decoders of us all (call it 'the Gold Bug complex'). (No space to pursue information painting in America any further beyond noting that Jasper Johns is its newest practitioner.) Gottlieb's latest work, the fine *Burst* series has carried him into the surface as space territory. However, it is interesting to note that he retains, though not on a huge scale, something of his earlier

symbolism: in this case, the chopped-in black mass is terrestrial, the swimming red blob above it solar.

Breton wrote about Gorky's form as 'hybrid', adding that 'the key lies in a free unlimited play with analogies'. This is not exactly what Gorky presents us with but it is close; his forms reveal a *limited* play with analogies. As Gottlieb said there is 'a curious emotional undertone of gentleness and brutality that emanates from the canvas'. The dual feeling is sexual, as is every inch of Gorky's iconography. He soaked his pictures in the sexual-visceral imagery which characterized the end of surrealism in the forties. It was the hypertrophy of the belief current in and around surrealism that an art of erotic symbols must be vital and authentic. The artist became a messenger from the libido (for example, Miró in his off-moments, Gorky all the time). His supple and attractive line makes chains of ambiguous sacs, membranes, openings, and asparagus. In this saturation of painted forms, with amorous biology Gorky contributed decisively to that shake-up of significative functions which occurs in the art of the forties (Wols is very close, in this respect, to Gorky). Parallel to Gorky is Baziotes, the Court Painter of the Biomorphic Kingdom compared to Gorky's compulsive Cupid. Baziotes's phosphorescent paintings, in which dwarfs, birds, sea forms, spiders, mirages, coalesce into perfect forms, derive from microscope-aided vision and Redon. His metamorphoses have incorporated 'the life in a drop of water' into a canon as calm and gentle as Tanguy in which moods are communicated with the reticence and pervasiveness of symbolist poetry.

De Kooning is clearly, in comparison with Still or Newman, a late cubist, though not in the debilitated sense that this is true of countless minor Parisians. *Painting* (1948), a powerful spectacle of murky and shiny blacks with white as a sharp negative contouring, spreads the mandolin form of cubism over a shallow cubist picture-niche. However, the forms increase and multiply so that the instrument becomes a crowd of mannequin figures, which both connote and deny anatomy. Instead of peaceable forms sliding together and interpenetrating as they do in cubism, they grind and collide because of their solidity and vehemence: they heave and crumble like a jigsaw puzzle being pushed from the sides. The women are also fundamentally cubist, though embodied in De Kooning's succulent paint and tough brushwork in uniquely painterly terms. The later work, such as *February* (1957), is in that territory between figuration and non-figuration which De Kooning, like Kline, and their followers, occupy, where the artist avoids both ready-made purity and obligations to a referential system. In *February* the huge forms imply a descriptive function but stay locked in the gestures which gave the picture its being.

The technology of painters has been enlarged by Pollock-pouring and by Kline's and De Kooning's house-painter's brushes, but American painting is not restricted to technical innovation. Philip Guston is an expert with the traditional tool of the artist, a small brush which, contracting down to a point, is his sole contact with the developing surface of the picture. His work in the early fifties (once he got on to his mature style, and like Rothko, Still, and Kline, he developed late) is a kind of impressionism on a grid, somewhere between Monet and plus-and-minus period Mondrian. Gradually the grid structure has been relaxed – though the main forms continue to be centred like islands, and the separate strokes have bunched together in a restless reper-tory of fat, petal-like forms. The lyricism of his Cytherean colour and tone, however, is the product of an anxiety which shows in a paint skin as twisted and ruffled as the Gulf Stream. Where French lyricism is the result of a relaxed enjoyment of set-forms and colours (related to Ronsard and Bonnard) Guston's lyricism is the crown of agonized process. 'To paint is a possessing rather than a picturing' he has said, and each brush mark is a claim on a mine which he has patiently and obstinately worked.

'The New American Painting,'
Art International, vol. 3, nos. 3–4,
1959, pp. 22, 23, 25, 26.

The use of black, this simplicity not so simple, is one of a cluster of renuncia-tions made by painters in the period c. 1947–53. By cutting down the number of colours, painters were able to increase their speed without losing their control. Black, in large areas tends to read as a flat area, more so than other colours, and it has, when used in linear forms, an ineradicable connection with message-making, either writing or drawing. Thus, black was at the centre of the widespread post-war desire to invest abstract art with a momen-tous subject or, to put it the other way round, to have an expressive art not slowed down by the need to represent objects. . . . Once drawings ceased to function as steps in an ascent towards a finished painting, the equal status of sketch and painting had to follow. The extension of an esthetics of the auto-graphic mark has destroyed the traditional idea of finish. Formality can no longer be achieved by working towards an agreed-on point of complexity. On the contrary, it is hard for the artist, and the spectator, to be sure now when a work of art is finished. Despite Cézanne's anguished doubts on this subject, European painters have not, on the whole, inherited this problem (except, perhaps, Giacometti and Bram van Velde). American painters, on the

contrary, have recorded their doubts on the matter, not in terms of hesitation or timidity but as an awareness of continuing possibilities. A string of etcs. has exploded the traditional ideal of a terminus. . . . American painters in black and white jump from the autographic to the monumental, without the usual intervening stages of preparation and rehearsal.

<div align="right">

'Sign and Surface: Notes on Black and
White Painting in New York,' *Quadrum*,
no. 9, 1960, pp. 50, 53.

</div>

Robert Goldwater

The history of the movement is relevant both to its present status of wide acceptance and its view of itself. In the background of its formative years were combined two separate and, in most ways, antithetical experiences; first, the Federal Art Project of the WPA (the government's economic assistance program), which during the thirties was literally essential to the continued existence of most of the artists who, sometime after 1945, were to become 'abstract expressionists' (as well as to many others whose styles were to evolve differently); and second, the arrival in New York, during the early forties, of an important group of School of Paris artists (and writers), most of them in or on the fringes of the surrealist movement.

The brief need for the use of these [mythological] symbols indicates, among other things, that independence came hard. So too in a different way does that phase of thick, reworked paint surface, heavy impasto and incrustation which for many of the older generation seems also to have been a necessary preliminary to a clear style. The pictures of this phase, most of them executed in the early forties and often containing the kind of symbolism just mentioned, reveal the artists' working process, the stages of development in the work, with less differentiation, less sureness and immediacy than is developed later; but the incorporation of this revelation into the final effect led toward subsequent freedoms.

To make the work itself the bearer of emotion – this goal was not attained without dedication and struggle. Criticism has commonly stressed that this battle (which is a battle for control) is evident in the finished work, and that the sum total of these works, mirroring the artist's internal combat, adds up

to an atmosphere of crisis. But if for a moment one ignores intentions, looks at this art historically, as it were, from the outside rather than the inside, and allows the art to speak for itself, as it so eloquently does, it is evident that one of the principal characteristics of the New York School has been its great sensuous appeal. With certain exceptions (of whom De Kooning is the most obvious) this is a lyric, not an epic, art. Judged by their finished works . . . here are artists who like the materials of their art: the texture of paint and the sweep of the brush, the contrast of colour and its nuance, the plain fact of the harmo‑ nious concatenation of so much of art's underlying physical basis to be en‑ joyed as such. They have become fine craftsmen with all the satisfaction that a craftsman feels in the controlled manipulation of his art, and all his ability to handle his medium so that his pleasure is transmitted to the beholder.

This concentration upon sensuous substance is something new to American art: to the extent that the abstract expressionist is a materialist (as he has been called) and views his art as more than pure vehicle, to that extent he is not simply an expressionist. It may be that the members of the New York School have been able to enjoy themselves and so please others because unlike the School of Paris they had no tradition of 'well‑made pictures' and *la belle peinture* to react against. Their 'academy' was one of subject‑matter, of realism and social realism, rather than the European one of clever, meaningless, manipulative skills, so that they have been able to rediscover the pleasures of paint.

'Reflections on the New York School,' *Quadrum*, no. 8, 1960, pp. 20, 26, 27, 30, 31.

Clement Greenberg

One has the impression – but only the impression – that the immediate future of Western art, if it is to have any immediate future, depends on what is done in this country. As dark as the situation still is for us, American painting in its most advanced aspects – that is, American abstract painting – has in the last several years shown here and there a capacity for fresh content that does not seem to be matched either in France or Great Britain.

There is a persistent urge, as persistent as it is largely unconscious, to go beyond the cabinet picture, which is destined to occupy only a spot on the wall, to a kind of picture that, without actually becoming identified with the wall like a mural, would *spread* over it and acknowledge its physical reality.

'The Situation at the Moment,'
Partisan Review, vol 15, no. 1,
January 1948, pp. 82, 83.

The morale of that section of New York's Bohemia which is inhabited by striving young artists has declined in the last twenty years, but the level of its intelligence has risen, and it is still downtown, below 34th Street, that the fate of American art is being decided – by young people, few of them over forty, who live in cold-water flats and exist from hand to mouth. Now they all paint in the abstract vein, show rarely on 57th Street, and have no reputations that extend beyond a small circle of fanatics, art-fixated misfits who are as isolated in the United States as if they were living in the Palaeolithic Europe. Most of the young artists in question have either been students of Hans Hoffmann or come in close contact with his students and ideas.

What we have . . . is the ferocious struggle to be a genius, which involves the artists downtown even more than the others. The foreseeable result will be a collection of *peintres maudits* – who are already replacing the *poètes maudits* in Greenwich Village. Alas, the future of American art depends on them. That it should is fitting but sad. Their isolation is inconceivable, crushing, unbroken, damning. That anyone can produce art on a respectable level in this situation is highly improbable. What can fifty do against a hundred and forty million?

'The Present Prospects of American
Painting and Sculpture,' *Horizon*
(London), nos. 93–94, October
1947, pp. 25, 26, 27, 29, 30.

The first problem these young Americans seemed to share was that of loosening up the relatively delimited illusion of shallow depth that the three master cubists – Picasso, Braque, Léger – had adhered to since the closing out of synthetic cubism. If they were to be able to say what they had to say, they had

also to loosen up that canon of rectilinear and curvilinear regularity in drawing and design which cubism had imposed on almost all previous abstract art. These problems were not tackled by program; very little in 'abstract expres-sionism' is, or ever was, programmatic; individual artists may have made 'statements' but there were no manifestoes; nor have there been 'spokesmen.' What happened, rather, was that a certain cluster of challenges was encoun-tered, separately yet almost simultaneously, by six or seven painters who had their first one-man shows at Peggy Guggenheim's Art of This Century gallery in New York between 1943 and 1946. The Picassos of the thirties and, in lesser but perhaps more crucial measure, the Kandinskys of 1910–18 were then suggesting new possibilities of expression for abstract and near-abstract art that went beyond the enormously inventive, but unfulfilled ideas of Klee's last decade. It was the unrealized Picasso rather than the unrealized Klee who became the important incentive for Americans like Gorky, de Kooning, and Pollock, all three of whom set out to catch, and to some extent did catch (or at least Pollock did) some of the uncaught hares that Picasso had started.

The years 1947 and 1948 constituted a turning-point for 'abstract expres-sionism.' In 1947 there was a great stride forward in general quality. Hofmann entered a new phase, and a different kind of phase, when he stopped painting on wood or fibreboard and began using canvas. In 1948 painters like Philip Guston and Bradley Walker Tomlin 'joined up,' to be followed two years later by Franz Kline. Rothko abandoned his 'surrealist' manner; de Kooning had his first show; and Gorky died. But it was only in 1950 that 'abstract expressionism' jelled as a general manifestation. And only then did two of its henceforth conspicuous features, the huge canvas and the black and white oil, become ratified.

'"American-Type" Painting' in
Art and Culture, Boston, Beacon
Press, 1961, pp. 211, 212, 219; revised
version of an article first appearing in
Partisan Review, vol. 22, no. 2, Spring 1955,
pp. 179–196.

Harold Rosenberg

Attached neither to a community nor to one another, these painters experience a unique loneliness of a depth that is reached perhaps nowhere else in the world. From the four corners of their vast land they have come to plunge themselves into the anonymity of New York, annihilation of their past being not the least compelling project of these esthetic Légionnaires. Is not the definition of true loneliness, that one is lonely not only in relation to people but in relation to things as well? Estrangement from American objects here reaches the level of pathos. It accounts for certain harsh tonalities, spareness of composition, aggressiveness of statement.

'Introduction to Six American
Artists,' *Possibilities*, no. 1, Winter
1947–48, p. 75.

At a certain moment the canvas began to appear to one American painter after another as an arena in which to act – rather as a space in which to reproduce, re-design, analyze, or 'express' an object, actual or imagined. What was to go on the canvas was not a picture but an event.

The painter no longer approached his easel with an image in his mind; he went up to it with material in his hand to do something to that other piece of material in front of him. The image would be the result of this encounter.

Call this painting 'abstract' or 'expressionist' or 'abstract expressionist,' what counts is its special motive for extinguishing the object, which is not the same as in other abstract or expressionist phases of modern art.

The new American painting is not 'pure' art, since the extrusion of the object was not for the sake of the esthetic. The apples weren't brushed off the table in order to make room for perfect relations of space and color. They had to go so that nothing would get in the way of the act of painting. In this gesturing with materials the esthetic, too, had been subordinated. Form, color, composition, drawing, are auxiliaries, any one of which – or practically all, as has been attempted logically, with unpainted canvases – can be dispensed with. What matters always is the revelation contained in the act. It is to be taken for granted that in the final effect, the image, whatever be or be not in it, will be a *tension*.

A painting that is an act is inseparable from the biography of the artist. The painting itself is a 'moment' in the adulterated mixture of his life – whether 'moment' means the actual minutes taken up with spotting the canvas on the entire duration of a lucid drama conducted in sign language. The act-

18

painting is of the same metaphysical substance as the artist's existence. The new painting has broken down every distinction between art and life.

'The American Action Painters,' in
The Tradition of the New, New York,
Horizon Press, 1959, pp. 25, 26–28;
originally published in *Art News*, vol. 51,
no. 8, December 1952, pp. 22–23, 48–50.

William Rubin

In attempting to bring into focus the historical picture of the remarkable transition that characterized the decade of the 1940s, we might start with the year 1947. If we accept Willem de Kooning's generous statement, that it was 'Jackson Pollock [who] broke the ice,' the breakthrough surely dates from the winter of 1946–47, when Pollock first articulated his canvases with 'all-over' webs of poured paint. Pollock had painted some beautiful pictures in the early forties, but, unlike his later work, they are not 'world-historical' in the Hegelian sense; despite their originality, they do not possess his full identity, containing perhaps too much of Picasso, Miró, and Masson, to allow this. De Kooning, Still, Motherwell, and Rothko, among others, also painted fine pictures in the early forties, but again, it was only during the period 1947–50 that they realized their more personal styles and painted what in some cases remain their best pictures.

The major influence on these American painters in the early forties was Picasso, but the most omnipresent and pervasive, though in generalized form, was surrealism, mostly Miró, secondarily Masson and Matta, and marginally Ernst and Arp (the illusionistic side of surrealist painting, as exemplified by Dali and Magritte, had no influence at all on these artists). But transcending the works of the surrealist painters were certain surrealist ideas relating picture-making to unconscious impulses and fantasies through the methods of auto-matism; these ideas – never fully realized in surrealist painting itself – were very much in the air in the early and middle forties. Gorky was by no means the first to come in contact with them; as early as 1940 Motherwell was exploring ideas like these in discussions with Matta, with whom he was then quite friendly, and the former soon brought them to the attention of Pollock. Within a few years such diverse painters as Still, Rothko, Gottlieb, Baziotes, and Newman were working in a manner that might well be termed quasi-

surrealist (what the French call *surréalisant*). None were members of the sur-
realist group (although Motherwell and Baziotes were shown in a major
surrealist exhibition), but the morphology of their work, its Freudianized
mythological symbolism, and the flirtation with automatism, all seemed
related to surrealism. These were just the qualities (with the exception of
automatism) which tended to be purged by the end of the decade.

'Arshile Gorky, Surrealism, and
the New American Painting,' *Art
International*, vol. 7, no. 2,
25 February 1963, p. 27.

Meyer Schapiro

In its most radical aspect – in the works of Willem de Kooning and Jackson
Pollock – the new painting appears as an art of impulse and chance. This does
not mean that it is formless and unconsidered; like any art, it aims at a coherent
style. What I am describing rather are qualities which make up the expressive-
ness of this art; its physiognomic, so to speak. We see excited movements,
scattered spots and dashes, fervent streaking, an explosive release. The strokes
of paint exist for themselves on the strongly marked plane of the canvas as
tangible elements of decided texture and relief; sometimes they appear as
distinct touches, sometimes they form dense complex crusts of interwoven,
built-up layers, sometimes they are drawn out as filaments, entangled over the
entire surface.

But all this describes only a single kind of painting, the one that catches the
eye soonest and provokes the greatest astonishment or exasperation. (To it
corresponds, by the way, a method of sculpture in which wires, rods, and small
bits of metal are welded or soldered together in intricate, open forms.) One can
point also to an opposite approach of the painter Mark Rothko, who builds
large canvases of a few big areas of colour in solemn contrast; his bands or
rectangles are finely softened at the edges and have the air of filmy spectres, or
after-effects of colour; generally three or four tones make up the scheme of the
whole, so that beside the restless complexity of Pollock or de Kooning,
Rothko's painting seems inert and bare. Each seeks an absolute in which the
receptive viewer can lose himself, the one in compulsive movement, the other
in an all-pervading, as if internalized, sensation of a dominant colour. The

result in both is a painted world with a powerful, immediate impact; in awareness of this goal, the artists have tended to work on a larger and larger scale – canvases as big as mural paintings are common in the shows in New York and indeed are the ones which permit the artists to realize their aims most effectively.

Between these two poles lies a rich spectrum of styles of different emotional tone. Ranging in the formal means from intricacy to amorphous cloud-like massing, from a style of energy to a style of passivity, they include also the taste for the balanced or constructive in the rough black grids of Franz Kline which isolate in a clear counterpoint the reserved spaces of the white ground. All these styles are united in the common weighting of the stroke, in the concreteness of the canvas surface as a material plane, and in the freedom of composition realized through ambiguous or random forms.

'The Younger American Painters of Today,' *The Listener* (London), 26 January 1956, pp. 146, 147.

The object of art is . . . more passionately than ever before, the occasion of spontaneity or intense feeling. The painting symbolizes an individual who realizes freedom and deep engagement of the self within his work. It is addressed to others who will cherish it, if it gives them joy, and who will recognize in it an irreplaceable quality and will be attentive to every mark of the maker's imagination and feeling.

The consciousness of the personal and spontaneous in the painting and sculpture stimulates the artist to invent devices of handling, processing, surfacing, which confer to the utmost degree the aspect of the freely made. Hence the great importance of the mark, the stroke, the brush, the drip, the quality of the substance of the paint itself, and the surface of the canvas as a texture and field of operation – all signs of the artist's active presence. The work of art is an ordered world of its own kind in which we are aware, at every point, of its becoming.

All these qualities of painting may be regarded as a means of affirming the individual in opposition to the contrary qualities of the ordinary experience of working and doing.

I need not speak in detail about this new manner, which appears in figurative as well as abstract art; but I think it is worth observing that in many ways it is a break with the kind of painting that was most important in the 1920s. After the First World War, in works like those of Léger, abstraction in art was

affected by the taste for industry, technology, and science, and assumed the qualities of the machine-made, the impersonal and reproducible, with an air of coolness and mechanical control, intellectualized to some degree. The artist's power of creation seems analogous here to the designer's and engineer's. That art, in turn, avowed its sympathy with mechanism and industry in an optimistic mood as progressive elements in everyday life, and as examples of strength and precision in production which painters admired as a model for art itself. But the experiences of the last twenty-five years have made such confidence in the values of technology less interesting and even distasteful.

In abstraction we may distinguish those forms, like the square and circle, which have object character and those which do not. The first are closed shapes, distinct within their field and set off against a definite ground. They build up a space which has often elements of gravity, with a clear difference between above and below, the ground and the background, the near and far. But the art of the last fifteen years tends more often to work with forms which are open, fluid, or mobile; they are directed strokes or they are endless tangles and irregular curves, self-involved lines which impress us as possessing the qualities not so much of things as of impulses, of excited movements emerging and changing before our eyes.

The impulse, which is most often not readily visible in its pattern, becomes tangible and definite on the surface of a canvas through the painted mark. We see, as it were, the track of emotion, its obstruction, persistence, or extinction. But all these elements of impulse which seem at first so aimless on the canvas are built up into a whole characterized by firmness, often by elegance and beauty of shapes and colors. A whole emerges with a compelling, sometimes insistent quality of form, with a resonance of the main idea throughout the work. And possessing an extraordinary tangibility and force, often being so large that it covers the space of a wall and therefore competing boldly with the environment, the canvas can command our attention fully like monumental painting in the past.

It is also worth remarking that as the details of form become complicated and free and therefore hard to follow in their relation to one another, the painting tends to be more centered and compact – different in this respect from the type of abstraction in which the painting seems to be a balanced segment of a larger whole. The artist places himself in the focus of your space.

'The liberating quality of avant-garde art,' *Art News*, vol. 56, no. 4, Summer 1957, pp. 38–39.

ARTISTS' STATEMENTS AND WORKS

GROUP STATEMENT

HOFMANN: A very great Chinese painter once said the most difficult thing in a work of art is to know the moment when to stop.

MODERATOR MOTHERWELL: The question then is, *'How do you know when a work is finished?'*

BAZIOTES: I consider my painting finished when my eye goes to a particular spot on the canvas. But if I put the picture away about thirty feet on the wall and the movements keep returning to me and the eye seems to be responding to something living, then it is finished.

GOTTLIEB: I usually ask my wife. . . . I think a more interesting question would be, 'Why does anyone start a painting instead of finishing it?'

NEWMAN: I think the idea of a 'finished' picture is a fiction. I think a man spends his whole lifetime painting one picture or working on one piece of sculpture. The question of stopping is really a decision of moral considerations. To what extent are you intoxicated by the actual act, so that you are beguiled by it. To what extent are you charmed by its inner life? And to what extent do you then really approach the intention or desire that is really outside of it. The decision is always made when the piece has something in it that you wanted.

DE KOONING: I refrain from 'finishing' it. I paint myself out of the picture, and when I have done that, I either throw it away or keep it. I am always in the picture somewhere. The amount of space I use I am always in, I seem to move around in it, and there seems to be a time when I lose sight of what I wanted to do, and then I am out of it. If the picture has a countenance, I keep it. If it hasn't, I throw it away. I am not really very much interested in the question.

25

REINHARDT: It has always been a problem for me – about 'finishing' paintings. I am very conscious of ways of 'finishing' a painting. Among modern artists there is a value placed upon 'unfinished' work. Disturbances arise when you have to treat the work as a finished and complete object, so that the only time I think I 'finish' a painting is when I have a dead-line. If you are going to present it as an 'unfinished' object, how do you 'finish' it?

HOFMANN: To me a work is finished when all parts involved communicate themselves, so that they don't need me.

MODERATOR MOTHERWELL: I dislike a picture that is too suave or too skil-fully done. But, contrariwise, I also dislike a picture that looks too inept or blundering. I noticed in looking at the Carré exhibition of young French painters who are supposed to be close to this group, that in 'finishing' a picture they assume traditional criteria to a much greater degree than we do. They have a real 'finish' in that the picture is a real object, a beautifully made object. We are involved in 'process' and what is a 'finished' object is not so certain.

HOFMANN: Yes, it seems to me all the time there is the question of a heritage. It would seem that the difference between the young French painters and the young American painters is this: French pictures have a cultural heritage. The American painter of today approaches things without basis. The French approach things on the basis of a cultural heritage – that one feels in all their work. It is a working towards a refinement and quality rather than working towards new experiences, and painting out these experiences that may finally become tradition. The French have it easier. They have it in the beginning.

DE KOONING: I am glad you brought up this point. It seems to me that in Europe every time something new needed to be done it was because of tradi-tional culture. Ours has been a striving to come to the same point that they had – not to be iconoclasts.

GOTTLIEB: There is a general assumption that European – specifically French – painters have a heritage which enables them to have the benefits of tradition, and therefore they can produce a certain type of painting. It seems to me that in the last fifty years the whole meaning of painting has been made international. I think Americans share that heritage just as much, and that if they deviate from tradition it is just as difficult for an American as for a Frenchman. It is a mistaken assumption in some quarters that any departure

from tradition stems from ignorance. I think that what Motherwell describes is the problem of knowing what tradition is, and being willing to reject it in part. This requires familiarity with his past. I think we have this familiarity, and if we depart from tradition, it is out of knowledge, not innocence.

DE KOONING: I agree that tradition is part of the whole world now. The point that was brought up was that the French artists have some 'touch' in making an object. They have a particular something that makes them look like a 'finished' painting. They have a touch which I am glad not to have.

BAZIOTES: We are getting mixed up with the French tradition. In talking about the necessity to 'finish' a thing, we then said American painters 'finish' a thing that looks 'unfinished,' and the French, they 'finish' it. I have seen Matisses that were more 'unfinished' and yet more 'finished' than any American painter. Matisse was obviously in a terrific emotion at the time, and it was more 'unfinished' than 'finished.'

STERNE: I think that the titling of paintings is a problem. The titles a painter gives his paintings help to classify him, and this is wrong. A long poetic title or number. . . . Whatever you do seems a statement of attitude. The same thing if you give a descriptive title. . . . Even refraining from giving any at all creates a misunderstanding.

REINHARDT: If a title does not mean anything and creates a misunderstanding, why put a title on a painting?

GOTTLIEB: I think the point Miss Sterne raised is inevitable. That is, whenever an artist puts a title on a painting, some interpretation about his attitude will be made. It seems obvious that titles are necessary when everybody uses them – whether verbal or numbers; for purposes of exhibition, identification, and the benefit of the critics there must be some way of referring to a picture. It seems to me that the artist, in making up titles for his pictures, must decide what his attitude is.

REINHARDT: The question of abandoning titles arose, I am sure, because of esthetic reasons. Even titles like 'still life' and 'landscape' do not say anything about a painting. If a painting does have a reference or association of some kind, I think the artist is apt to add a title. I think this is why titles are not used by a great many modern painters – because they don't have anything to do with the painting itself.

MODERATOR MOTHERWELL: I think Sterne is dealing with a real problem – what is the content of our work? What are we really doing? The question is how to name what as yet has been unnamed.

BAZIOTES: Whereas certain people start with a recollection or an experience and paint that experience, to some of us the act of doing it becomes the experience; so that we are not quite clear why we are engaged on a particular work. And because we are more interested in plastic matters than we are in a matter of words, one can begin a picture and carry it through and stop it and do nothing about the title at all. All pictures are full of association.

REINHARDT: Titles are very important in surrealist work. But the emphasis with us is upon a painting experience, and not on any other experience. The only objection I have to a title is when it is false or tricky, or is something added that the painting itself does not have.

DE KOONING: I think that if an artist can always title his pictures, that means he is not always very clear.

NEWMAN: I think it would be very well if we could title pictures by identifying the subject-matter so that the audience could be helped. I think the question of titles is purely a social phenomenon. The story is more or less the same when you can identify them. I think the implication has one of two possibilities: (1) We are not smart enough to identify our subject-matter, or (2) language is so bankrupt that we can't use it. I think both are wrong. I think the possibility of finding language still exists, and I think we are smart enough. Perhaps we are arriving at a new state of painting where the thing has to be seen for itself.

DE KOONING: If you are an artist, the problem is to make a picture work whether you are happy or not.

BAZIOTES: Mr Lippold's position, as I understand it, is that the beginning of a work now has something about it that would not have seemed quite logical to artists of the past. We apparently begin in a different way. Is that what you mean, Mr Lippold?

MODERATOR LIPPOLD: Yes.

BAZIOTES: I think the reason we begin in a different way is that this particular time has gotten to a point where the artist feels like a gambler. He does something on the canvas and takes a chance in the hope that something important will be revealed.

REINHARDT: I would like to ask a question about the exact involvement of a work of art. What kind of love or grief is there in it? I don't understand, in a painting, the love of anything except the love of painting itself. If there is agony, other than the agony of painting, I don't know exactly what kind of agony that would be. I am sure external agony does not enter very importantly into the agony of our painting.

MODERATOR BARR: I would like a show of hands on this question: Is there anyone here who works for himself alone – that is, purely for his own satisfaction – for himself as the sole judge?

(scattered showing of hands)

DE KOONING: I feel it isn't so much the act of being obliged to someone or to society, but rather one of conviction. I think, whatever happens, every man works for himself, and he does it on the basis of convincing himself. I force my attitude upon this world, and I have this right – particularly in this country – and I think it is wonderful, and if it does not come off, it is alright, too. I don't see any reason why we should go and look into past history and find a place or try to take a similar position.

MODERATOR MOTHERWELL: Is the artist his own audience?

REINHARDT: How many artists here consider themselves craftsmen or professionals? What is our relationship to the social world?

DE KOONING: There was that cave of paintings which were found in France just lately. Were they works of art before we discovered them? This is the question.

NEWMAN: I would like to go back to Mr Lippold's question – are we involved in self-expression or in the world? It seems to Lippold you cannot be involved in the world if you are a craftsman; but if you are involved in the world, you cannot be an artist. We are in the process of making the world, to a certain extent, in our own image. This removes us from the craft level.

DE KOONING: This difficulty of titling or not titling a picture – we ought to have more faith in the world. If you really express the world, those things eventually will turn out more or less good. I know what Newman means: it is some kind of feeling that you want to give yourself a place in the world.

NEWMAN: About specifying – if you specify your emotions – whether they are agony or fear, etc. – I believe it is bad manners to actually say one is feeling bad.

DE KOONING: I think there are different experiences or emotions. I feel certain parts you ought to leave up to the world.

NEWMAN: I think we start from a subjective attitude, which, in the process of our endeavour becomes related to the world.

BAZIOTES: When we make a work of art we must get our praise after it is finished.

BAZIOTES: If you were commissioned to do a picture of the Madonna in the Middle Ages that was praise to begin with.

GOTTLIEB: I think the answer is that the work that really has something to say constitutes its own signature.

DE KOONING: There is no such thing as being anonymous.

HARE: A man's work is his signature. In this sense art has never been anonymous.

REINHARDT: Exactly what is our involvement, our relation to the outside world? I think everybody should be asked to say something about this.

DE KOONING: I think somebody who professes something never is a professor. I think we are craftsmen, but we really don't know exactly what we are ourselves, but we have no position in the world – absolutely no position except that we just insist upon being around.

TOMLIN: It seems to me before we examine our position in relation to the world we should examine our position in relation to each other. I understood that

to be the point of this discussion and that is why we came together. I am sure there are a number of people who are interested in the matter of self-expression alone and there are others who are not.

NEWMAN: I would like to emphasize Mr Motherwell's remarks: we have two problems. (1) The problem of existing as men. (2) The problem of growth in our work.

NEWMAN: A concern with 'beauty' is a concern with what is 'known'.

POUSETTE-DART: 'Beauty' is unattainable, yet it is what gives art its significance, it *is* the *unknown*.

NEWMAN: The artist's intention is what gives a specific thing form.

POUSETTE-DART: I have the feeling that in the art world 'beauty' has become a discredited word. I have heard people say you can't use the word 'God'. When a word becomes trite it is not the word that has become trite but the people who use it.

STERNE: I am not here to define anything; but to give life to what I have the urge to give life to. We live by the particular, not by the general.

MODERATOR MOTHERWELL: It is not necessary for Sterne to define 'beauty' for what she is saying. 'Beauty' is not for her the primary source of inspiration. She thinks that 'beauty' is discovered *en route*.

REINHARDT: Is there anyone here who considers himself a producer of beautiful objects?

GOTTLIEB: I agree with Sterne that we are always concerned with the particular, not the general. Any general discussion of esthetics is a discussion of philosophy; any conclusion can apply to any work of art. Why not have people tell us why they do what they do? Why does Brooks use swirling shapes? Why Newman a straight line? What is it that makes each person use those particular forms that they use?

DE KOONING: I consider all painting free. As far as I am concerned, geometric shapes are not necessarily clear. When things are circumspect or

physically clear, it is purely an optical phenomenon. It is a form of uncertainty; it is like accounting for something. It is like drawing something that then is bookkeeping. Bookkeeping is the most unclear thing.

REINHARDT: An emphasis on geometry is an emphasis on the 'known,' on order and knowledge.

FERBER: Why is geometry more clear than the use of swirling shapes?

REINHARDT: Let's straighten out our terminology, if we can. Vagueness is a 'romantic' value, and clarity and 'geometricity' are 'classic' values.

DE KOONING: I meant geometry in art. Geometry was against art – the beauty of the rectangle, I mean.

MODERATOR LIPPOLD: This means that a rectangle is unclear?

DE KOONING: Yes.

MODERATOR MOTHERWELL: Lippold resents the implication that a geometric form is not 'clear.'

DE KOONING: The end of a painting in this kind of geometric painting would be almost the graph for a possible painting – like a blueprint.

TOMLIN: Would you say that automatic structure is in the process of becoming, and that 'geometry' has already been shown and terminated?

DE KOONING: Yes.

MODERATOR MOTHERWELL: It seems to me that what De Kooning is saying is plain. He feels resentful that one mode of expression should be called more clear, precise, rational, finished, than another.

BAZIOTES: I think when a man first discovers that two and two is four, there is 'beauty' in that; and we can see why. But if people stand and look at the moon and one says, 'I think it's just beautiful tonight,' and the other says, 'The moon makes me feel awful,' we are both 'clear.' A geometric shape – we know why we like it; and an unreasonable shape, it has a certain mystery that we recognize as real; but it is difficult to put these things in an objective way.

NEWMAN: The question of clarity is one of intention.

STERNE: I think it has to do with Western thinking. A Chinese thinks very well, but does not use logic. The use of geometrical forms comes from logical thinking.

HOFMANN: I believe that in an art every expression is relative, not absolutely defined as long as it is not the expression of a relationship. Anything can be changed. We speak here only about means, but the application of the means is the point. You can change one thing into another with the help of the relations of the things. One shape in relation to other shapes makes the 'expression'; not one shape or another, but the relationship between the two makes the 'meaning.' As long as a means is only used for itself, it cannot lead to anything. Construction consists of the use of one thing in relation to another, which then relates to a third, and higher, value.

MODERATOR MOTHERWELL (to Hofmann): Would you say that a fair statement of your position is that the 'meaning' of a work of art consists of the relations among the elements, and not the elements themselves?

HOFMANN: Yes, that I would definitely say. You make a thin line and a thick line. It is the same as with geometrical shapes. It is all relationship. Without all of these relationships it is not possible to express higher art.

FERBER: The means are important, but what we were concerned with is an expression of a relationship to the world. Truth and validity cannot be determined by the shape of the elements of the picture.

DE KOONING: About this idea of geometric shapes again: I think a straight line does not exist. There is no such thing as a straight line in painting.

REINHARDT: We are losing Ferber's point. I would like to get back to the question of whether there is another criterion of truth and validity, apart from the internal relationships in a work of art.

MODERATOR MOTHERWELL: It would be very difficult to formulate a position in which there were no external relations. I cannot imagine any structure being defined as though it only has internal meaning.

33

REINHARDT: I want to know the outside truth. I think I know the internal one.

MODERATOR MOTHERWELL: Reinhardt was emphasizing very strongly that the quality of a work depends upon the relations within it. Between Ferber and Reinhardt the question is being raised as to whether these internal relations also relate externally to the world, or better, as to what this external relation is.

TOMLIN: May I take this back to structure? In what was said about the parts in relation to Brooks's work, the entire structure was embraced. We were talking about shape, without relation to one possibility of structure. I would like to say that I feel that geometric shapes can be used to achieve a fluid and organic structure.

HOFMANN: There is a fluidity in the elements which can be used in a practical way, which is often used by Klee. It is related to handwriting – it often characterizes a complete personality. It can be used in a graphic sense and in a plastic sense. It leads a point to a relation with another point. It is a relationship of all points considered in a plastic relation. If offers a number of possibilities.

REINHARDT (to Hofmann): Do you consider the interrelationships of the elements in a work of art to be self-contained?

HOFMANN: It is related to all of this world – to what you want to express. You want to express something very definitely and you do it with your means. When you understand your means, you can.

MODERATOR MOTHERWELL: I find that I ask of the painting process one of two separate experiences. I call one the 'mode of discovery and invention,' the other the 'mode of joy and variation.' The former represents my deepest painting problem, the bitterest struggle I have ever undertaken: to reject everything I do not feel and believe. The other experience is when I want to paint for the sheer joy of painting. These moments are few. The strain of dealing with the unknown, the absolute, is gone. When I need joy, I find it only in making free variations on what I have already discovered, what I know to be mine. We modern artists have no generally accepted subject-matter, no inherited iconography. But to re-invent painting, its subject-matter, and its means, is a task so difficult that one must reduce it to a very simple concept in order to paint for the sheer joy of painting, as simple as the Madonna

34

was to many generations of painters in the past. An existing subject⁄matter for me – even though I had to invent it to begin with – variations gives me moments of joy. . . . The other mode is a voyaging into the night, one knows not where, on an unknown vessel, an absolute struggle with the elements of the real.

REINHARDT: Let's talk about that struggle.

MODERATOR MOTHERWELL: When one looks at a Renaissance painter, it is evident that he can modify existing subject⁄matter in a manner that shows his uniqueness and fineness without having to re⁄invent painting altogether. But I think that painters like Mondrian tend to move as rapidly as they can toward a simple iconography on which they can make variations. Because the strain is so great to re⁄invent reality in painting.

REINHARDT: What about the reality of the everyday world and the reality of painting? They are not the same realities. What is this creative thing that you have struggled to get and where did it come from? What reference or value does it have, outside of the painting itself?

DE KOONING: If we talk in terms of what kinds of shapes or lines we are using, we don't mean that and we talk like outsiders. When Motherwell says he paints stripes, he doesn't mean that he is painting stripes. That is still thinking in terms of what kinds of shapes we are painting. We ought to get rid of that. If a man is influenced on the basis that Mondrian is clear, I would like to ask Mondrian if he was so clear. Obviously, he wasn't clear, because he kept on painting. Mondrian is not geometric, he does not paint straight lines. A picture to me is not geometric – it has a face. . . . It is some form of impressionism. . . . We ought to have some level as a profession. Some part of painting has to become professional.

NEWMAN: De Kooning has moved from his original position that straight lines do not exist in nature. Geometry *can* be organic. Straight lines do exist in nature. When I draw a straight line, it does exist. It exists optically. When De Kooning says it doesn't exist optically, he means it doesn't exist in nature. On that basis, neither do curved lines exist in nature. But the edge of the UN building is a straight line. If it can be made, it does exist in nature. A straight line is an organic thing that can contain feeling.

35

DE KOONING: What is called Mondrian's optical illusion is not an optical illusion. A Mondrian keeps changing in front of us.

GOTTLIEB: It is my impression that the most general idea which has kept cropping up is a statement of the nature of a work of art as being an arrangement of shapes or forms of color which, because of the order or ordering of materials, expresses the artist's sense of reality or corresponds with some outer reality. I don't agree – that some expression of reality can be expressed in a painting purely in terms of line, color, and form, that those are the essential elements in painting and anything else is irrelevant and can contribute nothing to the painting.

MODERATOR MOTHERWELL: . . . All of the people here move as abstractly or back to the world of nature as freely as they like to, and would fight at any time for that freedom.

NEWMAN: We are raising the question of subject-matter and what its nature is.

DE KOONING: I wonder about the subject-matter of the Crucifixion scene – was the Crucifixion the subject-matter or not? What is the subject-matter? Is an interior subject-matter?

HOFMANN: I think the question goes all the time back to subject-matter. Every subject-matter depends on how to use meaning. You can use it in a lyrical or dramatic manner. It depends on the personality of the artist. Everyone is clear about himself, as to where he belongs, and in which way he can give esthetic enjoyment. Painting is esthetic enjoyment. I want to be a 'poet.' As an artist I must conform to my nature. My nature has a lyrical as well as a dramatic disposition. Not one day is the same. One day I feel wonderful to work and I feel an expression which shows in the work. Only with a very clear mind and on a clear day I can paint without interruptions and without food because my disposition is like that. My work should reflect my moods and the great enjoyment which I had when I did the work.

REINHARDT: We could discuss the question of the rational or intuitional. That might bring in subject-matter or content. We have forms in common. We have cut out a great deal. We have eliminated the naturalistic, and among other things, the super-realistic and the immediately political.

36

BARR: What is the most acceptable name for our direction or movement? (It has been called abstract expressionist, abstract symbolist, intro-subjectivist, etc.)

SMITH: I don't think we do have unity on the name.

ROSENBORG: We should have a name through the years.

SMITH: Names are usually given to groups by people who don't understand them or don't like them.

MODERATOR BARR: We should have a name for which we can blame the artists – for once in history!

MODERATOR MOTHERWELL: Even if there is any way of giving ourselves a name, we will all still be called abstract artists.

MODERATOR MOTHERWELL: In relation to the question of a name, here are three names: abstract expressionist; abstract symbolist; abstract objectionist.

BROOKS: A more accurate name would be 'direct' art. It doesn't sound very good, but in terms of meaning, abstraction is involved in it.

TOMLIN: Brooks also remarked that the word 'concrete' is meaningful; it must be pointed out that people have argued very strongly for that word. 'Non-objective' is a vile translation.

NEWMAN: I would offer 'self-evident' because the image is concrete.

DE KOONING: It is disastrous to name ourselves.

From 'Artists' Sessions at Studio 35 (1950)' in *Modern Artists in America*, first series, New York, Wittenborn Schutz, 1951.

The title 'abstract expressionism' was not heard by me nor was I ever aware that it had been mentioned before by any of the later claimants to authorship of the title. I insist on this point: before these panels, I, as the initiator of the panels, the writer of the weekly postcard/announcements to the club members, had never heard of this title except for a near sounding of it in Kandinsky's well/known title of the thirties, 'abstract/impressionism.' Kandinsky's writings contain many titles that, like this one, are rich in esthetic thinking. Anyone who lived in Paris during the thirties couldn't avoid exposure to pure and impure titles and some realisms. But the Germanic twist of 'abstract expres/sionism' I never heard till Thomas B. Hess mentioned the two esthetic strains and suspected that the artists were making underground changes in their art.

From 'The Unwanted Title;
Abstract Expressionism' by P. G.
Pavia in *It Is*, no. 5, Spring 1960,
p. 8

The recent 'School of New York' – a term not geographical but denoting a direction – is an aspect of the culture of modern painting. The works of its artists are 'abstract,' but not necessarily 'non/objective.' They are always lyrical, often anguished, brutal, austere, and 'unfinished,' in comparison with our young contemporaries of Paris; spontaneity and a lack of self/consciousness is emphasized; the pictures stare back as one stares at them; the process of painting them is conceived of as an adventure, without preconceived ideas on the part of persons of intelligence, sensibility, and passion. Fidelity to what occurs between oneself and the canvas, no matter how unexpected, becomes central. The specific appearance of these canvases depends not only on what the painters do, but on what they refuse to do. The major decisions in the process of painting are on the grounds of truth, not taste.

From *The School of New York*,
Frank Perls Gallery, Beverly Hills,
California, 1951, p. 3

WILLIAM BAZIOTES

(Pittsburgh, Pennsylvania, 1912 – New York City, 1963)

There is always a subject that is uppermost in my mind. Sometimes I am aware of it. Sometimes not. I work on my canvas until I think it is finished. Often I recognize my subject at completion of the picture and again I may wait a long time before I know what it is about.

From *Personal Statement*, 1945,
David Porter Gallery.

I work on many canvases at once. In the morning I line them up against the wall of my studio. Some speak; some do not. They are my mirrors. They tell me what I am like at the moment.

From *Possibilities*, vol. 1, no. 1,
Winter 1947–48.

To be inspired. That is the thing.
To be possessed; to be bewitched.
To be obsessed. That is the thing.
To be inspired.

From *Tiger's Eye,* vol. 1, no. 5,
October 1948, p. 55.

Everyone of us finds water either a symbol of peace or fear. I know I never feel better than when I gaze for a long time at the bottom of a still pond.

From a 1948 letter, quoted in
Location, no. 2, 1964.

Baudelaire said, *I have a horror of being easily understood.*

For the modern artist, an early understanding – an easy acceptance – would be a sensation similar to those great waving moments of the hand on the seismograph as it heralds the coming of death. All is lost! he'd cry, and like Hamlet he would wish 'to die, to sleep. . . .'

And if the artist's guardian angel should ask him, 'Why such desperation, my friend? why such a heaving of the breast?' the artist could very truthfully answer, 'I am a strange creature, and strange most of all to myself. Evil tempts me as much as good. I would like to be the purest of men – and yet the lewd fascinates me. A great love can bring tears to my eyes, yet at times you have seen me gaze with delight at corrupted men. I worship physical beauty like a Rubens – but then like Grünewald, I must smell the sores of the leper. My fellow man may prefer heaven after death. But let me, when I die, have the freedom to ramble between paradise and hell.'

And if all this seems strange to the practical man – have they ever turned their eyes inward? Is murder their waking thought? Or a dream of ancient Greece their joy in a joyless world? Have they lit the match in the dark?

No, practical men. Let the poet dream his dreams.

Yet, the poet must look at the world, must enter into other men's lives, must look at the earth and the sky, must examine the dust in the street, must walk through the world and his mirror.

. . . the poet must look at the world, must enter into other men's lives, must look at the earth and the sky, must examine the dust in the street, must walk through the world and his mirror.

Look back – look now, poet, to your friends. There they stand in the past. The lonely village eccentric – Cézanne. The pathetic mad Van Gogh. The arthritic, suffering Renoir, who could say, 'the pain passes, but the beauty remains.' And in our day, is there not something grand in the aged Matisse dreaming his dream of the joy of life? Or the famous and wealthy Picasso, painting the furies of the heart that only those condemned can ever feel? Or Miró, singing his fantastic songs about the moon, when all men walk with their eyes cast upon the ground? There they stand, artist – your friends.

And when the demagogues of art call on you to make the social art, the intelligible art, the good art – spit down on them, and go back to your dreams: the world – and your mirror.

From 'The Artist and his Mirror' in *Right Angle*, vol. 3, no. 2, June 1949 pp. 2, 3.

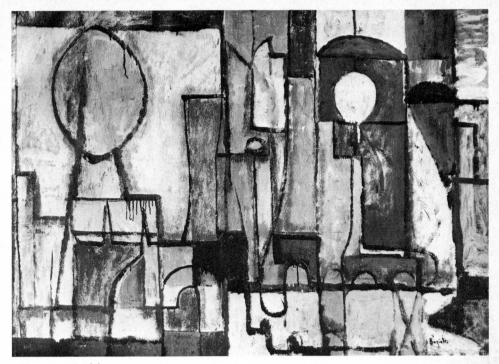

1 BAZIOTES *Untitled*, 1946

2 BAZIOTES *The Juggler*, 1947

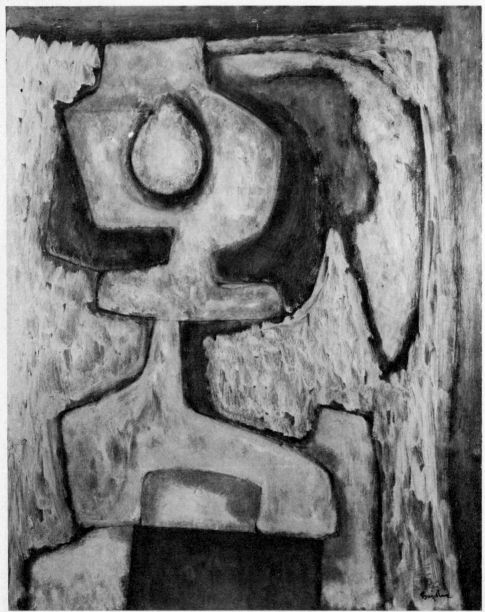

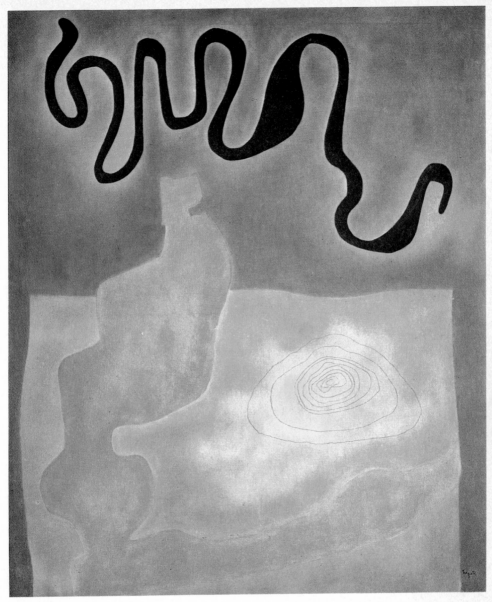

3 BAZIOTES *Congo*, 1954

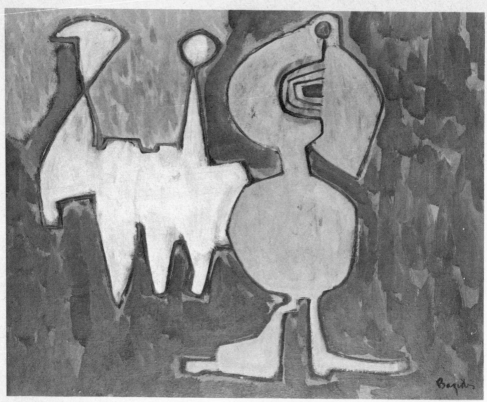

4 BAZIOTES
Figure in Orange, 1947

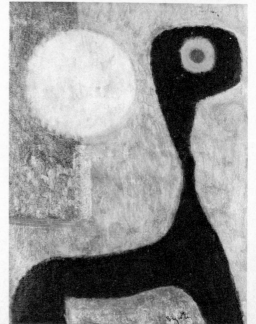

5 BAZIOTES *Toy,* 1949

44

It is the mysterious that I love in painting. It is the stillness and the silence. I want my pictures to take effect very slowly, to obsess and to haunt.

From *It Is*, Autumn 1959.

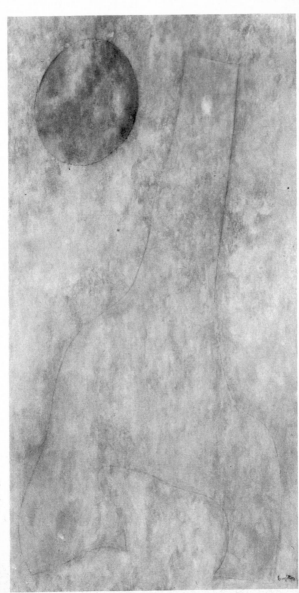

6 BAZIOTES
Toys in the Sun,
1951

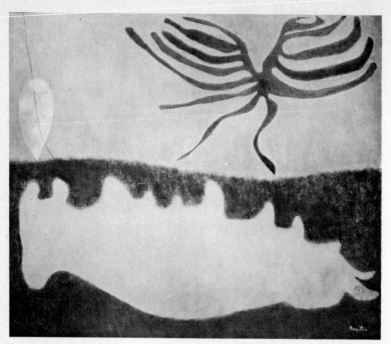

7 BAZIOTES
Primeval Landscape,
1953

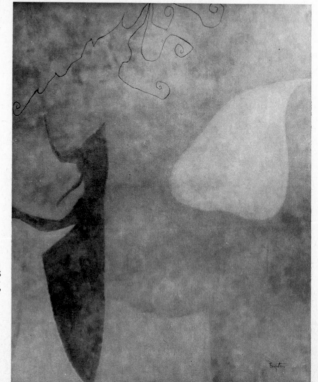

8 BAZIOTES
Autumn Leaf,
1959

WILLEM DE KOONING

(b. Rotterdam, The Netherlands, 1904)

The word 'abstract' comes from the light-tower of philosophers, and it seems to be one of their spotlights that they have particularly focused on 'Art'. So the artist is always lighted up by it. As soon as it – I mean the 'abstract' – comes into painting, it ceases to be what it is as it is written. It changes into a feeling which could be explained by some other words, probably. But one day, some painter used *Abstraction* as a title for one of his paintings. It was a still life. And it was a very tricky title. And it wasn't really a very good one. From then on the idea of abstraction became something extra. Immediately it gave some people the idea that they could free art from itself. Until then, Art meant everything that was in it – not what you could take out of it. There was only one thing you could take out of it sometime when you were in the right mood – that abstract and indefinable sensation, the esthetic part – and still leave it where it was. For the painter to come to the 'abstract' or the 'nothing,' he needed many things. Those things were always things in life – a horse, a flower, a milkmaid, the light in a room through a window made of diamond shapes maybe, tables, chairs, and so forth. The painter, it is true, was not always completely free. The things were not always of his own choice, but because of that he often got some new ideas.

The esthetics of painting were always in a state of development parallel to the development of painting itself. They influenced each other and vice versa. But all of a sudden, in that famous turn of the century, a few people thought they could take the bull by the horns and invent an esthetic beforehand. After immediately disagreeing with each other, they began to form all kinds of groups, each with the idea of freeing art, and each demanding that you should obey them. Most of these theories have finally dwindled away into politics or strange forms of spiritualism. The question, as they saw it, was not so much what you *could* paint but rather what you could *not* paint. You could *not* paint a house or a tree or a mountain. It was then that subject-matter came into existence as something you ought *not* to have.

47

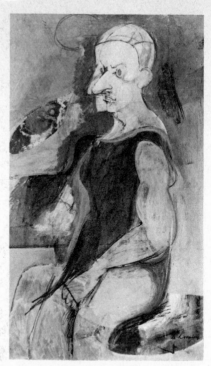

9 De Kooning *Clown*, c. 1941

This pure form of comfort became the comfort of 'pure form.'

Kandinsky understood 'Form' as *a* form, like an object in the real world; an object, he said, was a narrative – and so, of course, he disapproved of it. He wanted his 'music without words.' He wanted to be 'simple as a child.' He intended, with his 'inner self,' to rid himself of 'philosophical barricades' (he sat down and wrote something about all this). But in turn his own writing has become a philosophical barricade, even if it is a barricade full of holes. It offers a kind of Middle European idea of Buddhism or, anyhow, something too theosophic for me.

The sentiment of the futurists was simpler. No space. Everything ought to keep on going! That's probably the reason they went themselves. Either a man was a machine or else a sacrifice to make machines with.

The moral attitude of neo-plasticism is very much like that of constructivism, except that the constructivists wanted to bring things out in the open and the neo-plasticists didn't want anything left over.

I have heard a lot from all of them and they have confused me plenty too. One thing is certain, they didn't give me my natural aptitude for drawing. I am completely weary of their ideas now.

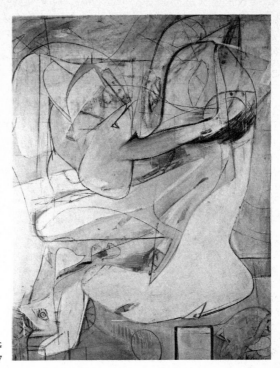

10 DE KOONING
Pink Angel, c. 1947

The only way I still think of these ideas is in terms of the individual artists who came from them or invented them. . . .

The point they all had in common was to be both inside and outside at the sametime. A new kind of likeness! The likeness of the group instinct.

Personally, I do not need a movement. What was given to me, I take for granted. Of all movements, I like cubism the most. It had that wonderful unsure atmosphere of reflection – a poetic frame where something could be possible, where an artist could practise his intuition. It didn't want to get rid of what went before. Instead it added something to it. The parts that I can appreciate in other movements came out of cubism. Cubism *became* a movement, it didn't set out to be one. It has force in it, but it was no 'force movement.' And then there is that one-man movement, Marcel Duchamp – for me a truly modern movement because it implies that each artist can do what he thinks he ought to – a movement for each person and open for everybody.

From 'What Abstract Art Means to Me,' *Museum of Modern Art Bulletin*, vol. 18, no. 3, Spring 1951.

Each new glimpse is determined by many,
Many glimpses before.
It's this glimpse which inspires you – like an occurrence
And I notice those are always my moments of having an idea
That maybe I could start a painting.

Everything is already in art – like a big bowl of soup
Everything is in there already:
And you just stick your hand in, and find something for you.
But it was already there – like a stew.

There's no way of looking at a work of art by itself
It's not self-evident
It needs a history; it needs a lot of talking about:
It's part of a whole man's life.

Y' know the real world, this so-called real world,
Is just something you put up with, like everybody else.
I'm in my element when I am a little bit out of this world:

11 DE KOONING *Dark Pond*, 1948

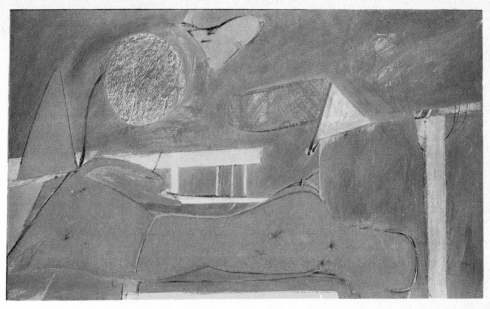

12 DE KOONING *Untitled, c.* 1943

then I'm in the real world – I'm on the beam.
Because when I'm falling, I'm doing all right;
when I'm slipping, I say, hey, this is interesting!
It's when I'm standing upright that bothers me:
I'm not doing so good; I'm stiff.
As a matter of fact, I'm really slipping, most of the time,
into that glimpse. I'm like a slipping glimpser.

I get excited just to see
That sky is blue; that earth is earth.
And that's the hardest thing: to see a rock somewhere,
And there it is: earth-colored rock,
I'm getting closer to that.

Then there is a time in life when you just take a walk:
And you walk in your own landscape.

From *Sketchbook 1: Three Americans,*
film script, New York, Time,
Inc., 1960, pp. 6, 7, 8, 9, 10.

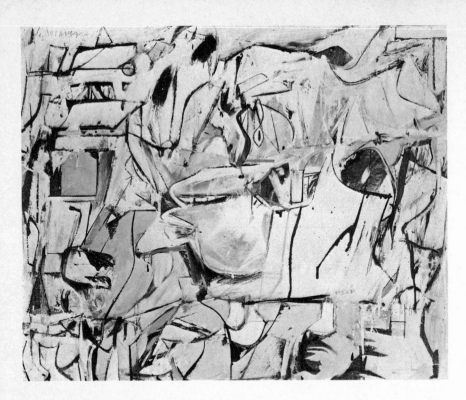

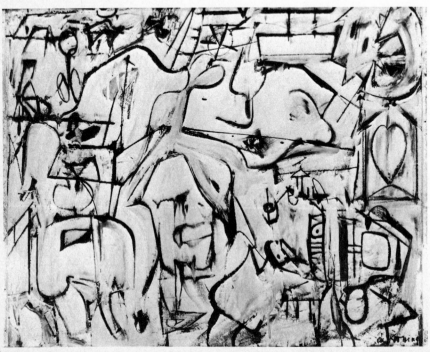

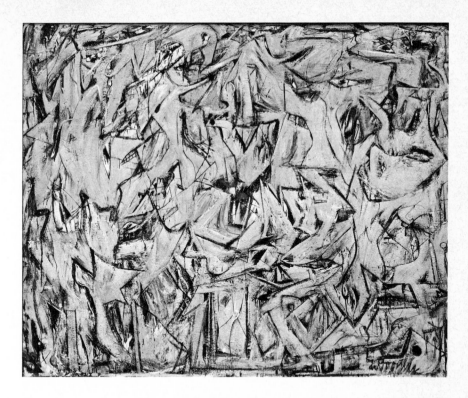

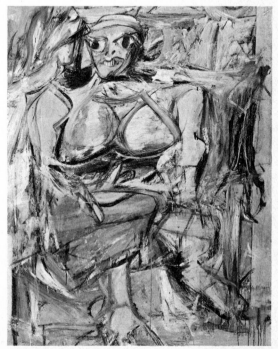

13 DE KOONING *Ashville*, 1949

14 DE KOONING *Little Attic*, 1949

15 DE KOONING *Excavation*, 1950

16 DE KOONING *Woman I*, 1950–52

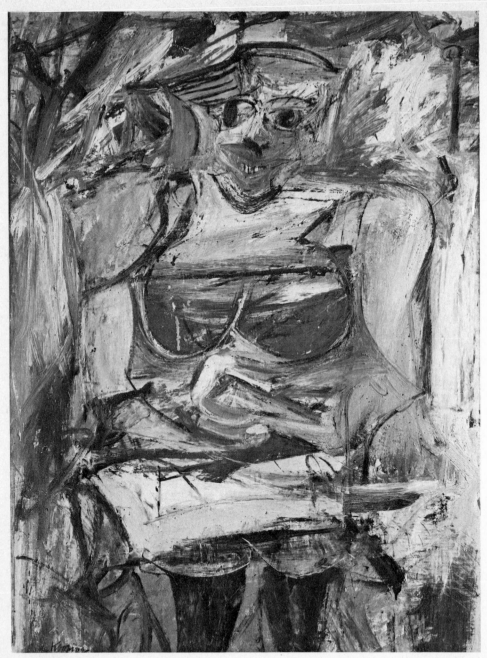

17 DE KOONING *Woman V*, 1952–53

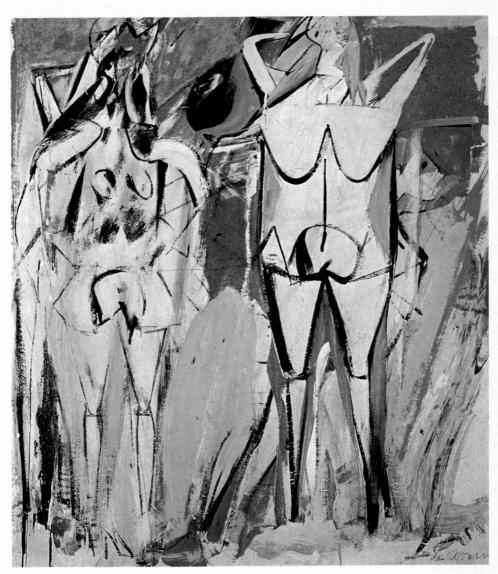

18 DE KOONING *Two Standing Women*, 1949

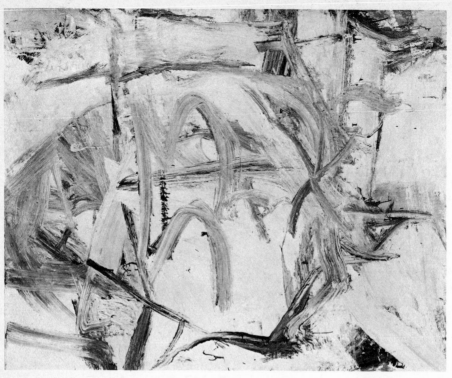

19 DE KOONING
Backyard on Tenth Street,
1956

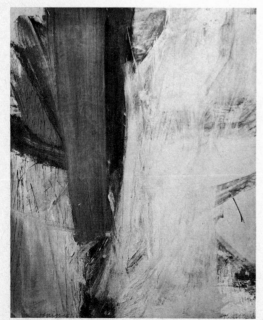

20 DE KOONING
Montauk Highway, 1958

ARSHILE GORKY

(Khorkom Vari Haiyotz, Armenia, 1905 –
New York City, 1948)

I call these murals non-objective art . . . but if labels are needed this art may be termed surrealistic, although it functions as design and decoration. The murals have continuity of theme. The theme – visions of the sky and river. The coloring likewise is derived from this and the whole design is contrived to relate to the very architecture of the building.

I might add that though the various forms all had specific meanings to me, it is the spectator's privilege to find his own meaning here. I feel that they will relate to or parallel mine.

Of course, the outward aspect of my murals seemingly does not relate to the average man's experience. But this is an illusion! What man has not stopped

21 GORKY *Mojave, c.* 1941–42

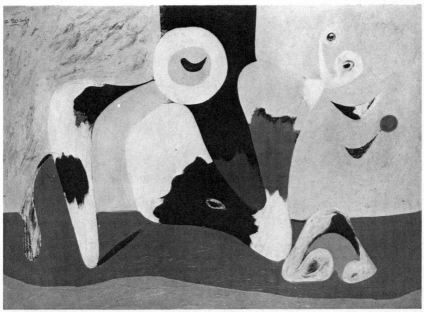

at twilight and on observing the distorted shape of his elongated shadow conjured up strange and moving and often fantastic fancies from it? Certainly we all dream and in this common denominator of every one's experience I have been able to find a language for all to understand.

From article and interview with Malcolm Johnson in the *New York Sun*, 22 August 1941.

22 GORKY *Orators*, 1947

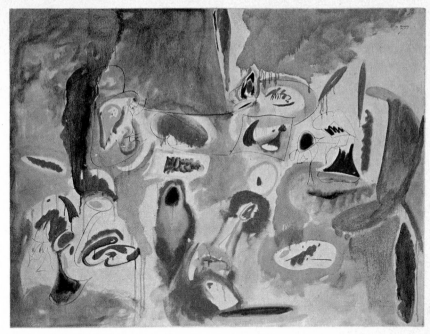

23 GORKY *Plumage Landscape*, 1947

24 GORKY *Terra Cotta*, 1947

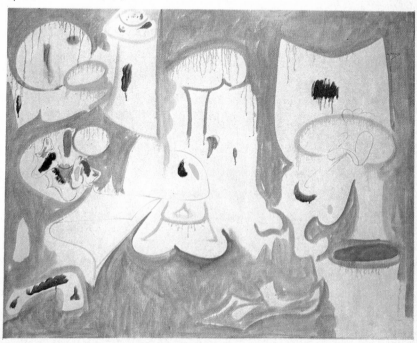

I like the heat the tenderness the edible the lusciousness the song
of a single person the bathtub full of water to bathe myself beneath
the water. I like Uccello Grünewald Ingres the drawings and sketches
for paintings of Seurat and that man Pablo Picasso.
I measure all things by weight.
I love my Mougouch. What about Papa Cézanne.
I hate things that are not like me and all the things I haven't got
are god to me.
Permit me –
I like the wheatfields the plough the apricots the shape of apricots
those flirts of the sun. And bread above all.
My liver is sick with the purple.

About 194 feet away from our house on the road to the spring my father had
a little garden with a few apple trees which had retired from giving fruit.
There was a ground constantly in shade where grew incalculable amounts of
wild carrots and porcupines had made their nests. There was a blue rock half
buried in the black earth with a few patches of moss placed here and there like
fallen clouds. But from where came all the shadows in constant battle like the
lancers of Paolo Uccello's painting? This garden was identified as the Garden
of Wish Fulfillment and often I had seen my mother and other village women
opening their bosoms and taking their soft and dependable breasts in their
hands to rub them on the rock. Above all this stood an enormous tree all
bleached under the sun the rain the cold and deprived of leaves. This was the
Holy Tree. I myself do not know why this tree was holy but I had witnessed
many people whoever did pass by that would tear voluntarily a strip of their
clothes and attach this to the tree. Thus through many years of the same act
like a veritable parade of banners under the pressure of wind all these personal
inscriptions of signatures very softly to my innocent ear used to give echo to
the sh-h-h of silver leaves of the poplars.

Written in June 1942, at request of
Dorothy Miller about the painting
Garden in Sochi which the Museum
of Modern Art had just acquired.
From the Collections Archives,
Museum of Modern Art,
New York, June 1942.

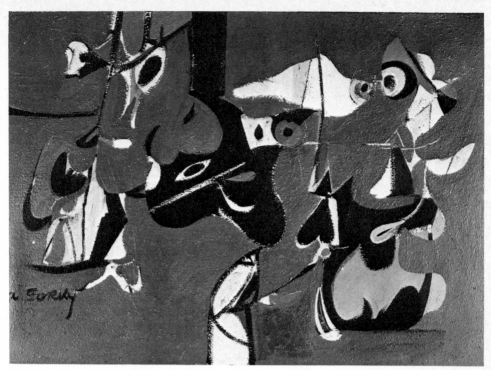

25 GORKY *Garden in Sochi,* 1941

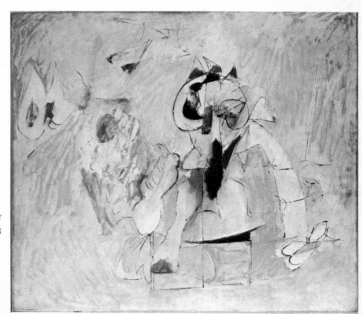

26 GORKY
Pirate II, 1943

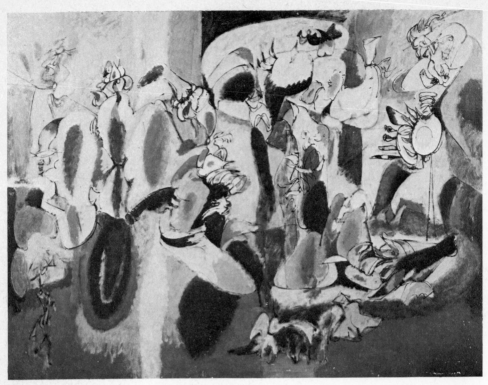

27 GORKY *The Liver is the Cock's Comb*, 1944

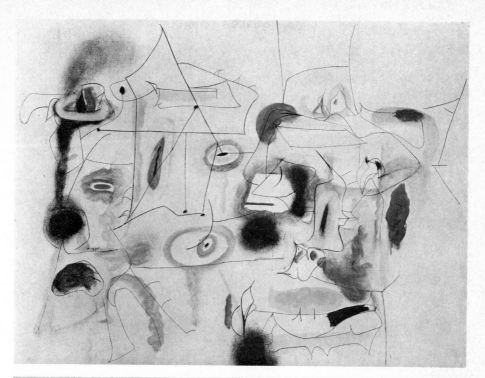

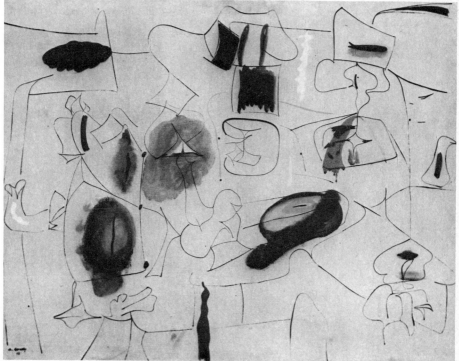

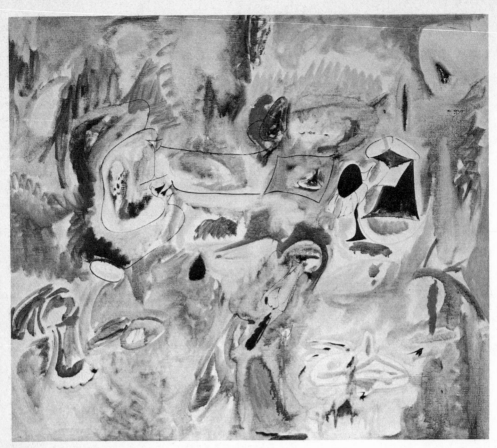

30 GORKY *Year After Year*, 1947

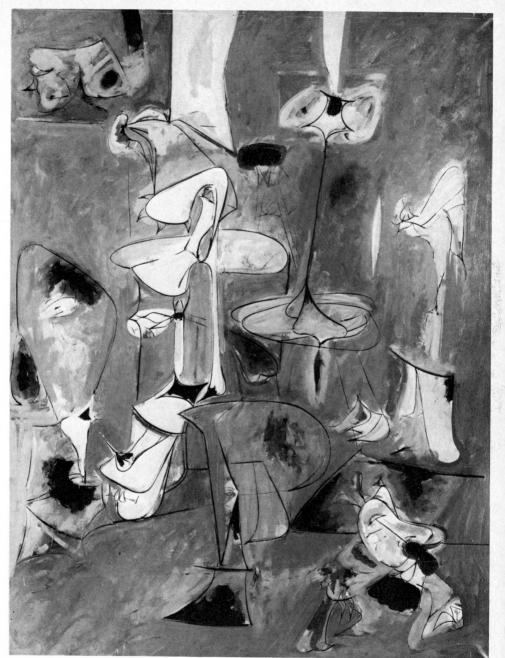

31 GORKY *Betrothal No. 1, 1947*

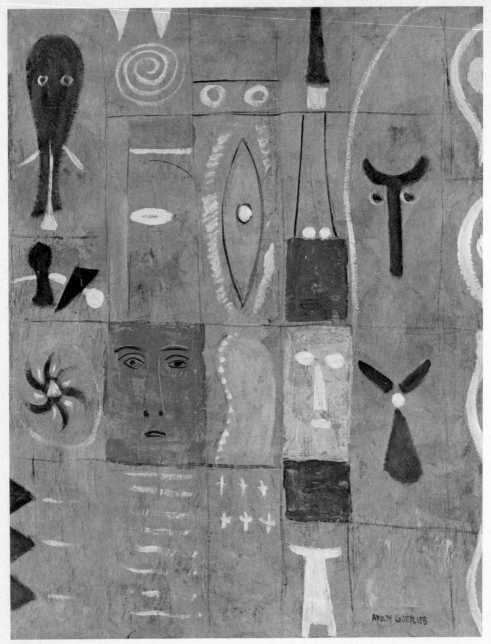

32 GOTTLIEB *Pictograph, c. 1946*

ADOLPH GOTTLIEB

(b. New York City, 1903)

You must admit . . . that knowledge of dimensions is a result of experience. Knowledge of science, of history, of history of art – the significance we attach to them – is a complex of all knowledge about things. Vision gives us little understanding of them. When I say I am reaching for a totality of vision, I mean that I take the things I know – hand, nose, arm – and use them in my paintings after separating them from their associations as anatomy. I use them as a totality of what they mean to me. It's a primitive method, and a primitive necessity of expressing, without learning how to do so by conventional ways. . . . It puts us at the beginning of seeing.

From *Limited Edition*, December 1945.

Certain people always say we should go back to nature. I notice they never say we should go forward to nature. It seems to me they are more concerned that we should go back, than about nature.

If the models we use are the apparitions seen in a dream, or the recollection of our prehistoric past, is this less part of nature or realism, than a cow in a field? I think not.

The role of the artist, of course, has always been that of image-maker. Different times require different images. Today when our aspirations have been reduced to a desperate attempt to escape from evil, and times are out of joint, our obsessive, subterranean and pictographic images are the expression of the neurosis which is our reality. To my mind certain so-called abstraction is not abstraction at all. On the contrary, it is the realism of our time.

From *Tiger's Eye*, vol. 1, no. 2, December 1947, p. 43.

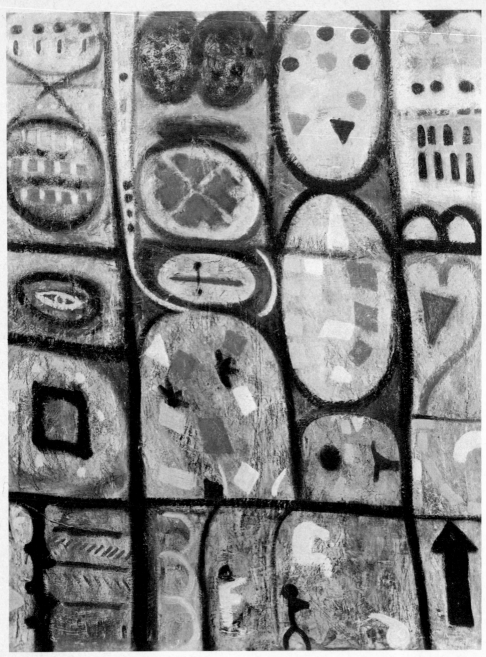

33 GOTTLIEB *Romanesque Façade*, 1949

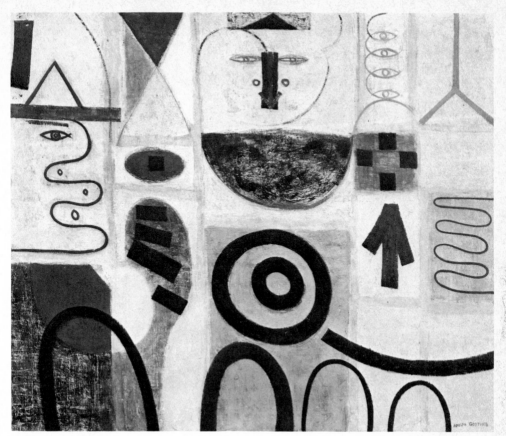

34 GOTTLIEB *The Seer*, 1950

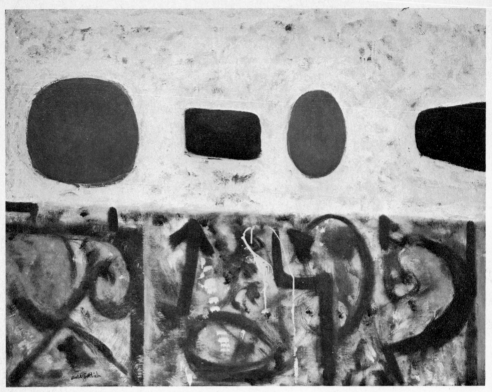

35 GOTTLIEB *Flotsam at Noon (Imaginary Landscape)*, 1952

I adopted the term Pictograph for my paintings . . . out of a feeling of disdain for the accepted notions of what a painting should be. This was in 1941. I decided that to acquiesce in the prevailing conception of what constituted 'good painting' meant the acceptance of an academic strait-jacket. It was, therefore, necessary for me to utterly repudiate so-called 'good painting' in order to be free to express what was visually true for me.

My Pictographs have been linked with totem-poles, Indian writing, psycho-analysis, neo-primitivism, private symbolism, etc., the implication being that my work is not quite what painting should be. This has never disturbed me because my aim has always been to project images that seem vital to me, never to make paintings that conform to the pattern of an external standard.

Now in 1955, as in the early forties and before, I am still concerned with the problem of projecting intangible and elusive images that seem to me to have meaning in terms of feeling. The important thing is to transfer the image to the canvas as it appears to me, without distortion. To modify the image would be to falsify it, therefore I must accept it as it is. My criterion is the integrity of the projection.

I frequently hear the question 'What do these images mean?' This is simply the wrong question. Visual images do not have to conform to either verbal thinking or optical facts. A better question would be 'Do these images convey any emotional truth?'

This, of course, indicates my belief that art should communicate. However, I have no desire to communicate with everyone, only with those whose thoughts and feelings are related to my own. That is why, even to some pundits, my paintings seem cryptic. Thus when we are solemnly advised to consolidate our gains, to be humanists or to go back to nature, who listens seriously to this whistling in the dark?

Painting values are not just black and white – I prefer innocent impurity to doctrinaire purism, but I prefer the no-content of purism to the shoddy content of social realism. Paint quality is meaningless if it does not express quality of feeling. The idea that a painting is merely an arrangement of lines, colors, and forms is boring. Subjective images do not have to have rational association, but the act of painting must be rational, objective, and consciously disciplined. I consider myself a traditionalist, but I believe in the spirit of tradition, not in the restatement of restatements. I love all paintings that look the way I feel.

From *The New Decade*, Whitney Museum of American Art, New York, 1955, pp. 35–36.

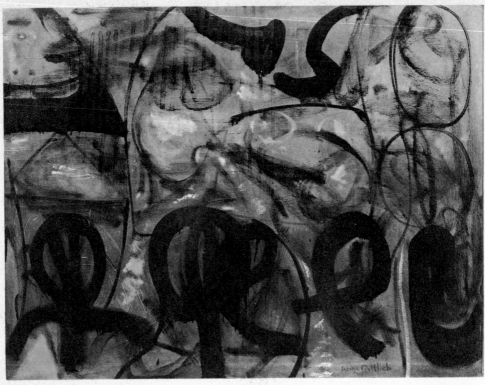

36 GOTTLIEB *Black, Unblack*, 1954

37 GOTTLIEB *Imaginary Landscape*, 1956

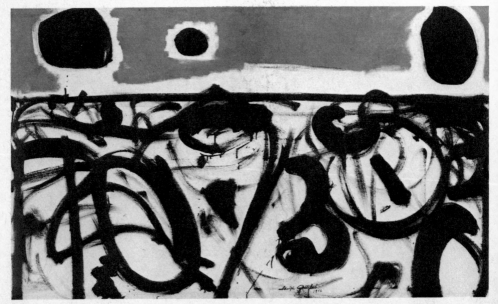

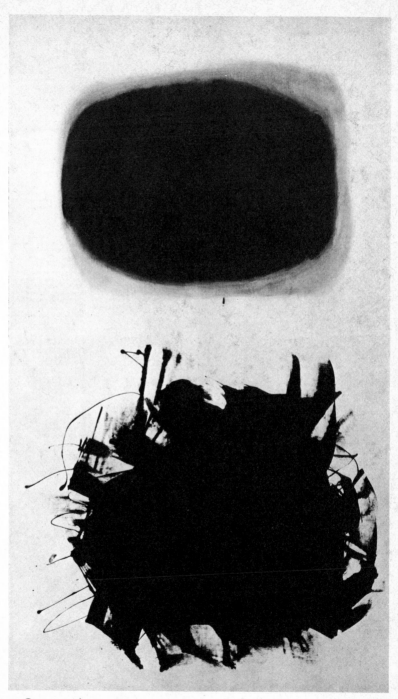

38 GOTTLIEB *Blast No. 3*, 1958

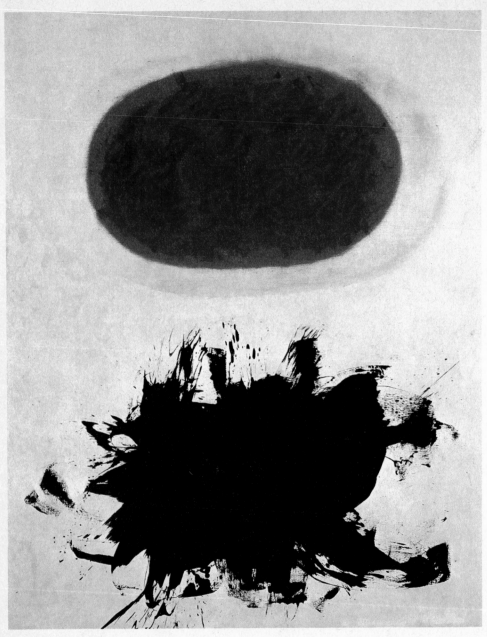

39 GOTTLIEB *Crimson Spinning No. 2*, 1959

PHILIP GUSTON

(b. Montreal, Canada, 1913)

Painting permits, ultimately, the joys of the possible. But the narrow passage to this domain of the possible, suppresses any illusion of mastery.

Only our surprise that the unforeseen was fated, allows the arbitrary to disappear. The delights and anguish of the paradoxes on this imagined plane resist the threat of painting's reducibility.

The poise, the isolation, of the image containing the memory of its past and promise of change is neither a possession nor is it frustrating. The forms, having known each other differently before, advance yet again, their gravity marked by their escape from inertia.

Painting is a clock that sees each end of the street as the edge of the world.

From *It Is*, no. 1, Spring 1958, p. 44.

I find it difficult to take a large view of things. The pressing thing for me in painting is 'When are you through?' I would like to think a picture is finished when it feels not new, but old. As if its forms had lived a long time in you, even though until it appears you did not know what it would look like. It is the looker, not the maker, who is so hungry for the new. The new can take care of itself.

Every idea that I have now or get about painting seems to follow from the daily work: from an in-fighting in painting itself – in the confusion of painting. What can be talked about? It seems that the possible subject is in fact impossible to discuss. As you paint, changing and destroying, nothing can be assumed. You remove continually what you can not vouch for or are not yet ready to accept. Until a certain moment.

I feel like insisting on this one point. The only morality in painting revolves around the moment when you are permitted to 'see' and the painting takes over. You can't jump the gun. You can't put yourself into that state by merely

75

wanting to see; but the painter knows when that time comes. Which is why there is only realism in painting. And unless you keep going through up to that time, no matter what in particular the picture looks like – as a matter of fact, you don't know what it's looking like – but unless you work up until that point – when you don't even know what you're 'seeing' but suddenly make a vault and 'see' – you are not finished, no matter how great and reasonable your ideas or intentions are. This sounds nagging and tedious, but that's the way it is.

The reasons for this condition are plaguing and not easily understood. When you do not paint from things or ideas – when there is no model, in others words – certainly something else is happening and that is the constant question, 'What is happening?'

I believe it was John Cage who once told me, 'When you start working, everybody is in your studio – the past, your friends, enemies, the art world, and above all, your own ideas – all are there. But as you continue painting, they start leaving, one by one, and you are left completely alone. Then, if you're lucky, even you leave.'

Well, there is always a strange assumption behind panels or discussions on art: that it should be understood. . . . I mean the assumption that art should

40 GUSTON *Tormentors*, 1947–48

41 GUSTON *Review*, 1948–49

be made clear. For whom? Someone once said, speaking about the public, that if a violinist came on the concert stage and played his violin as if to imitate the sound of a train coming into the station, everyone would applaud. But if he played a sonata, only the initiated would applaud. What a miserable alternative. The implication is that in the first case the medium is used to imitate something else and in the latter, as they say, is pure or abstract. But isn't it so that the sonata is above all an image? An image of what? We don't know, which is why we continue listening to it.

There is something ridiculous and miserly in the myth we inherit from abstract art: That painting is autonomous, pure and for itself, and therefore we habitually analyze its ingredients and define its limits. But painting *is* 'impure.' It is the adjustment of 'impurities' which forces painting's continuity. We are image-makers and image-ridden. There are no 'wiggly or straight lines' or any other elements. You work until they vanish. The picture isn't finished if they are seen.

From *It Is*, no. 5, Spring 1960, pp. 36, 37, 38.

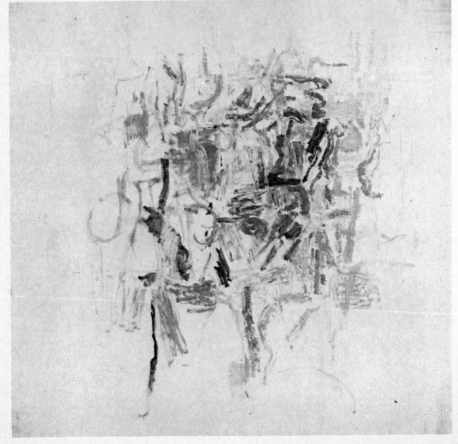

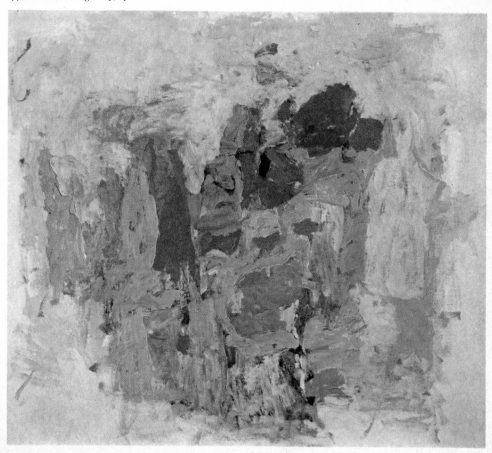

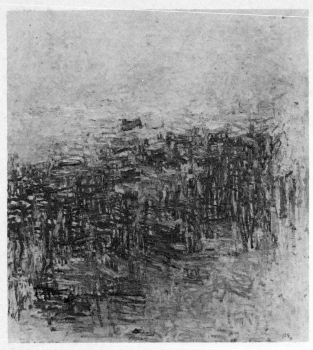

45 GUSTON
Painting, 1954

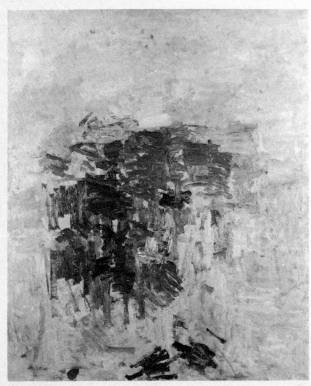

46 GUSTON
The Room, 1954–55

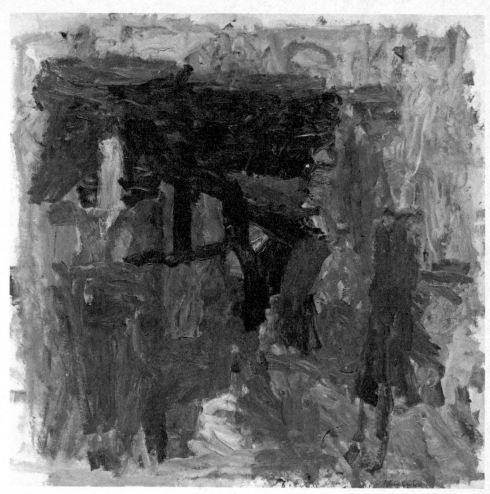

47 GUSTON *Grove I*, 1959

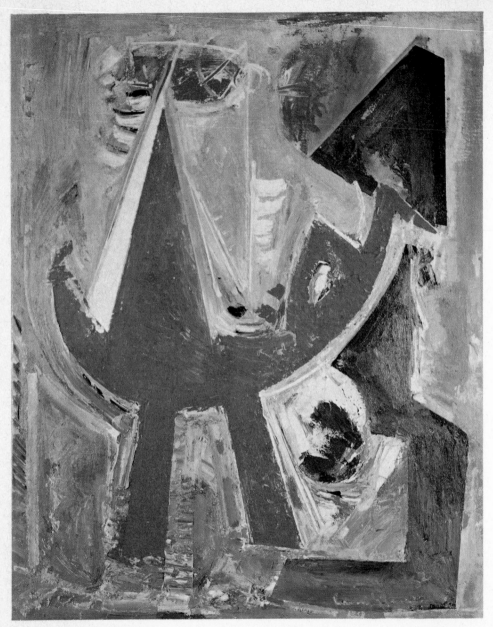

48 HOFMANN *Flight*, 1952

HANS HOFMANN

(Weissenburg, Bavaria, Germany, 1880 –
New York City, 1966)

America is at present in a state of cultural blossoming. I am supposed to have contributed my share as teacher and artist by the offering of a multiple awareness. This awareness I consider to constitute a visual experience and a pictorial creation.

'Seeing' without awareness, as a visual act, is just short of blindness. 'Seeing' with awareness is a visual experience; it is an art.

We must learn to see. The interpretation in pictorial terms of what we see is 'another' art.

Every act of pictorial creation has, therefore, a dual conceptual approach.

The origin of creation is, therefore, a reflection of nature on a creative mind:

We are nature

What surrounds us is nature

Our creative means are nature

Nothing, however, will happen without the creative faculties of our conscious-and-unconscious mind.

One of these faculties is an awareness of space in every form of manifestation: either

(a) in the form of movement and counter-movement, with the consequence of rhythm and counter-rhythm; or

(b) in the form of force and counter-force in a two-dimensional and three-dimensional play in every direction; or

(c) in the form of tension as a result of these forces.

The pictorial life as a pictorial reality results from the aggregate of two- and three-dimensional tensions: a combination of the effect of simultaneous expansion and contraction with that of push and pull.

The nature of the light-and-color problem in the plastic arts cannot be fully understood without an awareness of the foregoing considerations. Color and light are to a very great extent subjected to the formal problems of the picture surface.

The color problem follows a development that makes it a life and light emanating plastic means of first order. Like the picture surface, color has an inherent life of its own. A picture comes into existence on the basis of the interplay of this dual life. In the act of predominance and assimilation, colors love or hate each other, thereby helping to make the creative intention of the artist possible.

Talent is, in general, common – original talent is rare. A teacher can only accompany a talent over a certain period of time – he can never make one. As a teacher, I approach my students purely with the human desire to free them from all scholarly inhibitions.

And I tell them,

'Painters must speak through paint – not through words.'

From *It Is*, no. 3, Winter–Spring 1959, p. 10.

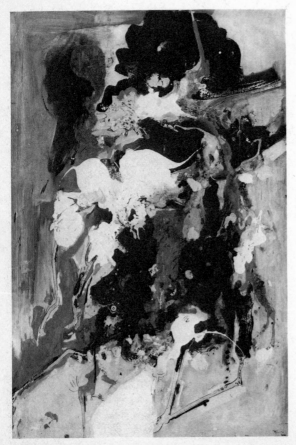

49 HOFMANN
Effervescence, 1944

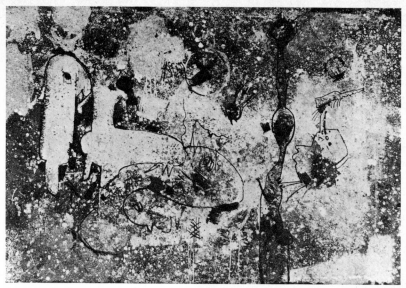

50 HOFMANN
Palimpsest, 1946

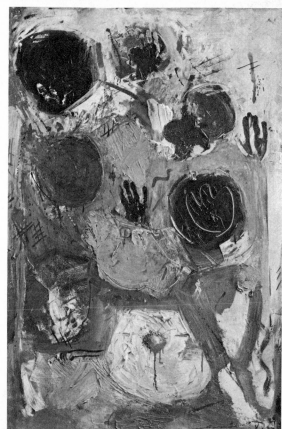

51 HOFMANN
Third Hand, 1947

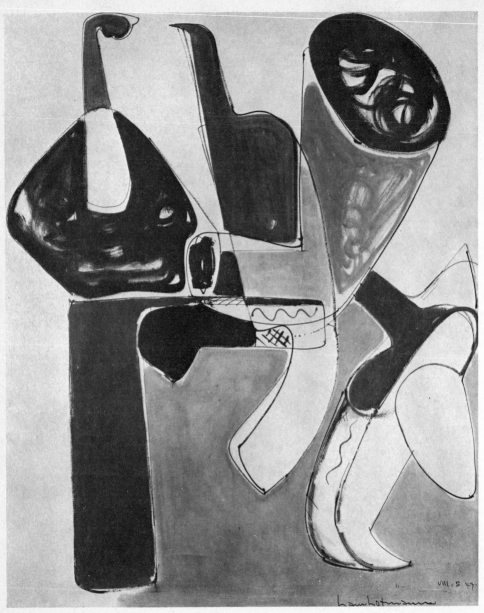

52 HOFMANN *Libration*, 1947

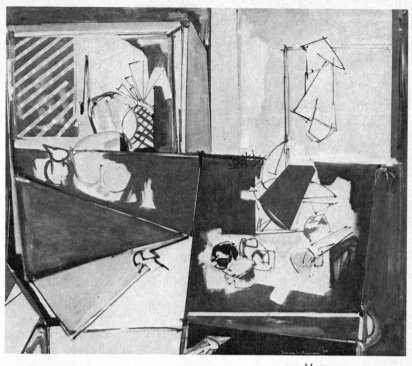

53 HOFMANN
Magenta and Blue, 1950

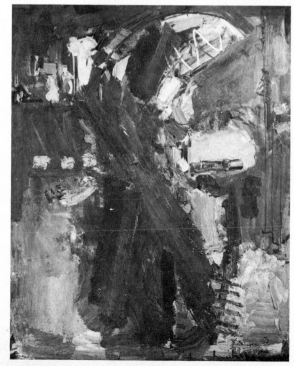

54 HOFMANN *X-1955*, 1955

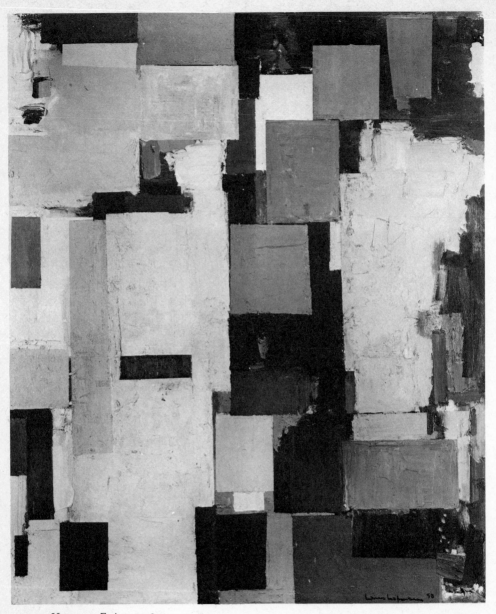

55 HOFMANN *Equinox*, 1958

FRANZ KLINE

(Wilkes-Barre, Pennsylvania, 1910 – New York City, 1962)

KLINE: It wasn't a question of deciding to do a black and white painting. I think there was a time when the original forms that finally came out in black and white were in colour, say, and then as time went on I painted them out and made them black and white. And then, when they got that way, I just liked them, you know. I mean there was that marvellous twenty-minute experience of thinking, well, all my life has been wasted but that marvellous – sort of thing.

KLINE: . . . I didn't have a particularly strong desire to use colour, say, in the lights or darks of a black and white painting, although what happened is that accidentally they look that way. Sometimes a black, because of the quantity of it or the mass or the volume, looks as though it may be a blue-black, as if there were blue mixed in with the black, or as though it were a brown-black or a red-black. No, I didn't have any idea of mixing up different kinds of blacks; as a matter of fact, I just used any black that I could get hold of.

KLINE: The whites the same way; the whites, of course, turned yellow, and many people call your attention to that, you know; they want white to stay white forever. It doesn't bother me whether it does or not. It's still white compared to the black.

SYLVESTER: Is it the case that you have been very much consciously concerned with equalizing the black and white on the canvas to make them part of the surface?

KLINE: No, no. When that finally came across me, it was through reading somebody talking about it that way. People have written on that, when they've brought in that everything is the same, brought in a little of Zen, and space, and the infinite illusion of form in space. No, I don't think about it that way.

I mean, I don't think about it either as calligraphy or infinite space. Coming from the tradition of painting the areas which, I think, came to its reality here through the work of Mondrian – in other words, everything was equally painted – I don't mean that it's equalized, but I mean the white or the space is painted, it's not . . .

SYLVESTER: Black on white?

KLINE: That's right. In other words, calligraphy is simply the art of writing.

KLINE: . . . You don't make the letter 'C' and then fill the white in the circle. When people describe forms of painting in the calligraphic sense they really mean the linear, inscribing or drawing or so on. No, I didn't have this feeling that painting was the equalization of the proportions of black or the design of black against a form of white; but, in a lot of cases, apparently it does look that way. I rather imagine as people have come from the tradition of looking at drawing, they look at the lines, until you go to art school and then some drawing teacher tells you to look at the white spaces in it; but I didn't think about the black and white paintings as coming that way. I thought about it in a certain sense of the awkwardness of 'not-balance,' the tentative reality of

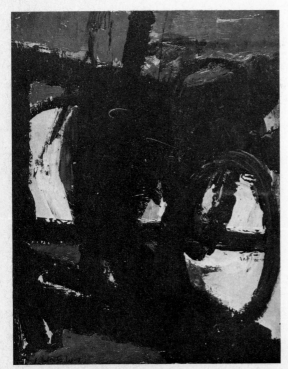

56 KLINE
Untitled, 1947

57 KLINE
Untitled, c. 1948

lack of balance in it. The unknown reason why a form would be there and look just like that and not meaning anything particularly, would, in some haphazard way, be related to something else that you didn't plan either.

KLINE: . . . I don't like to manipulate the paint in any way in which it doesn't normally happen. In other words, I wouldn't paint an area to make texture, you see? And I wouldn't decide to scumble an area to make it more interesting to meet another area which isn't interesting enough. I love the idea of the thing happening that way and through the painting of it, the form of the black or the white come about in exactly that way, plastically.

SYLVESTER: But there is no sort of preconception as to what the thing ought to be?

KLINE: No. Except – except paint never seems to behave the same. Even the same paint doesn't, you know. In other words, if you use the same white or black or red, through the use of it, it never seems to be the same. It doesn't dry the same. It doesn't stay there and look at you the same way. Other things seem to affect it. There seems to be something that you can do so much with paint and after that you start murdering it. There are moments or periods when

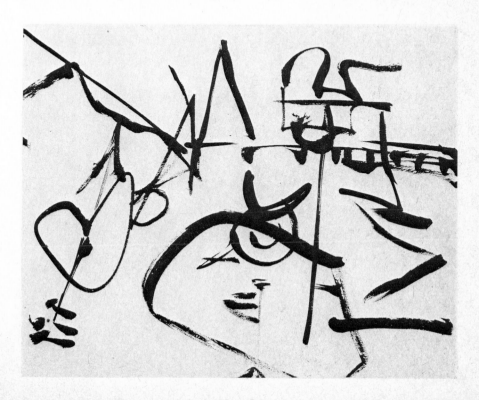

it would be wonderful to plan something and do it and have the thing only do what you planned to do, and then, there are other times when the destruction of those planned things becomes interesting to you. So then, it becomes a question of destroying – of destroying the planned form; it's like an escape, it's something to do; something to begin the situation. You yourself, you don't decide, but if you want to paint you have to find out some way to start this thing off, whether it's painting it out or putting it in, and so on.

KLINE: It can at times become like the immediate experience of beginning it; in other words, I can begin a painting if I decide it would be nice to have a large triangle come up and meet something that goes across like this. Now, on other occasions, I can think the whole thing through. The triangle needs an area that goes this way and then at the top something falls down and hits about here and then goes over there. So I try and rid my mind of anything else and attack it immediately from that complete situation. Other times, I can begin it with just the triangle meeting a large form that goes over that way, and when I do it, it doesn't seem like anything. When this series of relationships that go on in the painting relate – I don't particularly know what they relate to – but the relationship of those forms, I, in some way, try to form them in the original conception of what I rather imagined they would look like. Well then, at times, it's a question of maybe making them more than that. You see what I mean. It'd be a question of, say, eliminating the top or the bottom. Well, I can go through and destroy the whole painting completely without even going back to this original situation of a triangle and a long line, which seems to appear somewhere else in the painting. When it appears the way I originally thought it should, boy, then it's wonderful!

KLINE: . . . if someone says, 'that looks like a bridge,' it doesn't bother me really. A lot of them do. . . . I like bridges. . . . Naturally, if you title them something associated with that, then when someone looks at it in the literary sense, he says, 'he's a bridge painter,' you know. . . . There are forms that are figurative to me, and if they develop into a figurative image that's – it's all right if they do. I don't have the feeling that something has to be completely non-associative as far as figure form is concerned. . . . I think that if you use long lines, they become – what could they be? The only thing they could be is either highways or architecture or bridges.

KLINE: . . . it is nice to paint a happy picture after a sad one. I think that there is a kind of loneliness in a lot of them which I don't think about as the

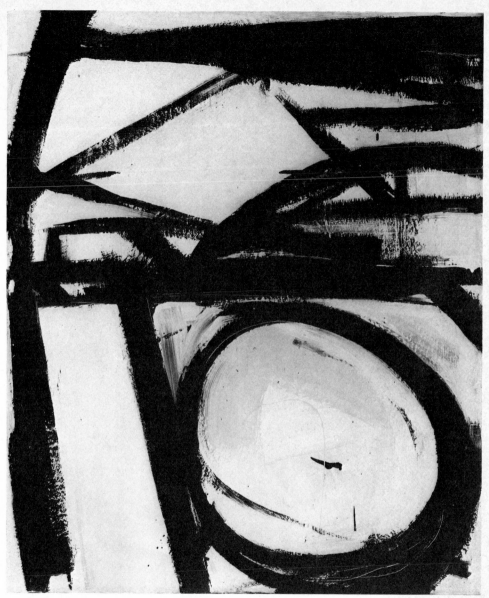

58 Kline *Clockface*, 1950

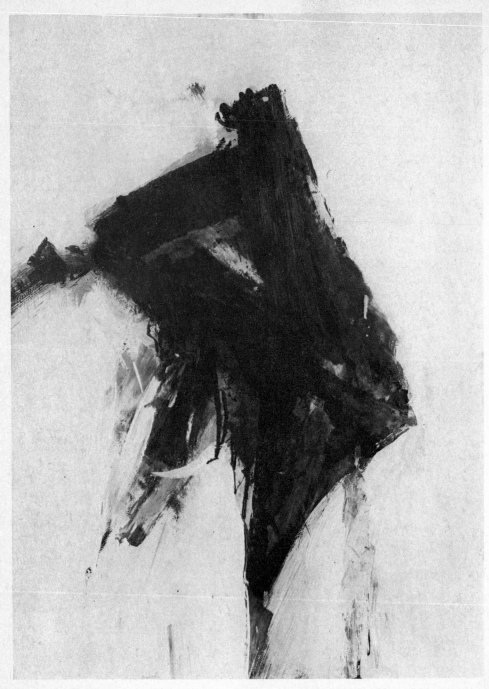

59 KLINE *Untitled*, 1952

fact that I'm lonely and therefore I paint lonely pictures, but I like kind of lonely things anyhow; so if the forms express that to me, there is a certain excitement that I have about that. Any composition – you know, the overall reality of that does have something to do with it; the impending forms of something, do maybe have a brooding quality, whereas in other forms, they would be called or considered happier.

SYLVESTER: Are you aware of these qualities when you are actually painting or only after you have finished the painting?

KLINE: No, I'm aware of them as I paint. I don't mean that I retain those. What I try to do is to create the painting so that the overall thing has that particular emotion; not particularly just the forms in it.

From an interview with David Sylvester published in *Living Arts* (London), vol. 1, no. 1, Spring 1963.

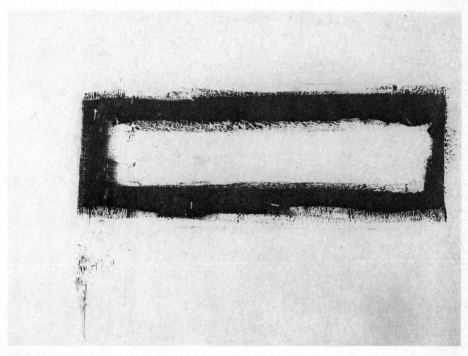

60 KLINE *Untitled*, 1953–54

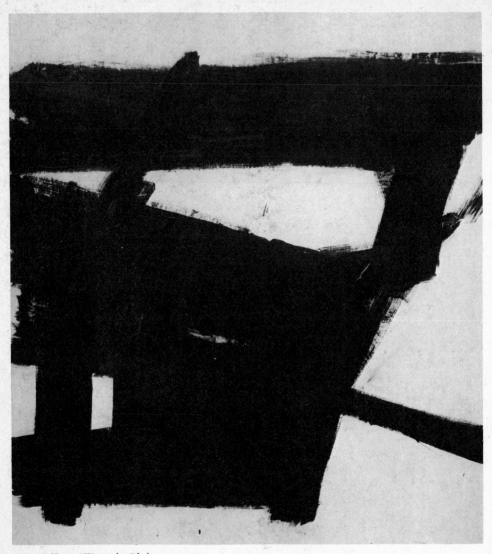

61 KLINE *Wanamaker Block*, 1955

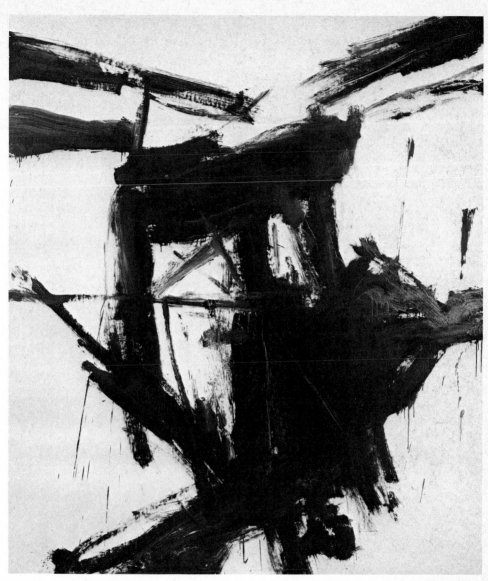

62 KLINE *August Day*, 1957

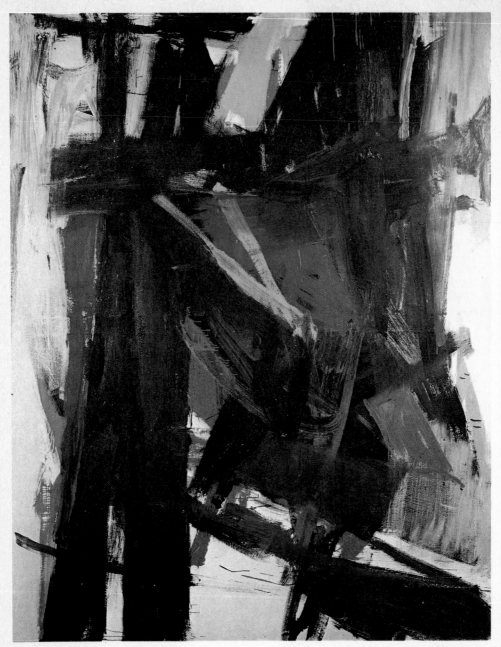

63 KLINE *King Oliver*, 1958

ROBERT MOTHERWELL

(b. Aberdeen, Washington, 1915)

As a result of the poverty of modern life, we are confronted with the circum-
stance that art is more interesting than life. '*Experience is bound to utility*,' as
André Breton says, '*and guarded by common sense*.' The pleasurable 'things' of
other times for the most part no longer exist, and those which do no longer
suffice. With what our epoch meant to replace the wonderful things of the
past – the late afternoon encounters, the leisurely repasts, the discriminations
of taste, the graces of manners, and the gratuitous cultivation of minds – what
we might have invented, perhaps we shall never know. We have been too
busy with *tasks*. At what other time could the juxtaposition of a bright square
on a white ground have seemed so portentous!

The surrealists alone among modern artists refused to shift the problem to
the plane of art. Ideally speaking, superrealism became a system for enhancing
everyday life. True, the surrealists were always saying that 'poetry should be
made by all'; but they did not mean precisely what we have always meant by
poetry. If they had been successful, we might not have needed 'poetry' at all.
Still, their various devices for finding pleasure – spiritual games, private
explorations, public provocations, sensory objects, and all the rest – were
artificial enough abroad before the war. In the hard and conventional English-
speaking world the devices simply could not work. Here it was the surrealists
who were transformed. And it may be that their pioneer, and therefore often
naïve effort to enhance the life of the modern mind will be forgotten.

Certain individuals represent a young generation's artistic chances. There are
never many such individuals in a single field, such as painting – perhaps a
hundred to begin with. The hazards inherent in man's many relations with
reality are so great – there is disease and premature death; hunger and alcoholism
and frustration; the historical moment may turn wrong for painters: it most
often does; the young artist may betray himself, consciously or not, or may be

betrayed – the hazards are so great that not more than five out of a whole young generation are able to develop to the end. And for the most part it is the painting of mature men which is best.

The importance of the one-man show of young Jackson Pollock (*Art of This Century*) lies just in this, that he represents one of the younger generation's chances. There are not three other young Americans of whom this could be said. In his exhibit Pollock reveals extraordinary gifts: his color sense is remarkably fine, never exploited beyond its proper role; and his sense of surface is equally good. His principal problem is to discover what his true *subject* is. And since painting is his thought's medium, the resolution must grow out of the process of his painting itself.

From *Partisan Review*, vol. 11, no. 1, Winter 1944, pp. 96, 97.

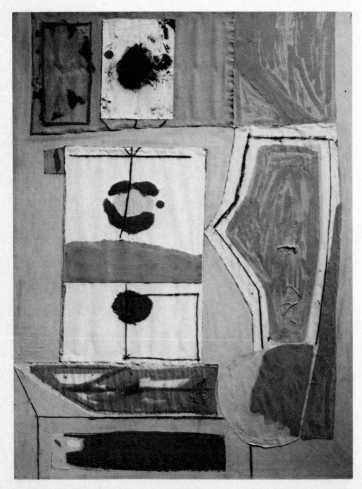

64 MOTHERWELL
*Blue with China Ink –
Homage to John Cage*,
1946

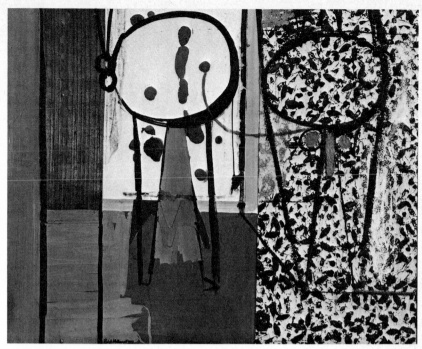

65 MOTHERWELL *Pancho Villa, Dead and Alive*, 1943

66 MOTHERWELL *Still Life, Ochre and Red*, 1947

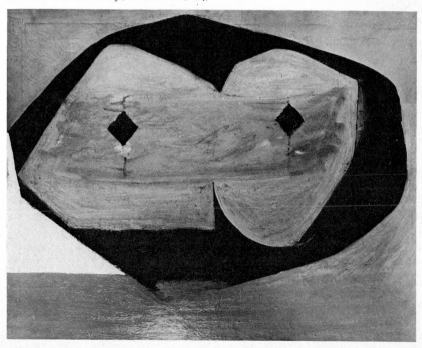

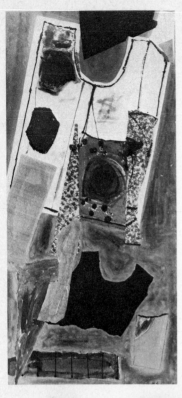

67 MOTHERWELL
The Best Toys Are Made of Paper, 1948

68 MOTHERWELL
At Five in the Afternoon, 1950

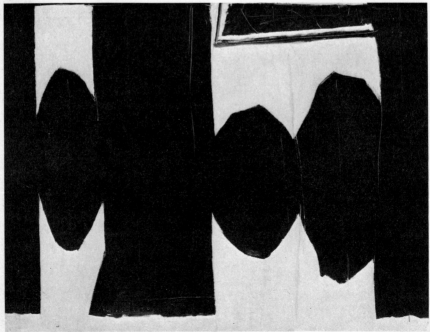

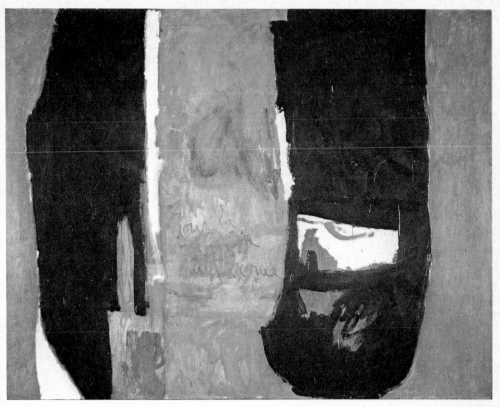

69 MOTHERWELL *Jour la Maison, Nuit la Rue*, 1957

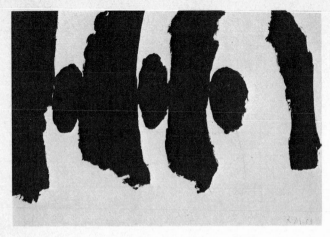

70 MOTHERWELL
*Elegy to the Spanish
Republic XXXVB*, 1953

71 MOTHERWELL *A Sculptor's Picture with Blue*, 1958

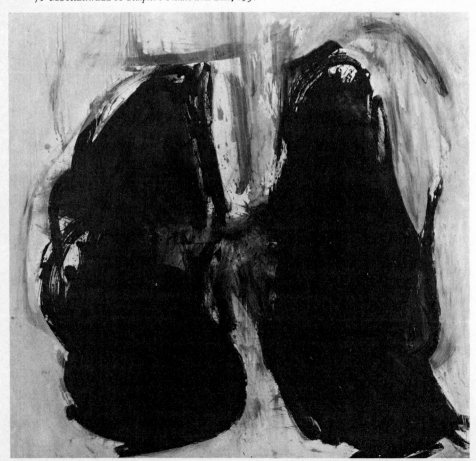

BARNETT NEWMAN

(New York City, 1905–1970)

The Kwakiutl artist painting on a hide did not concern himself with the inconsequentials that made up the opulent social rivalries of the Northwest Coast Indian scene, nor did he, in the name of a higher purity, renounce the living world for the meaningless materialism of design. The abstract shape he used, his entire plastic language, was directed by a ritualistic will towards metaphysical understanding. The everyday realities he left to the toy-makers; the pleasant play of non-objective pattern to the women basket-weavers. To him a shape was a living thing, a vehicle for an abstract thought-complex, a carrier of the awesome feelings he felt before the terror of the unknowable. The abstract shape was, therefore, real rather than a formal 'abstraction' of a visual fact, with its overtone of an already-known nature. Nor was it a purist illusion with its overload of pseudo-scientific truths.

The basis of an esthetic act is the pure idea. But the pure idea is, of necessity, an esthetic act. Here then is the epistemological paradox that is the artist's problem. Not space cutting nor space building, not construction nor fauvist destruction; not the pure line, straight and narrow, nor the tortured line, distorted and humiliating; not the accurate eye, all fingers, nor the wild eye of dream, winking; but the idea-complex that makes contact with mystery – of life, of men, of nature, of the hard, black chaos that is death, or the grayer, softer chaos that is tragedy. Everything else has everything else.

Spontaneous, and emerging from several points, there has arisen during the war years a new force in American painting that is the modern counterpart of the primitive art impulse. As early as 1942, Mr Edward Alden Jewell was the first publicly to report it. Since then, various critics and dealers have tried to label it, to describe it. It is now time for the artist himself, by showing the dictionary, to make clear the community of intention that motivates him and his colleagues. For here is a group of artists who are not abstract painters, although working in what is known as the abstract style.

From *The Ideographic Picture*, Betty Parsons
Gallery, 20 January–8 February 1947.

72 NEWMAN *Tundra*, 1950

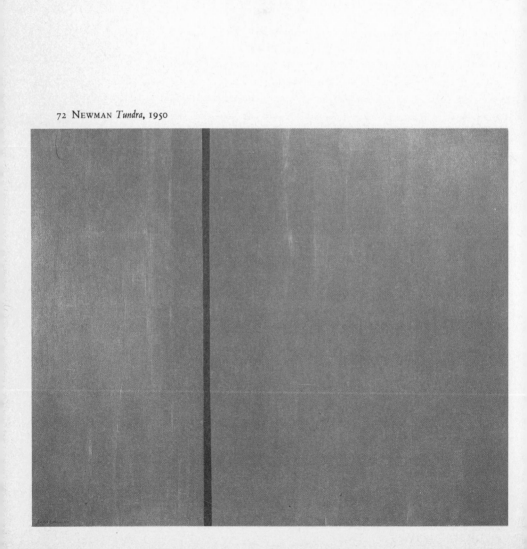

73 NEWMAN *Onement No. 6*, 1953

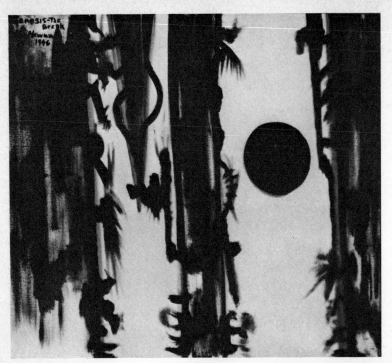

74 NEWMAN
Genesis – the Break, 1946

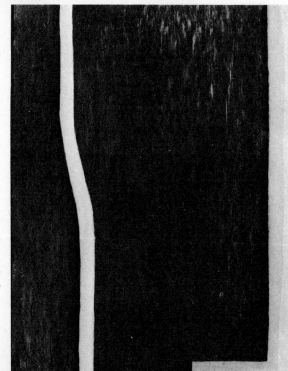

75 NEWMAN
Euclidean Abyss, 1947

The invention of beauty by the Greeks, that is, their postulate of beauty as an ideal, has been the bugbear of European art and European esthetic philosophies. Man's natural desire in the arts to express his relation to the Absolute became identified and confused with the absolutisms of perfect creations – with the fetish of quality – so that the European artist has been continually involved in the moral struggle between notions of beauty and the desire for sublimity. . . .

Michelangelo knew that the meaning of the Greek humanities for his time involved making Christ – the man, into Christ – who is God; that his plastic problem was neither the medieval one, to make a cathedral, nor the Greek one, to make a man like a god, but to make a cathedral out of man. In doing so he set a standard for sublimity that the painting of his time could not reach. Instead, painting continued on its merry quest for a voluptuous art until in modern times, the impressionists, disgusted with its inadequacy, began the movement to destroy the established rhetoric of beauty by the impressionist insistence on a surface of ugly strokes.

The impulse of modern art was this desire to destroy beauty. However, in discarding Renaissance notions of beauty, and without an adequate substitute for a sublime message, the impressionists were compelled to preoccupy themselves, in their struggle, with the culture values of their plastic history so that instead of evoking a new way of experiencing life they were able only to make a transfer of values. . . .

So strong is the grip of the *rhetoric* of exaltation as an attitude in the large context of the European culture pattern that the elements of sublimity in the revolution we know as modern art, exist in its effort and energy to escape the pattern rather than in the realization of a new experience. Picasso's effort may be sublime but there is no doubt that his work is a preoccupation with the question of what is the nature of beauty. Even Mondrian, in his attempt to destroy the Renaissance picture by his insistence on pure subject-matter, succeeded only in raising the white plane and the right angle into a realm of sublimity, where the sublime paradoxically becomes an absolute of perfect sensations. The geometry (perfection) swallowed up his metaphysics (his exaltation).

The failure of European art to achieve the sublime is due to this blind desire to exist inside the reality of sensation (the objective world, whether distorted or pure) and to build an art within a framework of pure plasticity (the Greek ideal of beauty, whether that plasticity be a romantic active surface, or a classic stable one). In other words, modern art, caught without a sublime content, was incapable of creating a new sublime image, and unable to move away from

the Renaissance imagery of figures and objects except by distortion or by denying it completely for an empty world of geometric formalisms – a pure rhetoric of abstract mathematical relationships, became enmeshed in a struggle over the nature of beauty; whether beauty was in nature or could be found without nature.

I believe that here in America, some of us, free from the weight of European culture, are finding the answer, by completely denying that art has any concern with the problem of beauty and where to find it. The question that now arises is how, if we are living in a time without a legend or mythos that can be called sublime, if we refuse to admit any exaltation in pure relations, if we refuse to live in the abstract, how can we be creating a sublime art?

We are reasserting man's natural desire for the exalted, for a concern with our relationship to the absolute emotions. We do not need the obsolete props of an outmoded and antiquated legend. We are creating images whose reality is self-evident and which are devoid of the props and crutches that evoke associations with outmoded images, both sublime and beautiful. We are freeing ourselves of the impediments of memory, association, nostalgia, legend, myth, or what have you, that have been the devices of Western European painting. Instead of making *cathedrals* out of Christ, man, or 'life,' we are making it out of ourselves, out of our own feelings. The image we produce is the self-evident one of revelation, real and concrete, that can be understood by anyone who will look at it without the nostalgic glasses of history.

From *Tiger's Eye*, vol. 1, no. 6, 15 December 1948, pp. 51, 52, 53.

Greece named both form and content; the ideal form – beauty, the ideal content – tragedy.

It is interesting that when the Greek dream prevails in our time, the European artist is nostalgic for the ancient forms, hoping to achieve tragedy by depicting his self-pity over the loss of the elegant column and the beautiful profile. This tortured emotion, however, agonizing over the Greek objects, is always refined. Everything is so highly civilized.

The artist in America is, by comparison, like a barbarian. He does not have the super-fine sensibility toward the object that dominates European feeling. He does not even have the objects.

This is then, our opportunity, free of the ancient paraphernalia, to come closer to the sources of the tragic emotion. Shall we not, as artists, search out the new objects for its image?

From *Tiger's Eye*, vol. 1, no. 3, March 1948, p. 111.

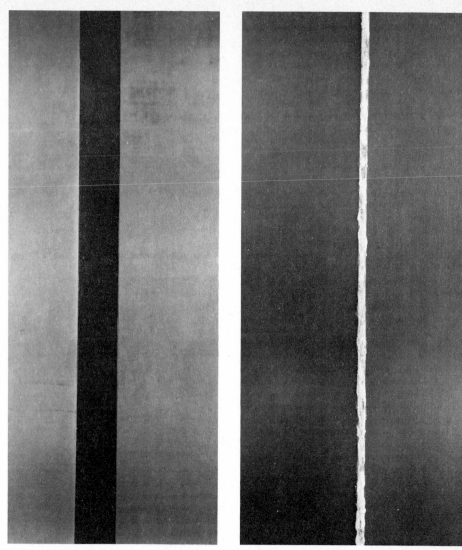

76 NEWMAN *Abraham*, 1949 77 NEWMAN *Onement No. 3*, 1949

The central issue of painting is the subject-matter. Most people think of subject-matter as what Meyer Schapiro has called 'object-matter.' It is the 'object-matter' that most people want to see in a painting. That is what, for them, makes the painting seem full. For me both the use of objects and the manipulation of areas for the sake of the areas themselves must end up being anecdotal. My subject is anti-anecdotal. An anecdote can be subjective and internal as well as of the external world so that the expression of the biography of self or the intoxicated moment of glowing ecstasy must in the end also become anecdotal. All such painting is essentially episodic which means it calls for a sequel. This must happen if a painting does not give a sensation of wholeness or fulfilment. That is why I have no interest in the episode or ecstatic, however abstract.

I am always referred to in relation to my color. Yet I know that if I have made a contribution, it is primarily in my drawing. The impressionists changed the way of seeing the world through their kind of drawing; the cubists saw the world anew in their drawing, and I hope that I have contributed a new way of seeing through drawing. Instead of using outlines, instead of making shapes or setting off spaces, my drawings declare the space. Instead of working with the remnants of space, I work with the whole space.

It is full of meaning, but the meaning must come from the seeing, not from the talking. I feel, however, that one of its implications is its assertion of freedom, its denial of dogmatic principles, its repudiation of all dogmatic life. Almost fifteen years ago Harold Rosenberg challenged me to explain what one of my paintings could possibly mean to the world. My answer was that if he and others could read it properly it would mean the end of all state capitalism and totalitarianism. That answer still goes.

From an interview with Dorothy Seckler in
Art in America, vol. 50. no. 2, Summer 1962, pp. 83, 86–87.

78 NEWMAN *Vir Heroicus Sublimis*, 1950–51

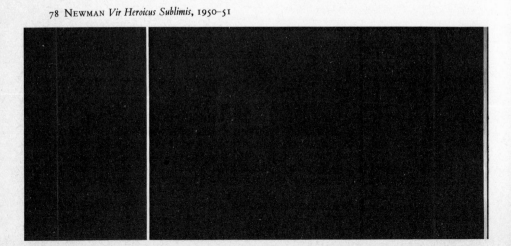

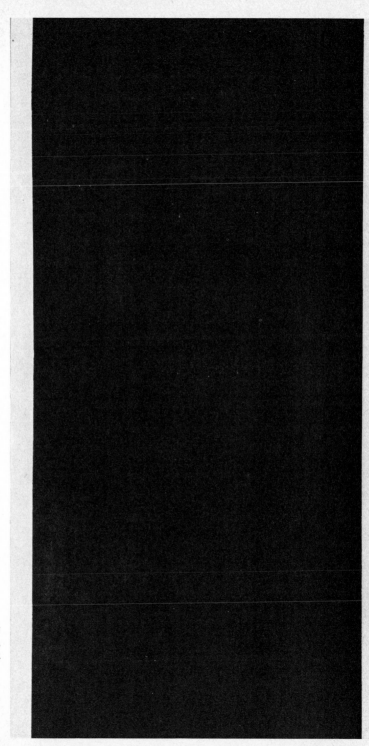

79 NEWMAN
Primordial Light,
1954

80 NEWMAN *The Word*, 1954

81 NEWMAN *Outcry*, 1958

JACKSON POLLOCK

(Cody, Wyoming, 1912 –
East Hampton, New York, 1956)

Where were you born?
Cody, Wyoming, in January 1912. My ancestors were Scotch and Irish.

Have you traveled any?
I've knocked around some in California, some in Arizona. Never been to Europe.

Would you like to go abroad?
No. I don't see why the problems of modern painting can't be solved as well here as elsewhere.

Where did you study?
At the Art Students' League, here in New York. I began when I was seven-teen. Studied with Benton, at the League, for two years.

How did your study with Thomas Benton affect your work, which differs so radically from his?
My work with Benton was important as something against which to react very strongly, later on; in this it was better to have worked with him than with a less resistant personality who would have provided a much less strong opposition. At the same time, Benton introduced me to Renaissance art.

Why do you prefer living here in New York to your native West?
Living is keener, more demanding, more intense and expansive in New York than in the West; the stimulating influences are more numerous and rewarding. At the same time, I have a definite feeling for the West: the vast horizontality of the land, for instance; here only the Atlantic ocean gives you that.

Has being a Westerner affected your work?
I have always been very impressed with the plastic qualities of American Indian art. The Indians have the true painter's approach in their capacity to get hold of appropriate images, and in their understanding of what constitutes

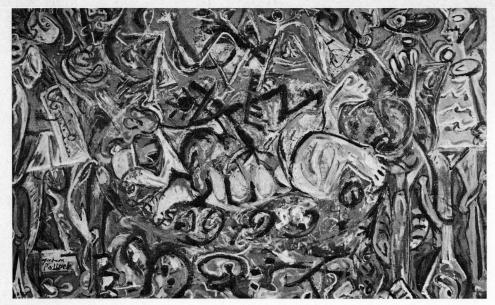

82 POLLOCK *Pasiphae*, 1943

painterly subject-matter. Their color is essentially Western, their vision has the basic universality of all real art. Some people find references to American Indian art and calligraphy in parts of my pictures. That wasn't intentional; probably was the result of early memories and enthusiasms.

Do you consider technique to be important in art?
Yes and no. Craftsmanship is essential to the artist. He needs it just as he needs brushes, pigments, and a surface to paint on.

Do you find it important that many famous modern European artists are living in this country?
Yes. I accept the fact that the important painting of the last hundred years was done in France. American painters have generally missed the point of modern painting from beginning to end. (The only American master who interests me is Ryder.) Thus the fact that good European moderns are now here is very important, for they bring with them an understanding of the problems of modern painting. I am particularly impressed with their concept of the source of art being the unconscious. This idea interests me more than these specific painters do, for the two artists I admire most, Picasso and Miró, are still abroad.

116

Do you think there can be a purely American art?

The idea of an isolated American painting, so popular in this country during the thirties, seems absurd to me, just as the idea of creating a purely American mathematics or physics would seem absurd. . . . And in another sense, the problem doesn't exist at all; or, if it did, would solve itself: An American is an American and his painting would naturally be qualified by that fact, whether he wills it or not. But the basic problems of contemporary painting are independent of any one country.

From *Arts and Architecture*, vol. 61, no. 2, February 1944, p. 14.

83 POLLOCK *Night Dancer (Green)*, 1944

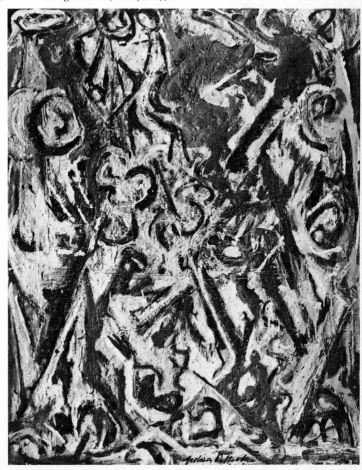

Abstract painting is abstract. It confronts you. There was a reviewer a while back who wrote that my pictures didn't have any beginning or any end. He didn't mean it as a compliment, but it was. It was a fine compliment.

<div style="text-align: right">

From the *New Yorker*, 5 August 1950, p. 16.

</div>

I've had a period of drawing on canvas in black – with some of my early images coming thru – think the non/objectionists will find them disturbing – and the kids who think it simple to splash a Pollock out.

<div style="text-align: right">

From an unpublished letter to Alfonso Ossorio and Edward Dragon, 7 June 1951.

</div>

84 POLLOCK *The Key*, 1946

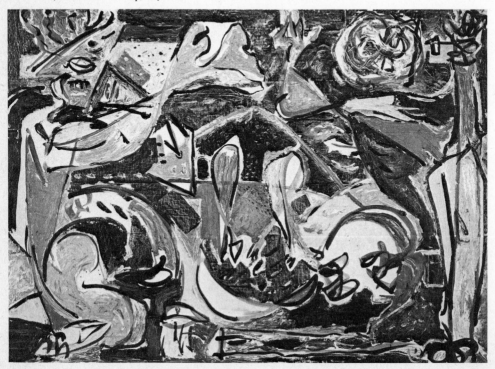

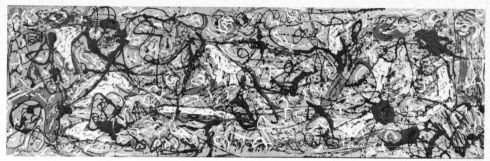

85 POLLOCK *White Cockatoo*, 1948

86 POLLOCK *One*, 1950

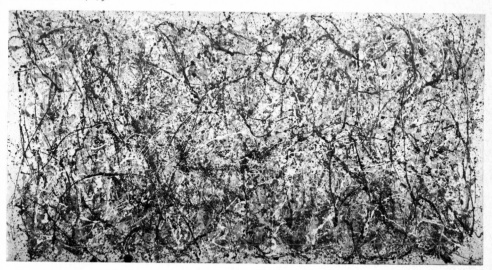

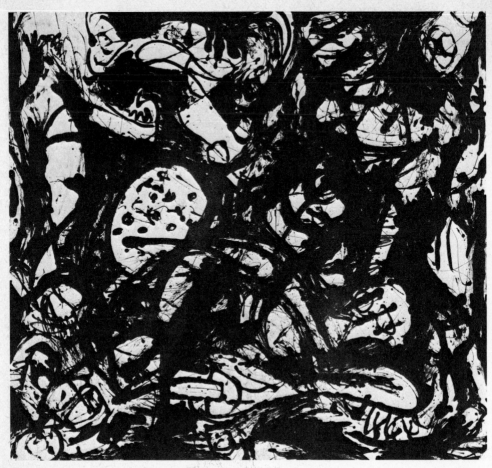

87 POLLOCK *Black and White – Number 20,* 1951

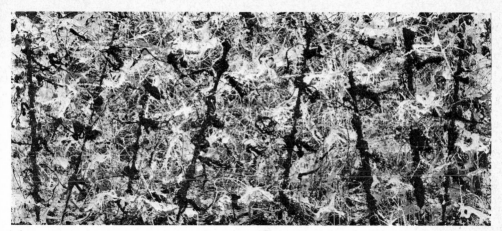

88 POLLOCK *Blue Poles*, 1953

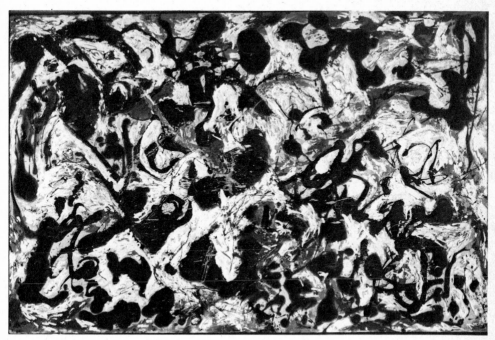

89 POLLOCK *Search*, 1955

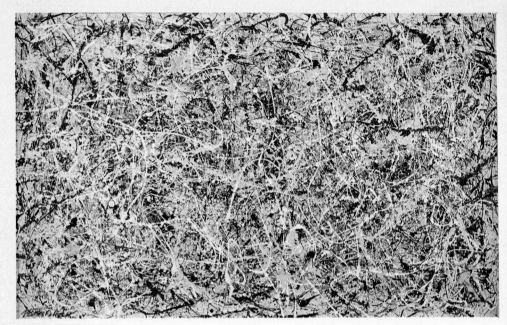

90 POLLOCK *No. 1*, 1949

91 POLLOCK *Four Opposites*, 1953

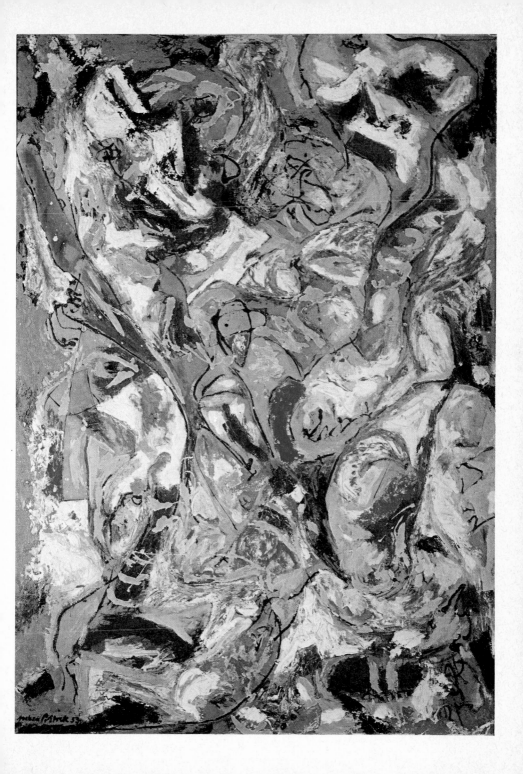

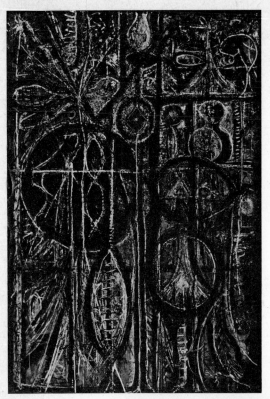

92 POUSETTE-DART
Fugue No. 4, 1947

93 POUSETTE-DART
Night World, 1948

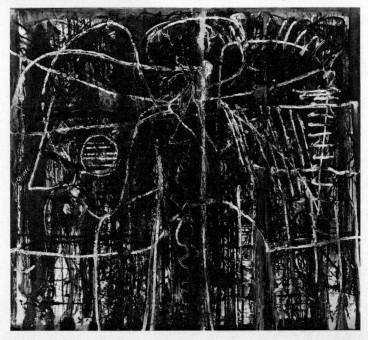

RICHARD POUSETTE-DART

(b. St Paul, Minnesota, 1916)

All art is abstract, and all abstract work must *needs be* of nature because we are of nature. Art is universal in its form. It matters not to true contemporary or universal truth whether it is a painting of a face, a figure, a tree, a cube, a line, a circle, or a biomorphic structure of paint, for a true work of art lives by the vitality of its own living significant form and the integrity of its inner life.

I believe a renaissance exists today which is felt and shared by all. There *is the birth of a new spirit and a new significance of form.* There is a vitality and beauty in art today as penetrating and as all embracing as has ever existed.

Art lies behind the cloth of surface things, it is *always* deeper than appearance and must be delved for. Within or about every living work of art, or thing of beauty, or fragment of life, there is some strange inner kernel which cannot be reached with explanations, clarifications examinations, or definitions. This *kernel* remains beneath, behind, beyond. It is *this* dimensionless particle which lives, breathes, and means. It is this living particle which makes art mystical, unknown, real, and experienceable.

Art for me is the heavens forever opening up, like asymmetrical, unpredict-able, spontaneous Kaleidoscopes. It is magic, it is Joy, it is gardens of surprise and miracle. It is energy, impulse. It is question and answer. It is transcendental reason. It is total in its spirit.

The best way to *talk* about art is to work. The best way to *study* art is to work. The best way to *think* about art is to work. Art is to *work hard* and one day it may become art and you may discover the artist that you are.

We have not learned to respect form as a thing in itself as we have done with sound for we have been and we still are under the yoke of the Greek prejudice.

The authenticity of painting lies in the pure form and inner life which springs from the artist's realization and experience.

Paintings can not be explained, they have a life and a being and a voice of their own, they must be personally experienced. We must go to them and look at them, and within them find reflected our own experience, as well as

125

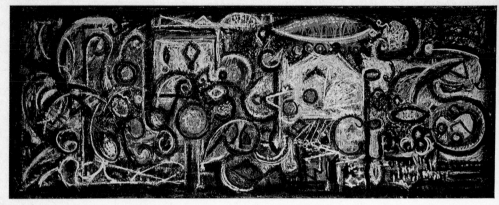

94 POUSETTE-DART *Fugue No. 2*, 1943

inspiration for our own growth, if we care to adventure: for in truth, art is the adventure of our own growth, whether we are acting in the capacity of creating, or whether we are acting in the creative capacity of appreciation.

Most people do not feel deeply enough to see through their own eyes, they merely recognize what their minds have catalogued and been told to remember, they need to open up their imaginations to the vast untouched and unknown wonders of their own feeling. I speak of feeling here as the whole intuitional sensibility.

The artist must beware of all schools, isms, creeds, or entanglements which would tend to make him other than himself. He must stand alone, free and open in all directions for exits and entrances, and yet with all freedom, he must be solid and real in the substance of his form.

Talk at Boston Museum School, Boston, 1951.

My definition of religion amounts to art and my definition of art amounts to religion. I don't believe you can have one significantly without the other. Art and religion are the inseparable structure and living adventure of the creative.

By the creative I mean the most penetrating, bursting through the particular to the universal, from the one thing to all things, from time to the eternal spirit. Religious is what dynamically realizes all within itself, it sees not in parts but in wholes. It is what passionately loves and emanates a feeling of aspiration and inspiration. It is what is directly in contact with the ultimate or absolute and

gives us bridge to the unknown within ourselves. Solid of form and free of spirit, it is timeless within the eternal present.

Art is always mystical in its final meaning, it is structure which stands up by the presence and significance of its own reality. It is a thing within itself, mirroring different things to different minds, stemming from and in accord with every work of art ever created, a thing of awe and wonder whose meaning is the measure of man's estate on earth.

Art is not a matter of perfect technique, it is life of the soul. It is my belief that ultimate reality can only be achieved by a passionate burning devotion to one's work.

Participation is the only explanation of art. Only another work of art clarifies or explains a work of art, and the only critic who tells no lies is the one whose criticism is the creation of his own work.

It does not matter how an artist works, whether he uses circles or squares or flowers or people, whether he works thick or thin, large or small, with metal, plaster, stone, or wood, tightly delicate filigree or bold and sparse and spacious, or whether he suggests with subtle shade or knife-like edge, it is the inner life of the work which breathes and truly means.

The artist is the only moral man because he alone overcomes fear and has the courage to create his own soul and to live by means of the light of it.

> Talk given at Union Theological
> Seminary on 2 December 1952 on
> *What Is the Relationship Between*
> *Religion and Art?*

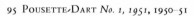

95 POUSETTE-DART *No. 1, 1951*, 1950–51

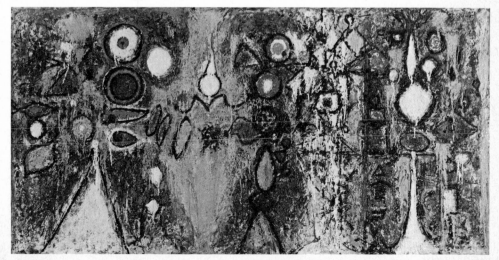

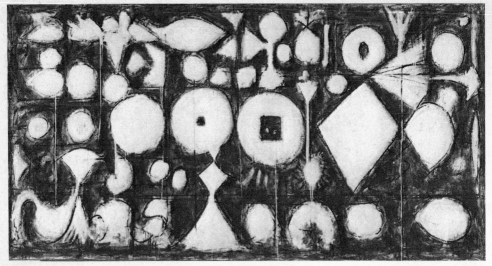

96 POUSETTE-DART
Path of the Hero,
c. 1955–56

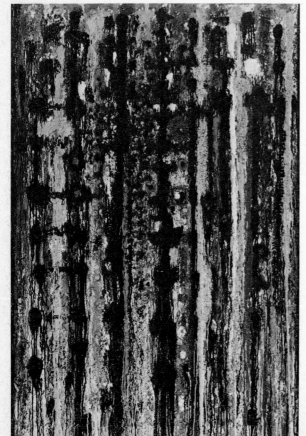

97 POUSETTE-DART
Savage Rose, 1951

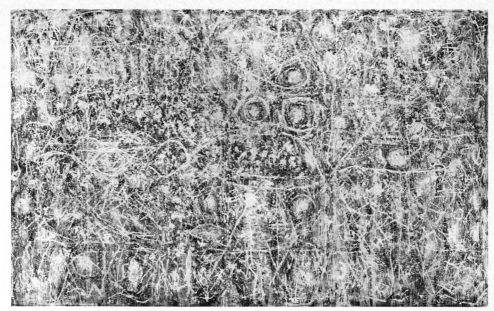

98 POUSETTE-DART *Path of the White Bird, c.* 1956

99 POUSETTE-DART *Blood Wedding,* 1958

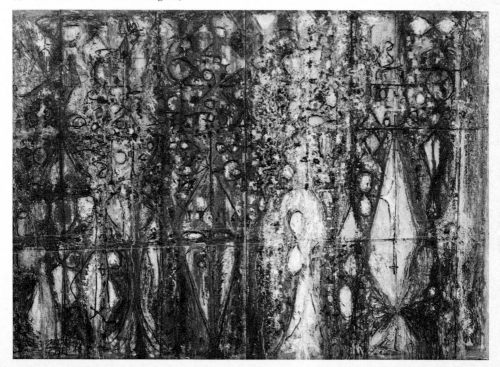

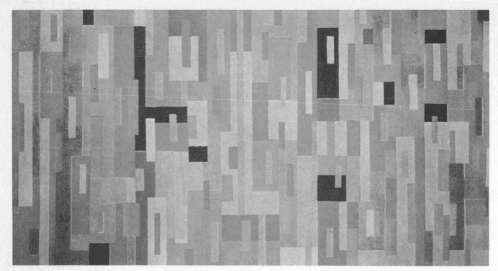

100 REINHARDT *Abstract Painting*, 1948

AD REINHARDT

(Buffalo, New York, 1913 – New York City, 1967)

Abstract art is celebrated widely today by critics for its contribution of com‿
positional arrangements and colour schemes to illustrative painting. Lauded
and described for its vast practical influence and deep spiritual insight, the
critical tribute paid a pure art adds up to 'an empty picture,' 'a cold meaningless
decoration,' or a hot 'unintelligible' mystery.

Perhaps pure painting is no degree of illustration, distortion, illusion, allusion,
or delusion. The addition or retention of eyes, teeth, feet to abstract shapes may
be unreasonable and dishonest, except as a form of wit. Perhaps semi‿abstract
is half‿wit. A representational fine art perhaps is as ridiculous and useless as
an abstract commercial art.

Perhaps pure painting is no art for art's sake and no part of the still‿life,
landscape, nude, and portrait business, with its trade skills and individualistic
styles displayed for their own sake.

Perhaps pure painting is no transcendental nonsense, and the picturing of
a 'reality behind reality' best left to inner‿eye artists, magic realists, dream
photographers, and the intellectually duped.

Perhaps pure painting is a direct experience and an honest communication.
Perhaps it is a creative completeness and total sensitivity related to personal
wholeness and social order because it is clear and without extra‿esthetic
elements.

Perhaps an abstract art‿work is other than something less than half a
representational painting. . . .

From *Recent Abstract Paintings by Ad Reinhardt*, Betty Parsons
Gallery, New York, 18 October–6 November 1948, p. 2.

It's been said many times in world‿art writing that one can find some of
painting's meanings by looking not only at what painters do but at what they
refuse to do.

131

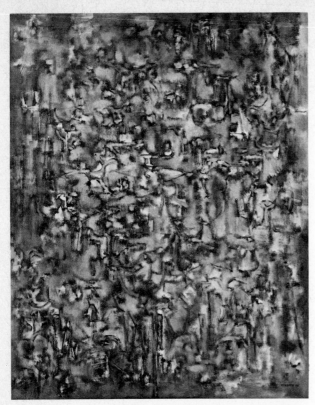

101 REINHARDT
Abstract Painting, Yellow,
1947

And today many artists like myself refuse to be involved in some ideas. In painting, for me – no fooling⁄the⁄eye, no window⁄hole⁄in⁄the⁄wall, no illu⁄ sions, no representations, no associations, no distortions, no paint⁄caricaturing, no dream pictures or drippings, no delirium trimmings, no sadism or slashings, no therapy, no kicking⁄the⁄effigy, no clowning, no acrobatics, no heroics, no self⁄pity, no guilt, no anguish, no supernaturalism or subhumanism, no divine inspiration or daily perspiration, no personality⁄picturesqueness, no romantic bait, no gallery gimmicks, no neo⁄religious or neo⁄architectural hocus⁄pocus, no poetry or drama or theatre, no entertainment business, no vested interests, no Sunday⁄hobby, no drug⁄store⁄museums, no free⁄for⁄all⁄history, no art history in America of ashcan⁄regional⁄WPA⁄Pepsi⁄Cola styles, no profes⁄ sionalism, no equity, no cultural enterprises, no bargain⁄art⁄commodity, no juries, no contests, no masterpieces, no prizes, no mannerisms or techniques, no communication or information, no magic tools, no bag of tricks⁄of⁄the⁄ trade, no structure, no paint qualities, no impasto, no plasticity, no relation⁄ ships, no experiments, no rules, no coercion, no anarchy, no anti⁄intellectualism,

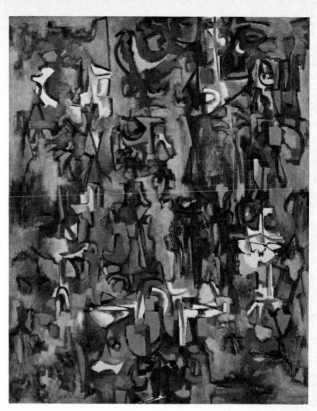

102 REINHARDT
Abstract Painting, 1943

no irresponsibility, no innocence, no irrationalism, no low level of conscious-
ness, no nature-mending, no reality-reducing, no life-mirroring, no abstracting
from anything, no nonsense, no involvements, no confusing painting with
everything that is not painting.

From *Contemporary American
Painting*, University of Illinois,
Urbana, 1952.

Let no one imagine, because he has made merry in the warm tilth and quaint
hooks of extract-expressionism, that he can even guess at the austere and
thrilling raptures of those who have climbed the cold, dark peaks of art.

From a statement made in 1957
published in *It Is*, no. 4, Autumn
1959, p. 25.

133

A CONTRIBUTION TO A JOURNAL OF SOME FUTURE ART HISTORIAN

Almost fifteen years ago, in the early forties, after he had made some paintings that were described as 'abstract all-over patterns that didn't represent anything,' Ad Reinhardt became interested in the 'all-over' as a pure-painting idea.

Almost ten years ago, in the late forties, he lost interest in this clear and distinct idea, which, I understand, everyone understands now.

What was this pure-painting idea?* Where did it come from?

Impressionism, with uniformity of brush strokes, unity of paint texture, suffused light, pervasive color, but without luminosity, sensuousness, impasto, without impressionist subjects?

Cubism, with brushwork like brickwork, dulled colors, rectilinear hand-brush marking, but without composition or decomposition, without cubist objects?

Post-plus-and-minus-Mondrianism, with consistency of deliberate and random repetition of identical elements but without scotch-taping-shifting-balancing-spacing-Cézanneism?

Prehistoric, historic, functional, organic, symbolic decoration – design in building, carpet, textile, pot? (No.)

Medieval, migration beast-interlaces, arabesque alphabets, floral scroll-work? (No.)

Metaphysical = aesthetic speculation, negative = positive space, depth = surface time, object = subject, presence = absence, micro-macrocosm, yin and yang, zemin u zemain? (No.)

Iconoclasm, with 'Thou shalt not make unto thee a graven image, nor any manner of likeness,' and images are 'primitive, immoral, offensive,' 'used solely for instructing the minds of the ignorant,' and 'images are for the poor in spirit?' (Maybe.)

*For expressionists, surrealist, obscurantists. This idea includes no bloodstains, sore spots, pimply skeins, mad hairs, sharp points, slash dashes, cold cuts, side swipes, hand sleights, leg pulls, back bites, false fronts, hindsights, hay seeds, polly wogs, nose drops, headaches, heart sleeves, intestinal flows, dry runs, whet washes, black eyes, purple patches, green horns, yellow bellies, grape vines, forest fears, jungle jiggles, fate leavings, death struggles, life businesses, soft soaps, hard cash, hot cakes, etc.

From *It Is*, no. 2, Autumn 1958, pp. 76, 77.

103 REINHARDT *Abstract Painting, Blue-Green,* 1949

104 REINHARDT *Abstract Painting, Red,* 1952

105 REINHARDT *Abstract Painting, Black*, 1954

106 REINHARDT *Abstract Painting*, 1954–59

107 REINHARDT
Abstract Painting, 1956–59

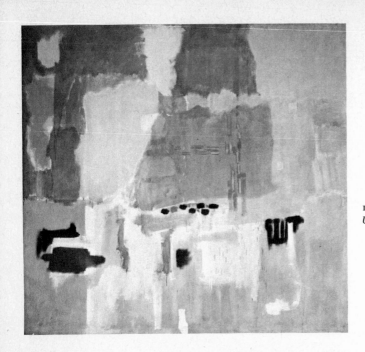

108 ROTHKO
Untitled, 1948

109 ROTHKO
No. 26, 1947,
1947

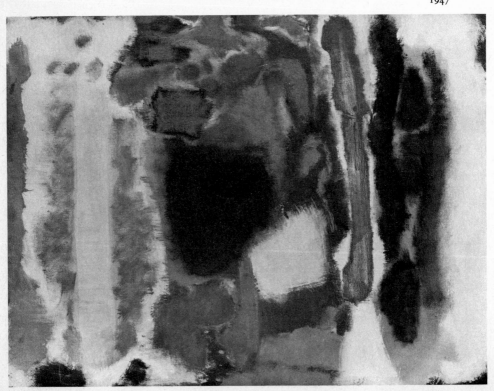

MARK ROTHKO

(Dvinska, Russia, 1903 – New York City, 1970)

If our titles recall the known myths of antiquity, we have used them again because they are the eternal symbols upon which we must fall back to express basic psychological ideas. They are the symbols of man's primitive fears and motivations, no matter in which land or what time, changing only in detail but never in substance, be they Greek, Aztec, Icelandic, or Egyptian. And modern psychology finds them persisting still in our dreams, our vernacular, and our art, for all the changes in the outward conditions of life.

Our presentation of these myths, however, must be in our own terms, which are at once more primitive and more modern than the myths themselves – more primitive because we seek the primeval and atavistic roots of the idea rather than their graceful classical version; more modern than the myths themselves because we must redescribe their implications through our own experience. Those who think that the world of today is more gentle and graceful than the primeval and predatory passions from which these myths spring, are either not aware of reality or do not wish to see it in art. The myth holds us, therefore, not thru its romantic flavor, not thru the remembrance of the beauty of some bygone age, not thru the possibilities of fantasy, but because it expresses to us something real and existing in ourselves, as it was to those who first stumbled upon the symbols to give them life.

<div style="text-align: right">

From 'The Portrait and the Modern Artist' in *Art in New York* Program, WNYC, New York, copy of broadcast, 13 October 1943, pp. 1, 2, 3.

</div>

It was with the utmost reluctance that I found the figure could not serve my purposes. . . . But a time came when none of us could use the figure without mutilating it.

<div style="text-align: right">

From an article by Dore Ashton in the *New York Times*, 31 October 1958.

</div>

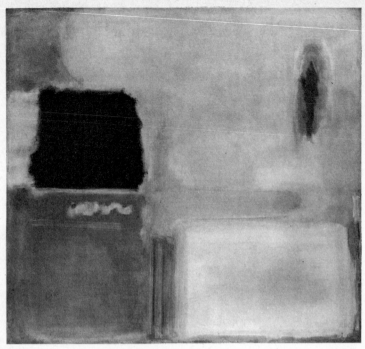

110 ROTHKO *Mauve Intersection. (No. 12)*, 1948

Rather be prodigal than niggardly. I would sooner confer anthropomorphic attributes upon a stone, than dehumanize the slightest possibility of con-sciousness.

<div style="text-align: right">

From a *Personal Statement*, 1945,
published by the David Porter
Gallery, Washington DC, 1950.

</div>

A picture lives by companionship, expanding and quickening in the eyes of the sensitive observer. It dies by the same token. It is, therefore, a risky and unfeeling act to send it out into the world. How often it must be permanently impaired by the eyes of the vulgar and the cruelty of the impotent who would extend their affliction universally!

<div style="text-align: right">

From *Tiger's Eye*, vol. 1, no. 2,
December 1947, p. 44.

</div>

I paint very large pictures. I realize that historically the function of painting large pictures is painting something very grandiose and pompous. The reason I paint them, however – I think it applies to other painters I know – is precisely because I want to be very intimate and human. To paint a small picture is to place yourself outside your experience, to look upon an experience as a stereopticon view or with a reducing glass. However you paint the larger picture, you are in it. It isn't something you command.

From *Interiors*, vol. 110, May 1951, p. 104.

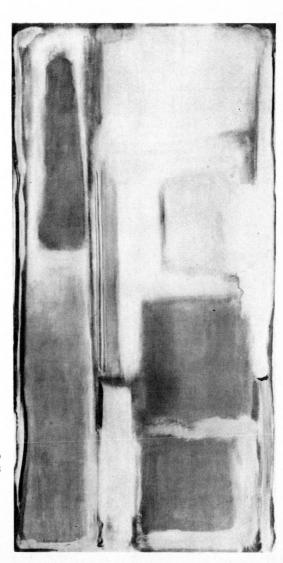

111 ROTHKO
Untitled, 1948

There is, however, a profound reason for the persistence of the word 'portrait' because the real essence of the great portraiture of all time is the artist's eternal interest in the human figure, character, and emotions – in short in the human drama. That Rembrandt expressed it by posing a sitter is irrelevant. We do not know the sitter but we are intensely aware of the drama. The Archaic Greeks, on the other hand used as their models the inner visions which they had of their gods. And in our day, our visions are the fulfilment of our needs.

It must be noted that the great painters of the figure had this in common. Their portraits resemble each other far more than they recall the peculiarities of a particular model. In a sense they have painted one character in all their work. What is indicated here is that the artist's real model is an ideal which embraces all of human drama rather than the appearance of a particular individual.

Today the artist is no longer constrained by the limitation that all of man's experience is expressed by his outward appearance. Freed from the need of describing a particular person, the possibilities are endless. The whole of man's experience becomes his model, and in that sense it can be said that all of art is a portrait of an idea.

Neither Mr Gottlieb's painting nor mine should be considered abstract paintings. It is not their intention either to create or to emphasize a formal color – space arrangement. They depart from natural representation only to intensify the expression of the subject implied in the title – not to dilute or efface it.

'There are some artists who want to tell all, but I feel it is more shrewd to tell little. My paintings are sometimes described as façades, and, indeed, they are façades.'

[Some of the 'ingredients' listed by Rothko as his 'recipe' for art]

'A clear preoccupation with death. All art deals with intimations of mortality.'

'Sensuality, the basis for being concrete about the world.'

'Tension: conflict or desire which in art is curbed at the very moment it occurs.'

'Irony: a modern ingredient. (The Greeks didn't need it.) A form of self-effacement and self-examination in which a man can for a moment escape his fate.'

'Wit, humor.'

'A few grams of the ephemeral, a chance.'

'About 10 per cent of hope. . . . If you need that sort of thing; the Greeks never mentioned it.'

'I paint large pictures because I want to create a state of intimacy. A large picture is an immediate transaction; it takes you into it.'

From Statements: Excerpts from
Pratt Lecture, 1958 (from Cimaise,
December 1958, noted by D. Ashton).

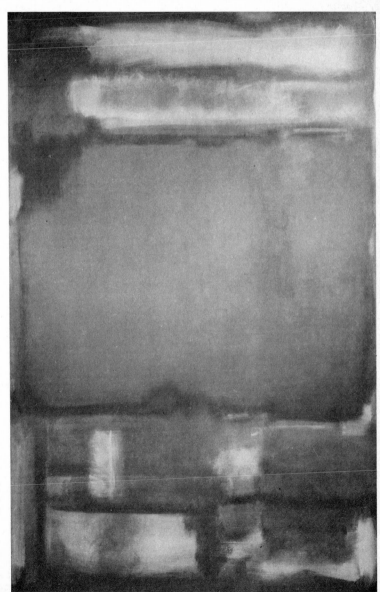

112 ROTHKO
No. 24, 1949,
1949

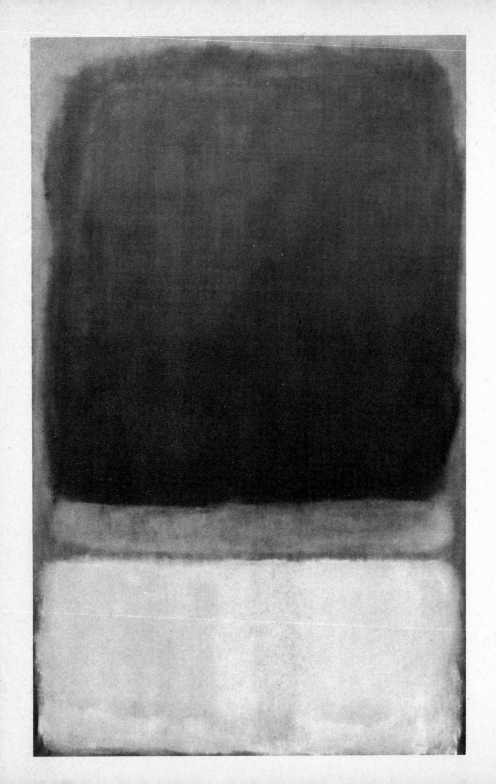

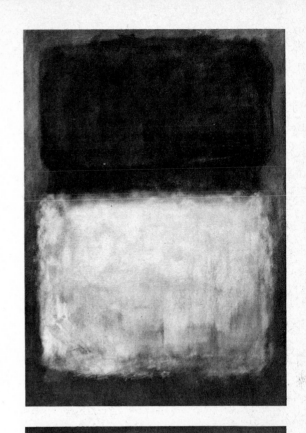

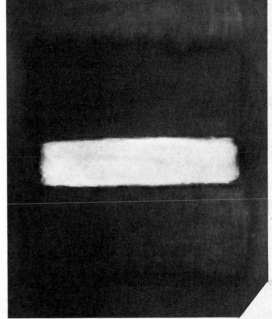

113 ROTHKO *Untitled,* 1951

114 ROTHKO *Green on Blue,* 1956

115 ROTHKO *White Center,* 1957

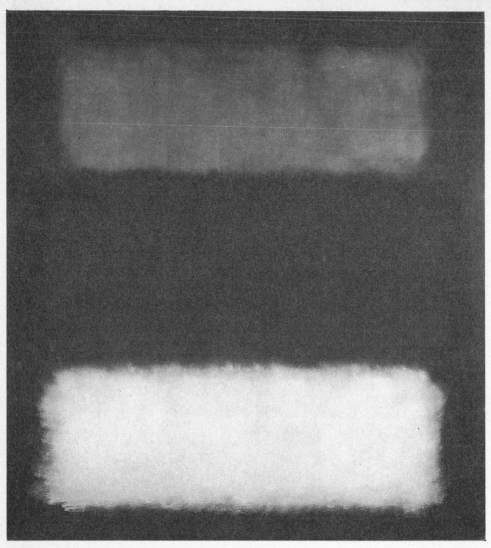

116 ROTHKO *Light Cloud, Dark Cloud,* 1957

CLYFFORD STILL

(b. Grandin, North Dakota, 1904)

That pigment on canvas has a way of initiating conventional reactions for most people needs no reminder. Behind these reactions is a body of history matured into dogma, authority, tradition. The totalitarian hegemony of this tradition I despise, its presumptions I reject. Its security is an illusion, banal, and without courage. Its substance is but dust and filing cabinets. The homage paid to it is a celebration of death. We all bear the burden of this tradition on our backs but I cannot hold it a privilege to be a pallbearer of my spirit in its name.

From the most ancient times the artist has been expected to perpetuate the values of his contemporaries. The record is mainly one of frustration, sadism, superstition, and the will to power. What greatness of life crept into the story came from sources not yet fully understood, and the temples of art which burden the landscape of nearly every city are a tribute to the attempt to seize this elusive quality and stamp it out.

The anxious men find comfort in the confusion of those artists who would walk beside them. The values involved, however, permit no peace, and mutual resentment is deep when it is discovered that salvation cannot be bought.

We are now committed to an unqualified act, not illustrating outworn myths or contemporary alibis. One must accept total responsibility for what he executes. And the measure of his greatness will be in the depth of his insight and his courage in realizing his own vision.

Demands for communication are both presumptuous and irrelevant. The observer usually will see what his fears and hopes and learning teach him to see. But if he can escape these demands that hold up a mirror to himself, then perhaps some of the implications of the work may be felt. But whatever is seen or felt it should be remembered that for me these paintings had to be something else. It is the price one has to pay for clarity when one's means are honoured only as an instrument of seduction or assault.

From 15 *Americans*, edited by Dorothy C. Miller, New York, Museum of Modern Art, 1952, pp. 21–22.

147

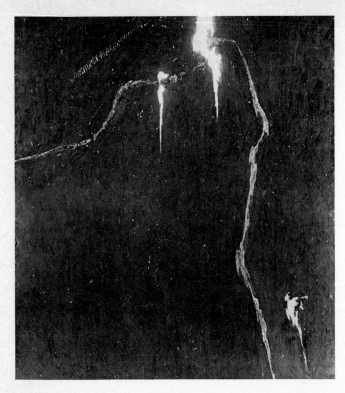

117 STILL
1944 N No. 1, 1944

I fight in myself any tendency to accept a fixed, sensuously appealing, recognizable style. . . . I am always trying to paint my way out of and beyond a facile, doctrinaire idiom. I do not want other artists to imitate my work – they do even when I tell them not to – but only my example for freedom and independence from all external, decadent, and corrupting influences.

The fact that I grew up on the prairies has nothing to do with my paintings, with what people think they find in them. I paint only myself, not nature.

I am not an action painter. Each painting is an act, the result of action and the fulfilment of action. I do not have a comic or tragic period in any real sense. I have always painted dark pictures; always some light pictures. I will probably go on doing so.

Orchestral. My work in its entirety is like a symphony in which each painting has its part.

From 'An Interview with Clyfford Still' by Benjamin Townsend in *Gallery Notes*, Albright Knox Art Gallery, vol. 24, no. 2, Summer 1961, pp. 10–16.

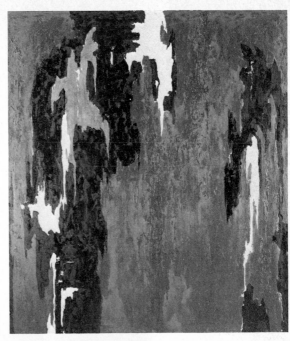

118 STILL
1946-H, 1946

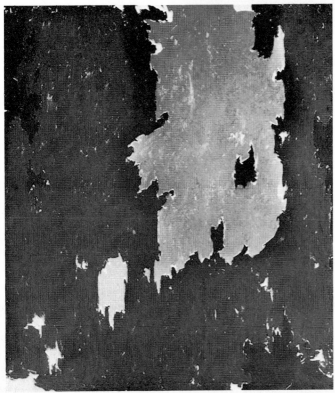

119 STILL
1950-A No. 2, 1950

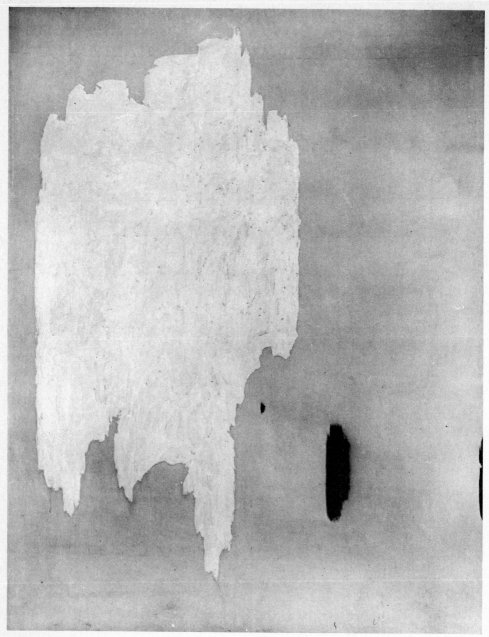

120 STILL *1950-1*, 1950

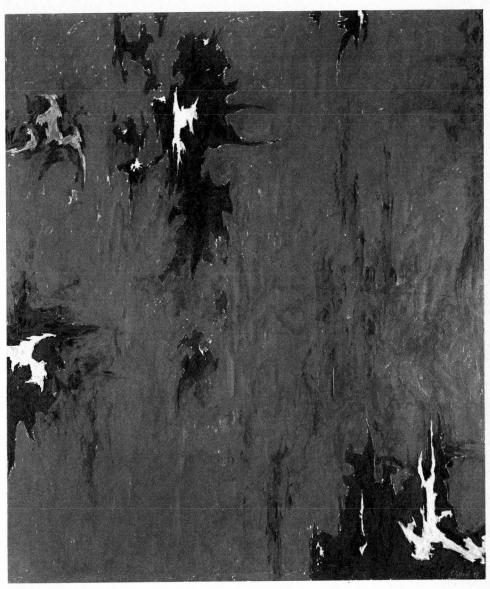

121 STILL *1947-M*, 1947

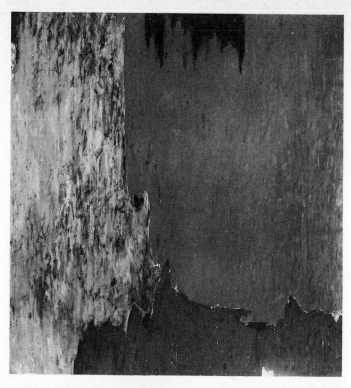

122 STILL
1955-K, 1955

123 STILL
1955-6, 1955

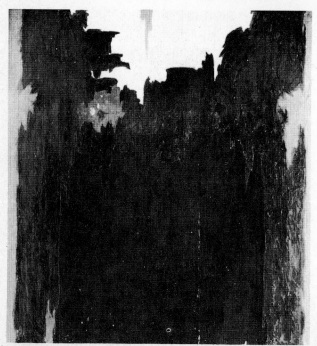

124 STILL
1957-K, 1957

By 1941, space and the figure in my canvases had been resolved into a total psychic entity, freeing me from the limitations of each, yet fusing into an instrument bounded only by the limits of my energy and intuition. My feeling of freedom was now absolute and infinitely exhilarating. . . .

I'm not interested in illustrating my time. A man's 'time' limits him, it does not truly liberate him. Our age – it is of science – of mechanism – of power and death. I see no point in adding to its mammoth arrogance the compliment of graphic homage.

I have no brief for signs or symbols or literary allusions in painting. They are just crutches for illustrators and politicians desperate for an audience.

The sublime? A paramount consideration in my studies and work from my earliest student days. In essence it is most elusive of capture or definition – only surely found least in the lives and works of those who babble of it the most. The dictator types have made a cliché of 'sublime' conceits throughout the centuries to impress and subjugate the ignorant or desperate. . . .

Action painting? A tricky phrase. Misleading especially to those to whom it is usually applied. By their definitions they really mean 'reaction' painting. But that would lose the glamour of the literary *mot*, plus some dialectical foot-work. . . .

From *Clyfford Still*, Institute of Contemporary Art, University of Pennsylvania, 18 October–29 November 1963, pp. 9–10.

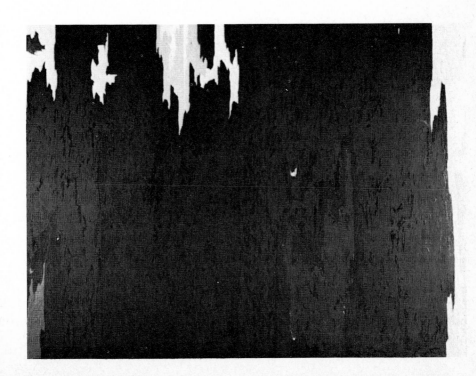

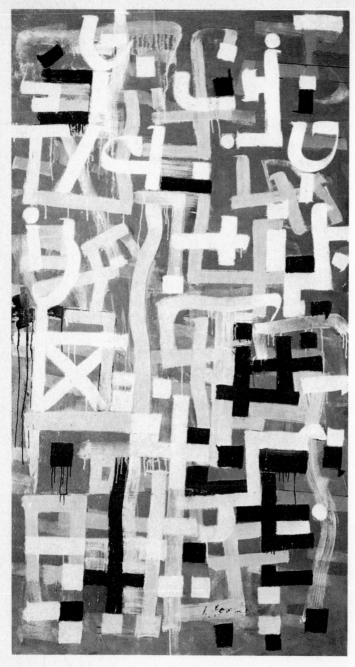

125 TOMLIN *No. 5, 1949,*
1949

BRADLEY WALKER TOMLIN

(Syracuse, New York, 1899 – New York City, 1953)

Formulation of belief has a way of losing its brightness and of fencing one in. The artist having found, and publicly declared, what seem to be the answers, will then in all likelihood swear to protect them, as if upon oath, since stated beliefs, like certificates in the anterooms of practitioners, imply the authority to pursue a predictable course of action. Doubts, however, creep in. One peers at the old diplomas more closely, speculating vaguely as to the guarantee in time the authoritative body might have had the temerity to fix upon. . . .

Moved deeply by a painting, the spectator may say, the artist has convinced me. This is really painting, it is the way it should be done. One can believe in paintings, as one can believe in miracles, for paintings, like miracles, possess an inner logic which is inescapable. But this again is to believe after the fact, which is merely to believe in the concrete.

What does the artist himself believe in, having produced his miracle? Does he feel that he is now in the clear, that in the future the canvases will be solved without pain? His intentions presumably are clear and it is possible to believe in the reality of intentions, good or bad. Can one be sure, however, that in different situations, intentions can be identical? Does the artist find that the seemingly effortless structure, which he has evolved with total clarity, tends on repetition to escape him? That in spite of the production of masterpieces, art itself remains infinitely mysterious and that the work in progress is merely a kind of hall rack on which he has hung various nicely woven articles of clothing: jackets shabbily elegant, old hats battered to his image. Confronted by the cast of his own mind he says, it is at least mine. Yet the jacket he has slipped into binds slightly under the armpits. Umbrellas and old walking-sticks clatter to the floor.

From *The New American Painting As Shown in Eight European Countries, 1958–1959*, Museum of Modern Art, New York, 1959, p. 80 ('presumably written in 1950').

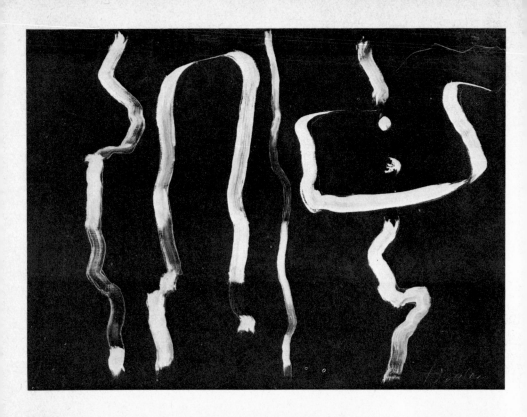

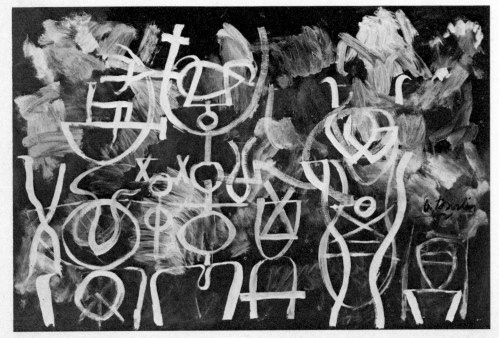

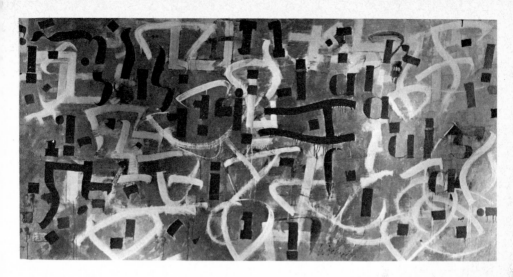

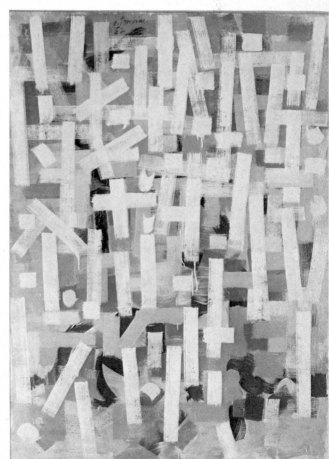

126 TOMLIN
Tension by Moonlight,
1948

127 TOMLIN
All Souls Night,
1948

128 TOMLIN
*No. 9: In Praise of
Gertrude Stein,* 1950

129 TOMLIN
No. 12, 1952

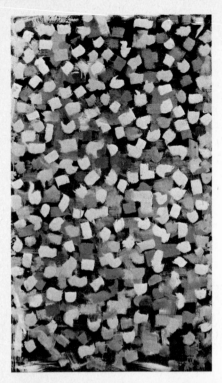

130 Tomlin *No. 1*, 1952–53

131 Tomlin *No. 10*, 1952–53

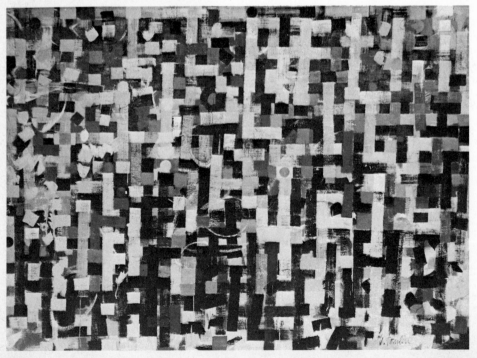

BIBLIOGRAPHY

INDIVIDUAL BIBLIOGRAPHIES
(by artists, articles on artists, catalogues and reviews)

William Baziotes

By Baziotes (chronologically)

1 'Call It an Eye,' *Time*, 17 November 1947.
2 'I Cannot Evolve Any Concrete Theory,' *Possibilities*, vol. 1, no. 1, Winter 1947–48, p. 2 illus.; also Paul Valéry text chosen by the artist. (Baziotes's statement reprinted in *bibls.* 990, 994.)
3 [Statement], *Tiger's Eye*, vol. 1, no. 5, October 1948, p. 55.
4 'The Artist and His Mirror,' *Right Angle*, vol. 3, no. 2, June 1949, pp. 3–4.
5 [Illustration for broadside], *The Kootz Review*, 25 November–23 December 1952. (*See also* illustrations for *bibl.* 1249.)
6 'Symposium: The Creative Process,' *Art Digest*, vol. 28, no. 8, 15 January 1954, pp. 14–16, 32–34.
7 'An Interview with William Baziotes,' *Perspective* (Hunter College, New York), no. 2, [1956?], pp. 26–30 illus.
8 'Notes on Painting,' *It Is*, no. 4, Autumn 1959, p. 11.

See also bibls. 9, 984, 986, 987, 989, 991, 993, 1256, 1300.

Articles on Baziotes (alphabetically)

9 HARE DAVID. 'William Baziotes, 1912–1963,' *Location*, vol. 1, no. 2, Summer 1964, pp. 83–90 illus.; also reprint of *bibl.* 12 and text by Thomas B. Hess; brief statements by the artist.
10 KOOTZ SAMUEL M. 'In Defense of Baziotes,' *Art Digest*, vol. 22, no. 5, 1 December 1947. (Letter to the editor; *see also Art Digest*, 15 December 1947, for another letter, 'Criticizing Cyclops,' by Laurentza Schantz-Hansen.)
11 ROBINSON, MURRAY. 'Paintings Talk Back to Him,' *New York World Telegram*, 24 November 1947.
12 ROSENBERG, HAROLD. 'Reminder to the Growing, To Patia, For a Painting by William Baziotes,' *Tiger's Eye*, vol. 1, no. 7, March 1949, pp. 82–83.
13 ROSENBERG, HAROLD. 'The Shapes in a Baziotes Canvas,' *Possibilities*, no. 1, Winter 1947–48, p. 2.
14 ROSENBERG, HAROLD. 'Smoke of Circe' [inspired by paintings by Baziotes], *bibl.* 1007, pp. 17–19.
15 'William Baziotes,' *Athene* (Chicago), vol. 8, no. 3, Autumn 1947, pp. 18–21.

Exhibition Catalogues and Reviews (chronologically)

16 RILEY, MAUDE. 'Baziotes' Color,' *Art Digest*, vol. 19, no. 1, 1 October 1944, p. 12.
17 'The Passing Shows,' *Art News*, vol. 43, no. 13, 15–31 October 1944, pp. 26–27.
18 'The Passing Shows,' *Art News*, vol. 44, no. 20, February 1946, p. 102 illus.
19 BREUNING, MARGARET. 'Baziotes Shows Craftsmanship and Invention,' *Art Digest*, vol. 20, no. 10, 15 February 1946, p. 10 illus.
20 ROSENBERG, HAROLD. *Baziotes*, Kootz Gallery, New York, 7–26 April 1947, p. 3.

21 'Baziotes,' *Art News*, vol. 46, no. 1, March 1947, p. 42.
22 LANSFORD, ALONZO. 'Color of Baziotes,' *Art Digest*, vol. 21, no. 14, 15 April 1947, p. 22.
23 KOOTZ, SAMUEL M. *Baziotes*, Kootz Gallery, New York, 16 February–6 March 1948, p. 2 illus.
24 'Baziotes,' *Art News*, vol. 46, no. 12, February 1948, p. 45.
25 LANSFORD, ALONZO. 'Baziotes in Solo Show,' *Art Digest*, vol. 22, no. 10, 15 February 1948, pp. 20–21 illus.
26 TODD, RUTHVEN. 'Baziotes,' *Art News*, vol. 48, no. 10, February 1950, p. 47.
27 KRASNE, BELLE. 'Lighter Baziotes,' *Art Digest*, vol. 24, no. 9, 1 February 1950, p. 14.
28 KEES, WELDON. 'Art,' *Nation*, 4 February 1950.
29 JARRELL, RANDALL. *The Lyrical New Paintings of Baziotes*, Kootz Gallery, New York, 12 February–5 March 1951, p. 3 illus.
30 KRASNE, BELLE. 'Baziotes,' *Art Digest*, vol. 25, no. 10, 15 February 1951, p. 20.
31 HOLLIDAY, BETTY. 'Baziotes,' *Art News*, vol. 50, no. 1, March 1951, p. 45.
32 HOLLIDAY, BETTY. 'Baziotes,' *Art News*, vol. 51, no. 1, March 1952, p. 45.
33 ASHTON, DORE. 'Baziotes,' *Art Digest*, vol. 26, no. 11, 1 March 1952, p. 18.
34 FITZSIMMONS, JAMES. *Baziotes*, Kootz Gallery, New York, 16 February–7 March 1953, p. 4 illus.
35 GOODNOUGH, ROBERT. 'Baziotes,' *Art News*, vol. 52, no. 1, March 1953, p. 35.
36 FEINSTEIN, SAM. 'In Baziotes' Aquarium,' *Art Digest*, vol. 27, no. 11, 1 March 1953, p. 15 illus.
37 FITZSIMMONS, JAMES. 'Art,' *Arts and Architecture*, vol. 70, no. 4, April 1953, p. 34.
38 O'HARA, FRANK. 'Baziotes,' *Art News*, vol. 53, no. 1, March 1954, p. 41.
39 TILLIM, SIDNEY, 'Baziotes,' *Art Digest*, vol. 29, no. 11, 1 March 1954, pp. 16–17 illus.
40 GEORGE, LAVERNE. 'Baziotes,' *Arts*, vol. 30, no. 7, April 1956, p. 53.
41 MUNRO, E. C. 'Baziotes,' *Art News*, vol. 55, no. 2, April 1956, pp. 82–83.
42 *The Magical Worlds of Redon, Klee, Baziotes*, Contemporary Arts Museum, Houston, 24 January–17 February 1957. 19-p. cat. illus.
43 FITZSIMMONS, JAMES. *Baziotes*, Kootz Gallery, New York, 19 February–8 March 1958. (Excerpts from *bibl.* 34.)
44 MELLOW, JAMES R. 'Baziotes,' *Arts*, vol. 32, no. 6, March 1958, p. 60.
45 PORTER, FAIRFIELD. 'Baziotes,' *Art News*, vol. 57, no. 1, March 1958, p. 13 illus.
46 CAMPBELL, LAWRENCE. 'Baziotes,' *Art News*, vol. 60, no. 2, April 1961, pp. 46, 60 illus.
47 SANDLER, IRVING HERSCHEL. 'New York Letter,' *Art International*, vol. 5, no. 4, May 1961, p. 53 illus.
48 SMITH, LAWRENCE. 'Baziotes,' *Arts*, vol. 35, nos. 8–9, May–June 1961, p. 88.
49 Solomon R. Guggenheim Museum, New York, *Baziotes*, February 1965. Introduction by Lawrence Alloway. Comprehensive bibliography.

See also bibls. 1234, 1238.

Recent Writings 1965–69 (chronologically)

50 'Silent Mirrors,' *Newsweek*, vol. 65, 22 February 1965, pp. 69–70 illus.
51 SANDLER, IRVING. 'Baziotes: Modern Mythologist,' *Art News*, vol. 63, no. 10, February 1965, pp. 28–31 illus. Reply with rejoinder. Lawrence Alloway, *Art News*, vol. 64, no. 2, April 1965, p. 6.
52 RAYNOR, VIVIAN. 'Exhibition at Guggenheim Museum,' *Arts Magazine*, vol. 39, no. 6, March 1965, p. 58.

Willem de Kooning

Supplement to bibliography in *bibl.* 71.

By De Kooning (chronologically)

53 [Letter to the Editor], *Art News*, vol. 48, no. 9, January 1949, p. 6. (On Gorky; reprinted *bibl.* 994.)
54 'The Renaissance and Order,' *trans/formation*, vol. 1, no. 2, 1951, pp. 85–87 illus. (Talk given at Studio 35, 1950.)
55 'What Abstract Art Means to Me,' *Museum of Modern Art Bulletin*, vol. 18, no. 3, Spring 1951, pp. 4–8 illus. (Contribution to a symposium held 5 February 1951; often reprinted and excerpted; see *bibls.* 991, 994; translated into Danish in *Aartiderne* (Copenhagen), vol. 9, no. 1, November 1951, pp. 21–25.)
56 DE HIRSCH, STORM. 'A Talk with Willem de Kooning,' *Intro Bulletin*, vol. 1, no. 1, October 1955, pp. 1, 3 illus.
57 'Is Today's Artist With or Against the Past?' *Art News,* vol. 57, no. 4, Summer 1958, pp. 27, 56. (Contribution to an inquiry.)
58 [Statement quoted in] FRIEDMAN, B. H., ed. *School of New York: Some Younger Artists,* Grove Press, New York, 1959, pp. 42, 46.
59 [Etching with poem by Harold Rosenburg, 'Revenge'] in *21 Etchings and Poems*, Morris Gallery, New York, 1960. (In portfolio; limited edition of 50.)
60 'Content is a Glimpse,' *Location*, vol. 1, no. 1, Spring 1963, pp. 45–53 illus. (From a BBC interview by David Sylvester.)

See also bibls. 65, 68, 71, 75, 81, 85, 987, 989, 995, 999, 1000, 1001, 1003, 1300.

Articles and Books on De Kooning (alphabetically)

61 ALLOWAY, LAWRENCE. 'Iconography Wreckers and Maenad Hunters,' *Art International*, vol. 5, no. 3, April 1961, pp. 32–34, 47 illus.

62 'Art Feature: Willem de Kooning,' *New Mexico Quarterly*, vol. 23, no. 2, Summer 1953, p. 176 plus 8 plates.
63 ASHTON, DORE. 'De Kooning's Verve,' *Studio*, vol. 163, no. 830, June 1962, pp. 216–217, 224 illus.
64 ASHTON, DORE. 'Willem de Kooning,' *Arts and Architecture*, vol. 76, no. 7, July 1959, pp. 5, 30–31.
65 'Big Splash,' *Time*, vol. 73, no. 20, 18 May 1959, p. 72 illus. (Includes statements by the artist.)
66 BLESH, RUDI AND JANIS, HARRIET. *De Kooning*, New York, Grove Press (Evergreen Gallery Book no. 8), 1960, 71 pp. illus.
66a COATES, ROBERT. 'Variety,' *New Yorker*, 16 May 1959.
67 'De Kooning's Backdrop for "Labyrinth,"' *Arts*, vol. 34, no. 9, June 1960, pp. 28–29 illus.
68 DENBY, EDWIN. [De Kooning], *bibl.* 1043, pp. 9–12 illus. (Includes statement by the artist.)
69 DENBY, EDWIN. 'My Friend, De Kooning,' *Art News Annual*, no. 29, 1964, pp. 82–99, 156 illus.
69a FAISON, S. LANE JR. 'Art,' *Nation*, 18 April 1953, pp. 333–34.
70 HAMMACHER, A. M. 'Mondrian and De Kooning: A Contrast in Transformation,' *Delta*, September 1959, pp. 67–71 plus plates.
71 HESS, THOMAS B. *Willem de Kooning*, George Braziller (Great American Artist Series), New York, 1959, 128 p. illus; bibliography pp. 119–24. (Includes statements by the artist.)
72 KOZLOFF, MAX. 'The Impact of de Kooning,' *Arts Yearbook*, no. 7, 1964, pp. 76–88 illus.
73 LOEW, MICHAEL. 'Notes in Explanation [of mural on the Hall of Pharmacy, executed by Loew, De Kooning and S. van Veen],' in *Painting and Sculpture in the World of Tomorrow; Fair-Commissioned Mural Painting*, New York, 1939, section 22.

74 NAMUTH, HANS. 'Willem de Kooning, Easthampton, Spring 1964,' *Location*, vol. 1, no. 2, Summer 1964, pp. 27–34 illus. (Photographic essay.)

75 O'DOHERTY, BRIAN. 'De Kooning: Grand Style,' *Newsweek*, 4 January 1965, pp. 56–57, illus., cover. (Includes statement by the artist.)

76 O'HARA, FRANK. 'Ode to Willem de Kooning,' *Metro*, no. 3, 1961, pp. 18–21.

77 ROSENBERG, HAROLD. 'Painting Is a Way of Living,' *New Yorker*, 16 February, 1963, pp. 126, 128, 130–37.

78 SAWYER, KENNETH B. 'A Backyard on Tenth Street,' *Baltimore Museum of Art News*, vol. 20, no. 2, December 1956. pp. 3–7 illus.

79 SAWYER, KENNETH B. 'Three Phases of Willem de Kooning,' *Art News and Review*, vol. 10, no. 22, 22 November 1958, pp. 4, 16.

80 SELZ, PETER. 'Willem de Kooning,' in *New Images of Man*, Museum of Modern Art, New York, 1959, pp. 88–95 illus.

81 'Talk of the Town,' *New Yorker*, vol. 35, no. 9, 18 April 1959, p. 34. (Account of art sale at Downtown Community School with statements by the artist.)

82 TONO, YOSHIAKI. 'De Kooning's Metamorphosis of "Woman,"' *Mizue*, no. 679, November 1961, pp. 56–62 illus. (Text in Japanese with brief English summary.)

83 TUCHMAN, MAURICE. 'De Kooning,' in *Van Gogh and Expressionism*, Solomon R. Guggenheim Museum, New York, 1964, pp. 36–39 illus.

84 TUCHMAN, MAURICE. 'Willem de Kooning,' in *Les Peintres Célèbres,* Paris, Mazenod, 1964.

85 'Willem the Walloper,' *Time*, 30 April 1951, p. 63 illus. (Includes brief statements from an interview with the artist.)

Exhibition Catalogues and Reviews (chronologically)

86 SCHWARTZ, MARVIN D. 'Willem de Kooning at the Sidney Janis Gallery,' *Apollo*, vol. 69, no. 412, June 1959, p. 197.

87 COATES, ROBERT. 'Art Galleries,' *New Yorker*, 16 May 1959.

88 KIPLINGER, SUZANNE. 'Willem de Kooning,' *Village Voice*, 21 October 1959, pp. 5, 11. (Review of *bibl.* 71.)

89 PORTER, FAIRFIELD. 'Art,' *Nation*, vol. 188, no. 23, 6 June 1959, pp. 520–21.

90 ODETS, CLIFFORD. 'Willem de Kooning, the Painter,' in *Willem de Kooning*, Paul Kantor Gallery, Beverly Hills, 3–29 April 1961, pp. 3–4, 21–23 illus.

91 ASHTON, DORE. 'A Love-Hate Relationship to Western Tradition,' *bibl.* 1083, pp. 90–102 illus. (Chapter 8, entirely on De Kooning.)

92 HESS, THOMAS B. 'Six Star Shows for Spring,' *Art News*, vol. 61, no. 1, March 1962, pp. 40–41, 60–61 illus.

93 HESS, THOMAS B. *De Kooning*, Sidney Janis Gallery, New York, 5–31 March 1962.

94 'Out of the Picture,' *Newsweek*, 12 March 1962, p. 100 illus.

95 SANDLER, IRVING H. 'In the Art Galleries,' *New York Post*, 18 March 1962, p. 12.

96 COATES, ROBERT. 'Hartley and De Kooning,' *New Yorker*, 24 March 1962.

97 ASHTON, DORE. 'Art,' *Arts and Architecture*, vol. 79, no. 5, May 1962, p. 6 illus.

98 KOZLOFF, MAX. 'New York Letter,' *Art International*, vol. 6, no. 4, May 1962, pp. 75–76 illus.

99 SAWYER, KENNETH. 'Painting and Sculpture: The New York Season,' *Craft Horizons*, vol. 22, no. 3, May–June 1962, pp. 52–55, 70.

100 TILLIM, SIDNEY. 'Month in Review,' *Arts*, vol. 36, no. 4, May–June 1962, pp. 82–83 illus.

101 GOLDWATER, ROBERT. 'Art Chronicle: Masters of the New,' *Partisan Review*, vol. 29, no. 3, Summer 1962, pp. 416–20.

102 BERKSON, BILL. 'Art Chronicle,' *Kulchur*, vol. 2, no. 7, Autumn 1962, pp. 31–36, 41 illus.

103 STONE, ALLAN, *De Kooning-Newman*, Allan Stone Gallery, New York, 23 October–17 November 1962, p. 16 illus.

104 ASHTON, DORE. 'New York Report,' *Kunstwerk*, vol. 16, nos. 5–6, November–

December 1962, pp. 68–69, 71 illus.

105 FRIED, MICHAEL. 'New York Letter,' *Art International*, vol. 6, no. 10, December 1962, pp. 54–55, 57 illus.

106 HESS, THOMAS B. 'Willem de Kooning and Barnett Newman,' *Art News*, vol. 61, no. 8, December 1962, pp. 12, 43 illus.

107 TILLIM, SIDNEY. 'Month in Review,' *Arts*, vol. 37, no. 3, December 1962, pp. 38–40 illus.

108 GOODMAN, MERLE. 'Some Notes on De Kooning, Drawings and Women,' in *'Woman' Drawings by Willem de Kooning*, James Goodman Gallery, Buffalo, 10–25 January 1964, p. 2.

109 JUDD, DON. 'De Kooning,' *Arts*, vol. 38, no. 6, March 1964, pp. 62–63 illus.

110 PETERSEN, VALERIE. 'Three Faces of Eve,' *Art News*, vol. 63, no. 1, March 1964, pp. 30, 65 illus.

111 FRIED, MICHAEL, 'New York Letter,' *Art International*, vol. 8, no. 3, April 1964, p. 59 illus.

See also bibls. 1022, 1032, 1148, 1168, 1203, 1220, 1234, 1241, 1310, 1311.

Recent Writings 1965–69 (chronologically)

112 'Vanity Fair: The New York Art Scene – de Kooning Grand Style,' *Newsweek*, vol. 65, 4 January 1965, pp. 56–57.

113 'Prisoner of the Seraglio,' *Time*, vol. 85, 26 February 1965, pp. 74–75 illus.

114 *Willem de Kooning*, Paul Kantor Gallery, Beverly Hills, 22 March–30 April 1965, 25 p. cat. illus., preface by William Inge.

115 HESS, THOMAS B. 'De Kooning's New Women,' *Art News*, vol. 64, no. 1, March 1965, pp. 36–38, 63–65 illus. and cover.

116 *Willem de Kooning*, Smith College Museum of Art, 8 April–2 May 1965, 40 p. cat. illus.; text by Dore Ashton, statement by De Kooning, 'The Renaissance and Order' reprinted from *trans/formation*, vol. 1, no. 2, 1951, pp. 85–87; chronology and bibliography.

117 MARMER, NANCY. 'Los Angeles Letter,' *Art International*, vol. 9, no. 5, June 1965, pp. 40–41 illus.

118 LIPPARD, LUCY R. 'Three Generations of Women: de Kooning's First Retrospective,' *Art International*, vol. 9, no. 8, 20 November 1965, pp. 29–31, illus. p. 27.

119 GOODALL, D. B. and M. MATTER. *Drawings*, Austin, University of Texas, 6 February–15 March 1966.

120 *De Kooning Drawings*. Walker and Company, New York, 1967, facsimile reproduction of 26 charcoal drawings from 1966.

121 BATTCOCK, GREGORY. 'Willem de Kooning,' *Arts Magazine*, vol. 42, no. 1, November 1967, pp. 34–37 illus.

122 FINKELSTEIN, LOUIS. 'Light of de Kooning,' *Art News*, vol. 66, no. 7, November 1967, pp. 28–31, 70–71 illus.

123 GLUECK, GRACE. 'Trend Toward Trendlessness,' *Art in America*, vol. 55, no. 6, November–December 1967, p. 122 illus.

124 HUTCHINSON, PETER. 'Willem de Kooning: the Painter in Times of Changing Belief,' *Program Guide 13* (Channel 13 WNDT, New York, November 1967, pp. 36–40).

125 SHIREY, DAVID. 'Don Quixote in Springs,' *Newsweek*, vol. 70, 20 November 1967, pp. 80–81.

126 MELLOW, JAMES R. 'New York Letter,' *Art International*, vol. 11, no. 10, Christmas 1967, p. 76 illus.

127 ROSENBERG, HAROLD. 'Art of Bad Conscience,' *New Yorker*, vol. 43, pt. 9, 16 December 1967, pp. 138–49.

128 KRAUSS, ROSALIND. 'The New de Koonings,' *Artforum*, vol. 6, no. 5, January 1968, pp. 44–47 illus.

129 HESS, THOMAS B. *De Kooning – Recent Paintings*, New York, Walker and Company, 1968, 63 pp. illus., published in connection with the exhibition at M. Knoedler Gallery, New York, 14 November–2 December 1967.

130 *De Kooning: peintures récentes*, M. Knoedler Gallery, Paris, 4–29 June 1968.

131 *Willem de Kooning*, Stedelijk Museum, Amsterdam, 19 September–17 November 1968; organized by the Museum of

Modern Art, New York; text by Thomas B. Hess; reprinted selections from De Kooning's writings; comprehensive bibliography by Bernard Karpel, pp. 151–59; 170-p. cat. illus.

132 BLOK, C. 'Willem de Kooning and Henry Moore,' *Art International*, vol. 12, no. 10, 20 December 1968, pp. 44–47 illus.

133 FORGE, ANDREW. 'De Kooning's "Women,"' *Studio International*, vol. 176, no. 906, December 1968, pp. 246–251 illus.

134 O'DOHERTY, BRIAN. 'Willem de Kooning: Fragmentary Notes Towards a Figure,' *Art International*, vol. 2, no. 10, 20 December 1968, pp. 21–29 (a chapter from a forthcoming book, *The Voice and the Myth: Eight American Masters*, New York, Random House).

135 KENEDY, R. C. 'London Letter,' *Art International*, vol. 13, no. 2, 20 February 1969, pp. 37–38 illus.

136 ALLOWAY, LAWRENCE. 'Art News,' *Nation*, vol. 208, 24 March 1969, p. 381.

137 FORGE, ANDREW. 'De Kooning in Retrospect,' *Art News*, vol. 68, no. 1, March 1969, pp. 44–47, 61–62, 64 illus.

138 LICHTBLAU, CHARLOTTE. 'Willem de Kooning and Barnett Newman,' *Arts Magazine*, vol. 43, no. 5, March 1969, pp. 28–32 illus.

139 PERREAULT, JOHN. 'The New de Koonings,' *Art News*, vol. 68, no. 1, March 1969, pp. 48–49, 68–69 illus.

140 BANNARD, DARBY. 'Willem de Kooning,' *Artforum*, vol. 7, no. 8, April 1969, pp. 42–49 illus.

141 DALI, SALVADOR. 'De Kooning's 300,000,000th Birthday,' *Art News*, vol. 68, no. 2, April 1969, pp. 56–57, 62–63 illus.

142 ASHTON DORE, 'New York Commentary,' *Studio International*, vol. 177, no. 911, May 1969, pp. 243–45 illus.

143 SCHJELDAHL, PETER. 'New York Letter,' *Art International*, vol. 13, no. 5, 20 May 1969, pp. 34–35 illus.

Arshile Gorky

Supplement to bibliographies in *bibls*. 171, 176, 177, 178.

By Gorky (chronologically)

144 'Fetish of Antique Stifles Art Here,' *New York Evening Post*, 15 September 1926. (Anonymous interview on Gorky's becoming a member of the faculty at the Grand Central School of Art; reprinted in *bibl*. 171, pp. 123–26.)

145 'Thirst,' *Grand Central School of Art Quarterly*, November 1926. (Poem; reprinted *bibl*. 176, p. 21.)

146 'The WPA Murals at the Newark Airport,' *c*. 1936, 5 pp. (Copy of a manuscript; published in *bibl*. 176, p. 70; *bibl*. 171, pp. 130–32; excerpts in *bibl*. 1003, pp. 242–43.)

147 'Stuart Davis,' *Creative Art*, vol. 9, no. 3, September 1931, pp. 212–17. (Excerpts reprinted in *bibls*. 171, 194.)

148 Johnson, Malcolm. 'Café Life in New York,' *New York Sun*, 22 August 1941. (On Gorky's murals for Ben Marden's Riviera Café; includes statements by the artist.)

149 *Camouflage*, Grand Central School of Art, 1942. (Announcement of Gorky's course on camouflage; reprinted *bibl*. 171, pp. 133–35.)

150 'Garden in Sochi,' 2-p. typescript, 26 June 1942. (Published omitting one line, in *bibl*. 176; excerpt in *bibl*. 174.)

151 [Drawn illustrations for] Breton, André. *Young Cherry Trees Secured Against Hares*, View, New York, and A. Zwemmer, London, 1946. *See also bibl*. 984.

Articles and Books on Gorky
(alphabetically)

152 ALLOWAY, LAWRENCE. 'Gorky,' Art-forum, vol. 1, no. 9, March 1963, pp. 28–31 illus.

153 APOLLONIO, UMBRO. 'Una Retrospet-tiva alla Biennale: Gorky,' Le Arti, May 1962, p. 32 illus.

154 ASHTON, DORE. 'Arshile Gorky peintre romantique,' XXe siècle, no. 19, June 1962, pp. 76–81 illus. (English text in supplement.)

155 BARILLI, RENATO. 'La Pittura di Arshile Gorky,' La Biennale, no. 43, April–June 1961, pp. 11–17 illus.

156 'The Bitter One,' Newsweek, vol. 60, no. 27, 31 December 1962, p. 39 illus.

157 BRETON, ANDRÉ. 'The Eye-Spring: Arshile Gorky,' It Is, no. 4, Autumn 1959, pp. 56–57. (Reprinted from Julien Levy Gallery catalogue, March 1945 and Le Surréalisme et la Peinture, 1945; also in bibl. 994.)

158 BRETON, ANDRÉ. 'Farewell to Arshile Gorky.' (Poem; bibl. 171, pp. 136–37.)

159 CARLES-GALY, HENRY. 'La Biennale de Venise: Les Retrospectives d'Odilon Redon et d'Arshile Gorky,' Aujourd'hui, no. 38, September 1962, p. 39 illus.

160 DENNISON, GEORGE. 'The Crisis-Art of Arshile Gorky,' Arts, vol. 37, no. 5, February 1963, pp. 14–18 illus.

161 GEIST, SIDNEY. 'Gorky/Rosenberg: two reviews,' Scrap, no. 8, 14 June 1962, pp. 1–3 illus. (Includes review of bibl. 171.)

162 GOLDWATER, ROBERT. 'The Genius of the Moujik,' Saturday Review, vol. 45, no. 20, 19 May 1962, p. 38 illus. (Review of bibl. 171.)

163 HABASQUE, GUY. 'La XXXIe Biennale de Venise,' L'Oeil, no. 93, September 1962, pp. 32–41, 72–73 illus.

164 LOFTUS, JOHN. Arshile Gorky, unpub-lished Master's Thesis, Columbia Uni-versity, 1952; bibliography.

165 O'DOHERTY, BRIAN. 'Gorky: Private Language, Universal Theme,' New York Times, 10 May 1964, sec. 2.

166 O'HARA, FRANK. 'Drawings by Arshile Gorky,' 2-p. typescript; introduction to a panel discussion, c. 1962.

167 OSBORN, MARGARET. 'The Mystery of Arshile Gorky: a Personal Account,' Art News, vol. 61, no. 10, February 1963, pp. 42–44 illus.

168 REIFF, ROBERT. 'The Late Works of Arshile Gorky,' Art Journal, vol. 22, no. 3, Spring 1963, pp. 148–52 illus.

169 REIFF, ROBERT. 'Harold Rosenberg· Arshile Gorky,' Art Journal, vol. 22, no. 4, Summer 1963, p. 274. (Review of bibl. 171.)

170 RESNICK, MILTON. '. . . A Distant Eye-Time,' Scrap, no. 8, 14 June 1962, p. 3.

171 ROSENBERG, HAROLD. Arshile Gorky: The Man, The Time, the Idea, New York, Horizon Press, 1962, 144 pp. illus.; 'selected bibliography,' pp. 138–43; chro-nology and reprinted statements by the artist and others, pp. 120–37 (see bibls. 144, 146, 147, 149, 158). (Reviewed bibls. 161, 162, 169, 173; excerpts from book pub-lished in Portfolio and Art News Annual, no. 5, 1962, pp. 102–14 illus.)

172 ROSENBERG, HAROLD. 'Art and Iden-tity: The Unfinished Masterpiece,' New Yorker, vol. 38, no. 46, 5 January 1963, pp. 70–77.

173 ROSENBERG, HAROLD AND GOODMAN, PAUL. 'Gorky and History· an Ex-change,' Partisan Review, vol. 29, no. 4, Fall 1962, pp. 587–93. (Review of bibl. 171, with reply by the author.)

174 RUBIN, WILLIAM S. 'Arshile Gorky, Surrealism and the New American Paint-ing,' Art International, vol. 7, no. 2, 25 February 1963, pp. 27–38 illus. (Portions delivered as lecture at the Museum of Modern Art, New York, Autumn 1963.)

175 SARKISIAN, MARDIROS. 'Arshile Gorky – A Struggle for Recognition,' Hoosharar (New York), vol. 45, no. 3, 1 February 1958, pp. 6–9 illus., cover. (Review bibl. 176.)

176 SCHWABACHER, ETHEL. Arshile Gorky, New York, Macmillan and Whitney Museum of American Art, 1957, 159 pp. illus.; preface by Lloyd Goodrich; intro-duction by Meyer Schapiro. (Includes bibliography, pp. 153–55 and numerous quotations from the artist and his contem-poraries, letters and reprinted statements by Gorky.)

177 SCHWABACHER, ETHEL. *Arshile Gorky, Memorial Exhibition,* New York, Whitney Museum of American Art, 5 January–18 February 1951, pp. 7–41. (Biographical notes by Lloyd Goodrich; *bibl.* pp. 49–50.)

178 SEITZ, WILLIAM C. *Arshile Gorky: Painting, Drawings, Studies,* Museum of Modern Art, New York, 1952, 56 pp. illus. (Foreword by Julien Levy; *bibl.* p. 52.)

179 SEITZ, WILLIAM C. 'A Gorky Exhibit,' *The Daily Princetonian,* 14 October 1952, p. 2.

180 SILVER, CATHY S. 'Gorky, When the Going Was Rough,' *Art News,* vol. 62, no. 2, April 1963, pp. 27, 61 illus.

181 'Tardy Tribute to a Tragic Figure,' *Life,* 29 December 1962 (Extra New York Edition), pp. 52–53 illus.

182 VACCARO, NICK DANTE. 'Gorky's Debt to Gaudier-Brzeska,' *Art Journal,* vol. 23, no. 1, Fall 1963, pp. 33–34.

Exhibition Catalogues and Reviews (chronologically)

183 FARBER, MANNY. 'Art,' *Nation,* vol. 172, no. 4, 27 January 1951, p. 92.

184 AFRO (BASALDELLA), *Arshile Gorky,* Galleria dell Obelisco, Rome, February 1957, p. 2.

185 *Thirty-Three Paintings by Arshile Gorky,* Sidney Janis Gallery, New York, 2–28 December 1957, 20-p. cat. illus.

186 COATES, ROBERT. 'Art Galleries,' *New Yorker,* 14 December 1957.

187 ASHTON, DORE. 'Lettre de New York,' *Cimaise,* series 5, no. 3, January–February 1958, pp. 36–37 illus.

188 ASHTON, DORE. 'Art,' *Arts and Architecture,* vol. 75, no. 1, January 1958, pp. 6, 34 illus.

189 *Late Drawings by Arshile Gorky,* Sidney Janis Gallery, New York, 28 September–24 October 1959, 16-p. cat. illus.; anonymous text.

190 SAWIN, MARTICA. 'New York Letter,' *Art International,* vol. 3, no. 9, 1959, p. 10 illus.

191 CREHAN, HUBERT, 'Gorky,' *Art News,* vol. 58, no. 6, October 1959, p. 12 illus.

192 MELLOW, JAMES R. 'Late Drawings of Arshile Gorky,' *Arts,* vol. 34, no. 1, October 1959, pp. 55–56 illus.

193 ASHTON, DORE. 'Art,' *Arts and Architecture,* vol. 76, no. 12, December 1959, p. 7 illus.

194 *Arshile Gorky Drawings 1929 to 1934,* David Anderson Gallery, New York, 3 February–1 March 1962, 13-p. cat. illus. (Brief excerpt from *bibl.* 147.)

195 *Paintings by Arshile Gorky from 1929 to 1948,* Sidney Janis Gallery, New York, 5 February–3 March 1962, 16-p. cat. illus.

196 KOZLOFF, MAX. 'New York Letter,' *Art International,* vol. 6, no. 3, April 1962, p. 42 illus.

197 TILLIM, SIDNEY. 'Gorky,' *Arts,* vol. 36, no. 7, April 1962, pp. 49–50 illus.

198 *Arshile Gorky 40 Drawings,* Everett Ellin Gallery, Los Angeles, 9 April–5 May 1962, 16-p. cat. illus. (Excerpts from *bibls.* 171, 176.)

199 O'HARA, FRANK. 'Art Chronicle,' *Kulchur,* vol. 2, no. 6, Summer 1962, pp. 55–56.

200 SANDLER, IRVING H. 'New York Letter,' *Quadrum,* no. 14, 1963, pp. 115–24 illus.

201 KRAMER, HILTON. 'Art,' *Nation,* 12 January 1963, pp. 38–39.

202 PRESTON, STUART. 'New York,' *Burlington Magazine,* vol. 105, no. 719, February 1963, p. 84.

203 BURKHARDT, HANS. *Arshile Gorky Paintings and Drawings 1927–1937 The Collection of Mr and Mrs Hans Burkhardt,* Art Center in La Jolla, 21 February–21 March 1963, p. 1.

204 ASHTON, DORE. 'New York,' *Kunstwerk,* vol. 16, no. 10, April 1963, pp. 31, 43 illus.

205 REUSCHEL, JON. 'Arshile Gorky,' *Artforum,* vol. 1, no. 11, May 1963, p. 47.

206 *Drawings by Gorky,* Seibu Gallery, Tokyo, 26 July–11 August 1963, 16 pp. illus. (Museum of Modern Art Circulating Exhibition; in Japanese.)

207 O'HARA, FRANK. 'Einführung,' *Arshile Gorky: Zeichnungen,* 20-p. cat. of Museum

of Modern Art Circulating Exhibition; shown in Karlsrühe, Hamburg, Berlin, Essen, July–November 1964.

See also bibls. 53, 703, 994, 1004, 1032, 1311.

Recent Writings 1965–69 (chronologically)

208 Arts Council of Great Britain. *Arshile Gorky Drawings*, travelling exhibition, 1964–65, organized by the Museum of Modern Art, New York under the auspices of its International Council, 20⁄p. cat. illus.

209 *Arshile Gorky, Paintings and Drawings*, The Tate Gallery Arts Council, 2 April– 2 May 1965, 36⁄p. cat. illus. with introduction by Robert Melville; chronology.
210 ROBERTS, KEITH. 'Major Retrospective at the Tate,' *Burlington Magazine*, vol. 107, no. 746, May 1965, pp. 270–71.
211 *Arshile Gorky*, Museum des Jahrhunderts, Vienna, 18 September–17 October 1965, 27⁄p. cat. illus; text by Werner Hofmann.
212 LEVY, JULIEN. *Arshile Gorky*, New York, Harry N. Abrams, Inc., 1966, 235 pp. illus.
213 *Arshile Gorky, Drawings from the Julien Levy Collection*, Richard Feigen Gallery, Chicago, 18 March–26 April 1969, 8⁄p. cat. illus.

Adolph Gottlieb

Supplement to bibliography in *bibl.* 229.

By Gottlieb (chronologically)

214 [Letter to the editor], *New York Times*, 13 June 1943, sec. 2, p. 9. (With Mark Rothko and Barnett Newman; partially reprinted in *bibls.* 1014, 1083.)
215 'The Portrait and the Modern Artist,' mimeographed script of broadcast by Gottlieb and Rothko – *Art in New York*, Program, H. Stix, director, WNYC, New York, 13 October 1943, 4 pp.
216 [Letter to the editor], *New York Times*, 22 July 1945.
217 [Statement], in 'The Ides of Art,' *Tiger's Eye*, vol. 1, no. 2, December 1947, p. 43.
218 'Unintelligibility,' 1948. Mimeographed script of talk given in *Forum: The Artist Speaks*, at the Museum of Modern Art, New York, 5 May 1948, 4 pp.
219 [Statement], in 'The Ides of Art: Eleven Graphic Artists Write,' *Tiger's Eye*, vol. 1, no. 8, 15 June 1949, p. 52.

220 *Selected Paintings by the late Arshile Gorky*, Kootz Gallery, New York, 28 March– 24 April 1950, p. 1.
221 [Statement], *Arts and Architecture*, vol. 68, no. 9, September 1951, p. 1.
222 HEMLEY, CECIL. *Seas and Seasons*, New York, Four Seasons Press, 1951. (Gottlieb illustrations: two drawings.)
223 [Statement], *Contemporary American Painting*, University of Illinois, Urbana, 1952, p. 194.
224 'The Artist and the Public,' *Art in America*, vol. 42, no. 4, December 1954, pp. 267–71 illus. (Talk given at College Art Association conference, 1954; revised and republished as 'Artist and Society: A Brief Case History,' *College Art Journal*, vol. 14, no. 2, Winter 1955, pp. 96–101.)
225 [Statement], in Gay Talese, 'Stevenson Studying Abstract Art,' *New York Times*, 23 December 1959.
226 [Statement], in 'Representational or Abstract?' *Junior League Magazine*, vol. 50, no. 6, November–December 1962, p. 2.
227 'Adolphe Gottlieb: An Interview with

David Sylvester,' *Living Arts*, vol. 1, no. 2, June 1963, pp. 2–10 illus.

228 'Postcards From Adolph Gottlieb,' *Location*, vol. 1, no. 2, Summer 1964, pp. 19–26. (Illus. only.)

See also bibls. 234, 984, 986, 987, 989, 991, 993, 999, 1001, 1256, 1300.

Books and Articles on Gottlieb (alphabetically)

229 FRIEDMAN, MARTIN. *Adolph Gottlieb*, Walker Art Center, Minneapolis, 28 April–9 June 1963, pp. 7–20 illus.; bibliography pp. 43–45; exhibition list and reviews pp. 39–43. (Also shown at the VII Bienal de São Paulo, *bibl.* 255, and at the Marlborough-Gerson Gallery, New York, 1964.)

230 FRIEDMAN, MARTIN. 'Adolph Gottlieb: Private Symbols in Public Statements,' *Art News*, vol. 62, no. 3, May 1963, pp. 5, 32–35, 52–53 illus. and cover.

231 MORITZ, CHARLES, ED. 'Adolph Gottlieb,' *Current Biography Yearbook*, H. W. Wilson Co., New York, 1959, pp. 155–56 illus.

232 'Oil Paintings by Adolph Gottlieb,' *Irregular* (Immaculate Heart College, Los Angeles), 1959, pp. 40–41 illus.

Exhibition Catalogues and Reviews (chronologically)

See also bibl. 229

233 NEWMAN, BARNETT B. *Adolph Gottlieb*, Wakefield Gallery, New York, 7–19 February 1944, pp. 2–3.

234 'Adolph Gottlieb,' *Limited Edition*, December 1945, pp. 5–6. (Includes statements by the artist.)

235 WOLFSON, VICTOR. *Adolph Gottlieb*, Kootz Gallery, New York, 6–25 January 1947, p. 2.

236 'Adolph Gottlieb,' *MKR's Art Outlook*, 20 January 1947.

237 GREENBERG, CLEMENT. 'Art,' *Nation*, 6 December 1947.

238 KOOTZ, SAMUEL M. *Adolph Gottlieb*, Kootz Gallery, New York, 8–26 January 1952, p. 4.

239 MACLEISH, ARCHIBALD. *Adolph Gottlieb*, Kootz Gallery, New York, 5–24 January 1953, illus. (Anonymous text and quotation from MacLeish.)

240 FAISON, S. LANE, JR. 'Art,' *Nation*, 10 January 1953.

241 GREENBERG, CLEMENT. *Adolph Gottlieb*, Bennington College and Williams College, 23 April–5 May and 7–23 May 1954, p. 2.

242 GOOSSEN, E. C. 'Adolph Gottlieb,' *Monterey Peninsula Herald*, 12 May 1954.

243 FAISON, S. LANE, JR. 'Art,' *Nation*, 15 May 1954.

244 GREENBERG, CLEMENT. *Adolph Gottlieb*, Jewish Museum, New York, November–December 1957, pp. 5–8 illus. (Text reprinted in catalogue of Gottlieb exhibition at Andre Emmerich Gallery, New York, 3–31 January 1958, p. 2.)

245 LONNGREN, LILLIAN. 'Abstract Expression in the American Scene,' *Art International*, vol. 2, no. 1, 1958, pp. 54–56.

246 SAWIN, MARTICA. 'New York Letter,' *Art International*, vol. 3, nos. 1–2, 1959, p. 46.

247 GREENBERG, CLEMENT. *Adolph Gottlieb and the New York School*, Galerie Rive Droite, Paris, 3–30 April 1959.

248 *Adolph Gottlieb*, Paul Kantor Gallery, Beverly Hills, 27 April–23 May 1959, 8-p. cat. illus.

249 GREENBERG, CLEMENT. *Adolph Gottlieb*, ICA Gallery, London, June 1959, pp. 2–3.

250 BUTLER, BARBARA. 'Movie Stars and Other Members of the Cast,' *Art International*, vol. 4, nos. 2–3, 1960, pp. 50–52.

251 *Adolph Gottlieb*, French and Company, New York, January 1960, 8-p. cat. illus.

252 *Adolph Gottlieb*, Galerie Handschuh, Basel, September–10 October 1961, 8-p. cat. illus.

253 *Adolph Gottlieb*, Sidney Janis Gallery, New York, 1–27 October 1962, 20-p. cat. illus.

254 SAWYER, KENNETH. 'Painting and Sculpture: The New York Season,' *Craft Horizons*, vol. 22, no. 3, May–June 1962, pp. 52–55, 70.

255 *Estados Unidos da America VII Bienal do Museu de arte moderna*, São Paulo, September–December 1963, 'I. Adolph Gottlieb,' pp. 6–29. (Text by Martin Friedman, see *bibl.* 229.)
256 ASHTON, DORE. 'New York Letter,' *Kunstwerk*, vol. 15, no. 7, January 1963, p. 32.
257 ASHTON, DORE. 'New York Commentary,' *Studio*, vol. 165, no. 837, p. 26 illus.
258 TILLIM, SIDNEY. 'Gottlieb,' *Arts*, vol. 38, no. 7, April 1964, p. 32.

See also bibls. 539, 1007, 1026, 1234, 1241, 1249, 1310, 1311.

Recent Writings 1965–69 (chronologically)

259 *Adolph Gottlieb: Twelve Paintings*, Marlborough-Gerson Gallery, New York, February 1966, 16 p. cat. illus.
260 ROSENSTEIN, HARRIS. 'Gottlieb at the Summit,' *Art News*, vol. 65, no. 2, April 1966, pp. 42–43, 65–66 illus.
261 *Recent Works of Adolph Gottlieb*, The Arts Club of Chicago, 22 May–23 June 1967, 8 p. cat. illus.
262 DOTY, ROBERT AND DIANE WALDMAN. *Adolph Gottlieb*, Whitney Museum of American Art, New York, 14 February–31 March 1968 and The Solomon R. Guggenheim Museum, New York, 14 February–7 April 1968, 121 p. cat. illus.; chronology and bibliography.
263 SIEGEL, JEANNE. 'Adolph Gottlieb: Two Views,' *Arts Magazine*, vol. 42, no. 4, February 1968, pp. 30–34 illus.
264 WALDMAN, DIANE. 'Gottlieb: Signs and Suns,' *Art News*, vol. 66, no. 10, February 1968, pp. 26–29, 65–69 illus.
265 KOZLOFF, MAX. 'Guggenheim Museum Exhibition,' *Nation*, vol. 206, 4 March 1968, pp. 315–17.
266 ROSENBERG, HAROLD. 'Exhibition at the Guggenheim and the Whitney,' *New Yorker*, vol. 44, 23 March 1968, pp. 107–10.
267 ALLOWAY, LAWRENCE. 'Melpomene and Graffiti,' *Art International*, vol. 12, no. 4, 20 April 1968, pp. 21–24 illus.
268 ASHTON, DORE. 'Adolph Gottlieb at the Guggenheim and Whitney Museums,' *Studio International*, vol. 175, no. 899, April 1968, pp. 201–02 illus.
269 CONE, JANE HARRISON. 'Adolph Gottlieb,' *Artforum*, vol. 6, no. 8, April 1968, pp. 36–39 illus.
270 HUDSON, ANDREW. 'Adolph Gottlieb's Paintings at the Whitney,' *Art International*, vol. 12, no. 4, 20 April 1968, pp. 24–29 illus.

Philip Guston

Supplement to the bibliography in *bibl.* 279.

By Guston (chronologically)

271 [Statement], in MILLER, DOROTHY C., ed. *Twelve Americans*, Museum of Modern Art, New York, 1956, p. 36 plus illus.
272 'Notes on the Artist,' *Bradley Walker Tomlin*, Whitney Museum of American Art, New York, 1957, p. 9. (Reprinted *bibl.* 994.)
273 [Recorded interview with June Pring], Columbia University, New York, 25 June 1957.
274 HUNTER, SAM. 'Art in New York,' *Playbill*, vol. 1, no. 8, November 1957, pp. 52–53. (Interview.)
275 'Statement,' *It Is*, no. 1, Spring 1958, p. 44.
276 [Recorded interview with H.H. Arnason], Solomon R. Guggenheim Museum, New York, 22–30 January 1962.
277 [Interview with David Sylvester] *c.* 1963, typescript.

See also bibls. 993, 994, 995, 998, 1000, 1256, 1300.

Articles and Books on Guston (alphabetically)

278 ALLOWAY, LAWRENCE. 'Notes on Guston,' *Art Journal*, vol. 22, no. 1, Fall 1962, pp. 8–11 illus. and cover.

279 ARNASON, H. H. *Philip Guston*, Solomon R. Guggenheim Museum, New York, 2 May–1 July 1962, pp. 11–39 illus.; bibliography pp. 120–23.

280 ASHTON, DORE. *Philip Guston*, New York, Grove Press (Evergreen Gallery Book no. 10), 1960, 63 pp. illus.

281 ASHTON, DORE. 'Philip Guston,' *Aujourd'hui*, no. 37, June 1962, pp. 28–29, illus.

282 HUNTER, SAM. 'Philip Guston,' *Art International*, vol. 6, no. 4, May 1962, pp. 62–67 illus.

283 KOZLOFF, MAX. 'Art,' *Nation*, vol. 194, no. 20, 19 May 1962, pp. 453–55.

284 MULLINS, EDWIN. 'Guston and the Imaginative Experiment,' *Apollo*, vol. 77, no. 13, March 1963, pp. 229–30 illus.

285 O'HARA, FRANK. 'Growth and Guston,' *Art News*, vol. 61, no. 3, May 1962. pp. 31–33, 51–52 illus.

286 KARP, IVAN C. 'Philip Guston,' *Village Voice*, 15 February 1956.

287 YATES, PETER. 'Philip Guston at the County Museum,' *Arts and Architecture*, vol. 80, no. 9, September 1963, pp. 4–5, 31–32 illus.

Exhibition Catalogues and Reviews (chronologically)

288 ASHTON, DORE. 'New York,' *Cimaise*, series 5, no. 4, March–April 1957, pp. 30–31 illus.

289 ALLOWAY, LAWRENCE. 'Some Notes on Abstract Impressionism,' in *Abstract Impressionism*, Arts Council Gallery, London, 11–28 June 1958, pp. 4–8 illus.

290 BUTLER, BARBARA. 'Movie Stars and Other Members of the Cast,' *Art International*, vol. 4, nos. 2–3, 1960, pp. 50–52.

291 'Guston,' *Art International*, vol. 4, no. 7, September 1960, pp. 38–39. (Illus. only.)

292 SANDLER, IRVING H. 'New York Letter,' *Art International*, vol. 5, no. 3, April 1961, p. 38 illus.

293 *Philip Guston*, 'The Solomon R. Guggenheim Museum, New York, 2 May–1 July 1962; text by H. H. Arnason, pp. 11–37, chronology, p. 117, bibliography, pp. 120–123; 125–p. cat. illus.

294 'One Man Show by Philip Guston at Guggenheim,' *Art Students League News*, vol. 15, no. 5, May 1962, pp. 1–2.

295 SANDLER, IRVING. 'In the Art Galleries,' *New York Post*, 27 May 1962.

296 RAYNOR, VIVIEN. 'Guston,' *Arts*, vol. 36, no. 10, September 1962, p. 50.

297 *Philip Guston*. Stedelijk Museum, Amsterdam, 20 September–15 October 1962, 16–p. cat. illus.; biography, reprinted and translated statements by the artist.

298 BERKSON, BILL. 'Art Chronicle,' *Kulchur*, vol. 2, no. 7, Autumn 1962, pp. 36–38, illus. p. 42.

299 BURN, GUY. 'Guston,' *Arts Review*, vol. 15, no. 1, 26 January–9 February 1963, p. 10 illus.

300 LYNTON, NORBERT. 'London Letter,' *Art International*, vol. 7, no. 2, February 1963, pp. 69–70 illus.

301 ROBERTS, KEITH. 'London,' *Burlington Magazine*, vol. 105, no. 720, March 1963, p. 136.

302 HARRISON, JANE. 'London,' *Arts*, vol. 37, no. 7, April 1963, p. 27.

303 MELVILLE, ROBERT. 'Exhibitions,' *Architectural Review*, vol. 133, no. 794, April 1963, p. 289 illus.

304 [Lecture], mimeographed script at Betty Parsons Gallery, New York, 4 pp. (Delivered at symposium on abstract art held during annual American Abstract Artists Exhibition, 16 February 1941, Riverside Museum, New York.

See also bibls. 1204, 1226, 1228, 1234, 1241, 1310, 1311.

305 ASHTON, DORE. 'Philip Guston, the Painter as Metaphysician,' *Studio International*, vol. 169, no. 862, February 1965, pp. 64–67 illus.

306 GUSTON, PHILIP. 'Piero della Francesca: the Impossibility of Painting,' *Art News*, vol. 64, no. 3, May 1965, pp. 38–39 illus.

307 *Philip Guston, Recent Paintings and Drawings*, The Jewish Museum, New York, 12 January 1966–20 February 1967, cat. illus.; introduction by Sam Hunter.

308 BENEDIKT, MICHAEL. 'New York Letter,' *Art International*, vol. 10, no. 4, 20 April 1966, pp. 79–80 illus.

309 *Philip Guston*, The Santa Barbara Museum of Art, 15 February–26 March 1967, 8-p. cat. illus. introduction by Sam Hunter, reprinted from *Philip Guston, Recent Paintings and Drawings*, 1967.

Hans Hofmann

Supplement to bibliography in *bibl.* 327.

By Hofmann (chronologically)

Due to the large number of writings by the artist, only a few recent and important references are cited below; over thirty items are listed in *bibl.* 327, pp. 60–61.

310 [Statement] in *Hans Hofmann*, Art of This Century Gallery, New York, March 1944.

311 [Statement], typescript at Betty Parsons Gallery, New York, 1 p., dated 5 February 1946.

312 *Search for the Real and Other Essays*, Addison Gallery of American Art, Andover, Mass., *c.* 1948, pp. 46–78. (The major collection of Hofmann's writings.)

313 'The Mystery of Creative Relations,' *New Ventures*, July 1953, pp. 22–23.

314 'The Resurrection of the Plastic Arts,' *New Ventures*, July 1953, pp. 20–22.

315 'The Color Problem in pure painting – its creative origin,' in *Hans Hofmann*, Kootz Gallery, New York, 7 November–3 December 1955, pp. 2–4. (Reprinted in *Arts and Architecture*, vol. 73, no. 2, February 1956, pp. 14–15, 33–34 and in *bibl.* 328.)

316 [Statement], *It Is*, no. 3, Winter–Spring 1959, p. 10.

317 'Space and Pictorial Life,' *It Is*, no. 4, Autumn 1959, p. 10.

318 'Hans Hofmann on Art,' *Art Journal*, vol. 22, no. 3, Spring 1963, pp. 180, 182. (Speech delivered at the inauguration of Hopkins Center, Dartmouth College, 17 November 1962.)

319 'Photo-Critic,' *Location*, vol. 1, no. 2, Summer 1964, p. 98.

See also bibls. 322, 325, 327, 343, 984, 987, 989, 993, 1001, 1002, 1003, 1108, 1256.

Books and Articles on Hofmann (alphabetically)

320 BULTMAN, FRITZ. 'The Achievement of Hans Hofmann,' *Art News*, vol. 62, no. 5, September 1963, pp. 43–45, 54–55 illus.

321 BURCKHARDT, RUDOLPH. 'Repertory of Means: "Bald Eagle" by Hans Hofmann,' *Location*, vol. 1, no. 1, Spring 1963, pp. 67–72. (A photographic essay.)

322 HUNTER, SAM. *Hans Hofmann*, New York, Harry N. Abrams, 1963, 227 pp. illus. (Includes reprints of five texts by the artist, pp. 33–51.)

323 KAPROW, ALLAN. 'The Effect of Recent Art upon the Teaching of Art,' *Art Journal*, vol. 33, no. 2, Winter 1963–64, pp. 136–38.

324 LORAN, ERLE. 'Hans Hofmann and His Work,' *Artforum*, vol. 2, no. 11, May 1964, pp. 32–35 illus. and cover. (Excerpt from *bibl.* 352.)

325 PLASKETT, JOE. 'Some New Canadian Painters and Their Debt to Hans Hofmann,' *Canadian Art*, vol. 10, no. 2, Winter 1953, pp. 59–63, 79 illus. (Includes statements by the artist.)

326 ROSENBERG, HAROLD. 'Hans Hofmann and the Stability of the New,' *New Yorker*, vol. 39, no. 37, 2 November 1963, pp. 100, 103–05, 108–10.

327 SEITZ, WILLIAM C. *Hans Hofmann*, Museum of Modern Art, New York, 1963, pp. 6–54 illus.; bibliography pp. 60–62. (Text includes lengthy quotations from the artist's writings.)

328 WIGHT, FREDERICK S. *Hans Hofmann*, University of California Press, Berkeley and Los Angeles, 1957, 66 pp. illus. (Published on occasion of the Hofmann Retrospective Exhibition at the Whitney Museum of American Art and the Art Galleries of the University of California. Foreword by John I. H. Baur; bibliography pp. 64–66; reprinted text by the artist from *bibl.* 315.)

Exhibition Catalogues and Reviews (chronologically)

329 ASHTON, DORE. 'Art', *Arts and Architecture*, vol. 74, no. 6, June 1957, pp. 8–10 illus.

330 LONNGREN, LILLIAN. 'Abstract Expression in the American Scene,' *Art International*, vol. 2, no. 1; 1958, pp. 54–56.

331 SAWIN, MARTICA. 'New York Letter,' *Art International*, vol. 3, nos. 1–2, 1959, p. 40.

332 SCHWARTZ, MARVIN D. 'Hans Hofmann at Kootz,' *Apollo*, vol. 69, no. 409, March 1959, pp. 93–94 illus.

333 BUTLER, BARBARA. 'Movie Stars and Other Members of the Cast,' *Art International*, vol. 4, nos. 2–3, 1960, pp. 50–52.

334 'Hofmann: American,' *Art International*, vol. 4, no. 6, June 1960, pp. 78–79. (Illus. only.)

335 SANDLER, IRVING H. 'New York Letter,' *Art International*, vol. 5, no. 4, May 1961, pp. 52–53 illus.

336 LANGSNER, JULES. 'Los Angeles Letter,' *Art International*, vol. 5, no. 8, October 1961, p. 85 illus.

337 SAWYER, KENNETH. 'Painting and Sculpture: The New York Season,' *Craft Horizons*, vol. 22, no. 3, May–June 1962, pp. 52–55, 70.

338 FRIED, MICHAEL. 'New York Letter,' *Art International*, vol. 7, no. 4, April 1963, pp. 54–55 illus.

339 JUDD, DON. 'Hofmann,' *Arts*, vol. 37, no. 7, April 1963, p. 55 illus.

340 MUNRO, ELEANOR C. 'Hofmann,' *Art News*, vol. 62, no. 2, April 1963, p. 10 illus.

341 GEBHARD, DAVID. 'Hofman,' *Artforum*, vol. 1, no. 11, May 1963, p. 43.

342 TAPIÉ, MICHEL, *Hans Hofmann*, Galerie Anderson-Mayer, Paris, 1963.

343 WATT, ALEXANDER. 'Paris Commentary,' *Studio*, vol. 166, no. 844, August 1963, p. 77. (Includes statement by the artist.)

344 RAYNOR, VIVIEN. 'Hofmann,' *Arts*, vol. 38, no. 1, October 1963, p. 57 illus.

345 ASHTON, DORE. 'New York Report,' *Kunstwerk*, vol. 17, no. 6, December 1963, pp. 23–24, plates pp. 29–30.

346 ASHTON, DORE. 'Sadness and Delectation,' *Studio*, vol. 166, no. 848, December 1963, pp. 232, 234 illus.

347 FRIED, MICHAEL. 'New York Letter,' *Art International*, vol. 7, no. 9, December 1963, p. 66.

348 *Hans Hofmann*, Kootz Gallery, New York, 18 February–7 March 1964, 6-p. cat. illus. and 2-p. excerpts from reviews of Museum of Modern Art exhibition (*bibl.* 327) in *Newsweek*, *New Yorker*, *New York Times*, *New York Post* and *Art News*.

349 NEUMANN, THOMAS. 'Hofmann,' *Art News*, vol. 63, no. 1, March 1964, p. 8 illus.

350 HARRISON, JANE. 'Hofmann,' *Arts*, vol. 38, no. 7, April 1964, p. 29 illus.

351 ROSE, BARBARA. 'New York Letter,' *Art International*, vol. 8, no. 3, April 1964, p. 55 illus.

352 LORAN, ERLE. 'Hans Hofmann and His Work,' in *Recent Gifts and Loans of Paint-*

ings by Hans Hofmann, Worth Ryder Art Gallery, University of California, Berkeley, 2 April–3 May 1964, pp. 7–23. (Excerpt published in *bibl.* 324.)

353 TAPIÉ, MICHEL. *Hans Hofmann*, American Art Gallery, Copenhagen, 18 April–9 May 1964, p. 1.

See also bibls. 1007, 1032, 1172, 1204, 1234, 1241, 1249, 1311.

Recent Writings 1965–69 (chronologically)

354 *Hans Hofmann: 85th Anniversary: Paintings of 1964*, Kootz Gallery, New York, 16 February–6 March 1965, 8-p. cat. illus.

355 LIPPARD, LUCY R. 'New York Letter,' *Art International*, vol. 9, no. 3, April 1965, p. 60, illus. p. 61.

356 ROSENBERG, HAROLD. 'Hans Hofmann,' *Vogue*, vol. 145, May 1965, pp. 192–95.

357 *Hans Hofmann at Kootz*, Kootz Gallery, New York, 1–26 February 1966, 5-p. cat. illus.

358 MELLOW, JAMES R. 'New York Letter,' *Art International*, vol. 10, no. 4, 20 April 1966, p. 86 illus.

359 ROSENBERG, HAROLD. 'Eulogy, February 20, 1966,' *Art News*, vol. 65, no. 2, April 1966, p. 21.

360 *Hans Hofmann: Twenty-One Paintings from the Collection of the University of California, Berkeley*, Stanford Art Museum, Stanford University, 22 June–17 August 1966, 18-p. cat. illus., with excerpts from Hofmann's essay 'Painting and Culture' reprinted from *Search for the Real*, revised edition, Cambridge, Mass., MIT Press, 1966.

361 *Hans Hofmann*, Andre Emmerich Gallery, New York, 21 January–9 February 1967, 4-p. cat. illus.

362 ROSENBERG, HAROLD. 'Homage to Hans Hofmann,' *Art News*, vol. 65, no. 9, January 1967, pp. 49, 72–73 illus.

363 KOOTZ, SAMUEL M. 'Credibility of Color: Hans Hofmann, an Area of Optimism,' *Arts Magazine*, vol. 41, no. 4, February 1967, pp. 37–39 illus.

364 *Hans Hofmann*, Andre Emmerich Gallery, New York, 6–31 January 1968, 4-p. cat. illus.

365 *Hans Hofmann*, Richard Gray Gallery, Chicago, 31 January–2 March 1968, 4-p. cat. illus.

366 *Hans Hofmann: Ten Major Works*, Andre Emmerich Gallery, New York, 11–30 January 1969, 10-p. cat. illus.

367 BANNARD, DARBY. 'Hans Hofmann,' *Artforum*, vol. 7, no. 10, Summer 1969, pp. 38–41 illus.

Franz Kline

Supplement to bibliographies in *bibls.* 377, 387.

By Kline (chronologically)

368 [Letter to the editor], *Bokubi* (Tokyo), no. 12, May 1952, p. 4. (In Japanese.)

369 [Statement], in 'Younger American Painters at the Guggenheim,' *Vogue*, vol. 124, no. 2, 1 August 1954, pp. 120–23 illus.

370 KARP, IVAN C. 'The Unweary Mr Franz Kline: Artist Without Metaphysics,' *Village Voice*, 7 March 1956. (Interview.)

371 'Is Today's Artist With or Against the Past?' *Art News*, vol. 57, no. 5, September 1958, pp. 40, 58. (Contribution to an inquiry.)

372 O'HARA, FRANK. 'Franz Kline Talking,' *Evergreen Review*, vol. 2, no. 6, Autumn 1958 pp. 56–68 illus. (Often reprinted: see *bibls.* 387, 413, 994.)

373 [Etching with 'Poem' by Frank O'Hara], in *21 Etchings and Poems*, Morris Gallery, New York, 1960. (In portfolio: limited edition of 50.)

374 CROTTY, FRANK. 'Around These Parts:

Franz Kline,' *Evening Gazette* (Worcester, Mass.) 9 February 1960 illus. (Includes brief statement by the artist.)

375 PICARD, LIL. 'Jedesmal eine Feuerprobe: Interview mit Franz Kline – Anlässlich einer Ausstellung,' *Die Welt* (Hamburg), 2 January 1962.

376 'Franz Kline 1910–1962: An Interview with David Sylvester,' *Living Arts*, vol. 1, no. 1, Spring 1963, pp. 2–13 illus.

See also bibls. 380, 991, 995, 990, 1000, 1002, 1003, 1300.

Books and Articles on Kline (alphabetically)

377 DE KOONING, ELAINE. *Franz Kline Memorial Exhibition*, Washington Gallery of Modern Art, Washington DC, 30 October–27 December 1962, pp. 8–18 plus illus.; also foreword by Adelyn Breeskin; bibliography pp. 57–59. (De Kooning text revised as 'Franz Kline: Painter of His Own Life,' *Art News*, vol. 61, no. 7, November 1962, pp. 28–31, 64–69 illus.)

378 DYPRÉAU, JEAN. 'Franz Kline,' *XXe siècle*, no. 23, May 1964, pp. 113–14 illus.

379 'Farewell to a Gentle Man with a Vital Talent,' *Life*, vol. 52, 25 May 1962, p. 40 illus.

380 'A Fitting Tribute,' *Newsweek*, 5 November 1962, p. 104 illus. (Includes statements by the artist.)

381 'Franz Kline: American,' *Art International*, vol. 4, no. 6, June 1960, pp. 56–57. (Illus. only.)

382 'Franz Kline: A Firm Point of American Painting,' *Metro*, nos. 4–5, May 1962, pp. 134–35. (Illus. only.)

383 HASEGAWA, SABRO. 'The Beauty of Black and White,' 1951. (Translation from the Japanese of an article in *Bokubi*, no. 12, May 1952; copy of typescript in Museum of Modern Art Library, New York.)
384 'Kline,' *Art International*, vol. 4, no. 7, September 1960, pp. 40–41. (Illus. only.)

385 'Kline's Last Painting,' *Art in America*, vol. 50, no. 3, Fall 1962, p. 104.

386 MORITA, SHIRYU. 'Impressions of Kline's Recent Works,' *Bokubi*, no. 12, May 1952,

pp. 5–10. (Text in Japanese with English translation.)

387 O'HARA, FRANK. *Franz Kline*, Galleria civica d'arte moderna, Turin, 5 November–1 December 1963, pp. 11–19; also translation of *bibl.* 372; bibliography pp. 30–35; 69 plates. (Exhibition organized and circulated in Europe by the Museum of Modern Art International Council; catalogues also issued in German for Basel, Vienna showings.)

388 RICHARDS, LOUISE S. 'Three Contemporary Drawings,' *Bulletin of the Cleveland Museum of Art*, vol. 49, no. 3, March 1962, pp. 55–59 illus.

389 ROBBINS, DANIEL AND EUGENIA. 'Franz Kline: Rough Impulsive Gerture,' *Studio*, vol. 167, no. 853, May 1964, pp. 186–89 illus.

390 RODMAN, SELDEN. 'An Important Abstractionist,' *Cosmopolitan*, February 1959, pp. 66–69 illus. (From *bibl.* 990.)

391 SURO, DARIO. 'Kline and the Image,' n.d. (Copy of typescript, in Museum of Modern Art Library, New York.)

392 TILLIM, SIDNEY. 'Editorial: Franz Kline (1910–1962),' *Arts*, vol. 36, no. 10, September 1962, p. 6.

393 VILLENEUVE, PAQUERETTE. 'Franz Kline,' *Aujourd'hui*, no. 37, June 1962, p. 34.

394 FISH, JOHN. 'Kline,' *Village Voice*, 14 March 1956.

Exhibition Catalogues and Reviews (chronologically)

See also bibl. 377.

395 PASSONI, FRANCO. *Franz Kline*, Galleria del Naviglio, Milan, 18–28 March 1958, pp. 1–3.

396 BUTLER, BARBARA. 'Kline and Smith,' *Art International*, vol. 4, no. 4, May 1960, p. 67 illus.

397 SAWYER, KENNETH B. *Franz Kline*, New Arts Gallery, Atlanta, 1961.

398 *Franz Kline: Barroom Paintings 1940*, Collectors' Gallery, New York, 2–25 February 1961, 5-p. cat. illus.

399 LANGSNER, JULES. 'Los Angeles Letter,' *Art International*, vol. 5, nos. 5–6, June–August 1961, pp. 64–65 illus.

400 *New Paintings by Franz Kline*, Sidney Janis Gallery, New York, 4–30 December 1961, 28-p. cat. illus.

401 SANDLER, IRVING H. 'In the Art Galleries,' *New York Post*, 17 December 1961.

402 KOZLOFF, MAX. 'Art,' *Nation*, vol. 192, no. 22, 23 December 1961, p. 520.

403 *Franz Kline*, Arts Club of Chicago, 8 December 1961–9 January 1962, 8-p. cat. illus.

404 KOZLOFF, MAX. 'Kline,' *Art International*, vol. 6, no. 1, February 1962, pp. 71–72 illus.

405 *Franz Kline*. Galerie Lawrence, Paris, 15 March–15 April 1962, 5-p. cat. illus.

406 LEVEQUE, JEAN-JACQUES. 'Kline,' *Aujourd'hui*, no. 36, April 1962, pp. 48–49 illus.

407 SAWYER, KENNETH. 'Painting and Sculpture: The New York Season,' *Craft Horizons*, vol. 22, no. 3, May–June 1962, pp. 52–55, 70.

408 LANGSNER, JULES. 'Kline,' *Artforum*, vol. 1, no. 2, July 1962, pp. 4–5 illus.

409 GOLDWATER, ROBERT. 'Art Chronicle/ Masters of the New,' *Partisan Review*, vol. 29, no. 3, Summer 1962, pp. 416–20.

410 GETLEIN, FRANK. 'Washington,' *Burlington Magazine*, vol. 104, no. 717, December 1962, p. 565.

411 LANGSNER, JULES. 'Art News from Los Angeles . . . Kline in Local Collections,' *Art News*, vol. 62, no. 3, May 1963, p. 48.

412 FACTOR, DON. 'Franz Kline, Dwan Gallery,' *Artforum*, vol. 1, no. 12, 1963, p. 10.

413 *Franz Kline*, La Tartaruga Galleria d'arte, Rome, November 1963, 10-p. cat. illus.; excerpts from *bibl.* 372.

414 CAMPBELL, LAWRENCE. 'Kline,' *Art News*, vol. 62, no. 9, January 1964, p. 11.

415 TILLIM, SIDNEY. 'The New Avant-Garde,' *Arts*, vol. 38, no. 5, February 1964, pp. 18–20 illus.

416 DIENST, ROLF-GUNTER. 'Geste, Geometrie, Phantastik: Ausstellungen in Basel und Zürich,' *Kunstwerk*, vol. 17, no. 9, March 1964, pp. 40–41, illus. p. 35.

417 MARCHIS, GIORGIO DI. 'Kline,' *Art International*, vol. 8, no. 1, 1964, p. 54 illus.

418 KOZLOFF, MAX. 'Kline,' *Art International*, vol. 8, no. 1, 1964, pp. 45–46 illus.

419 STABER, MARGIT. 'Basel: Franz Kline – Alfred Jensen,' *Art International*, vol. 8, no. 2, March 1964, pp. 76–77 illus.

420 MOHOLY, LUCIA. 'Switzerland,' *Burlington Magazine*, vol. 106, no. 732, March 1964, p. 142.

421 C.H. 'Ausstellungen: Basel,' *Werk*, vol. 51, no. 4, April 1964, pp. 80, 82 illus.

See also bibls. 1022, 1203, 1204, 1234, 1311.

Recent Writings 1965–69 (chronologically)

422 *Franz Kline*, Marlborough-Gerson Gallery, New York, March 1967, 39-p. cat. illus.; introduction by Robert Goldwater.

423 GOLDWATER, ROBERT. 'Franz Kline: Darkness Visible,' *Art News*, vol. 66, no. 1, March 1967, pp. 38–43, 77 illus.

424 ALLOWAY, LAWRENCE. 'Kline's Estate,' *Arts Magazine*, vol. 41, no. 6, April 1967, pp. 40–43 illus. [Discussion], in *Arts Magazine*, vol. 41, no. 8, Summer 1967, p. 6.

425 MELLOW, JAMES R. 'New York,' *Art International*, vol. 11, no. 4, 20 April 1967, p. 57 illus.

426 ASHTON, DORE. 'New York Commentary,' *Studio International*, vol. 173, no. 889, May 1967, pp. 263–65 illus.

427 DAWSON, FIELDING. *Emotional Memoir of Franz Kline*, New York, Pantheon Books, 1967

428 GORDON, JOHN. *Franz Kline*, Whitney Museum of American Art, New York, 1 October–24 November 1968, 67-p. cat. illus.; bibliography pp. 64–67 by Libby W. Seaberg.

429 ALLOWAY, LAWRENCE. 'Retrospective at the Whitney,' *Nation*, vol. 207, 21 October 1968, pp. 412–13.

430 SCHUYLER, JAMES. 'As American as Franz Kline,' *Art News*, vol. 67 no. 6, October 1968, pp. 30–33, 58–59 illus.

431 SHIREY, DAVID L. 'American Scene,' *Newsweek*, vol. 72, 21 October 1968, p. 114.

432 ROSE, BARBARA. 'Franz Kline. Half-Dozen Masterpieces,' *Vogue*, vol. 152, December 1968. p. 178.

Robert Motherwell

Supplement to bibliography in *bibl.* 508. A forthcoming monograph to be published by the Museum of Modern Art will include a selective bibliography by Bernard Karpel and a forth-coming monograph by Bryan Robertson will include an extensive bibliography, also by Karpel.

From 1947 to 1955, Motherwell edited *The Documents of Modern Art* for Wittenborn, Schultz, New York. Only those items for which he also wrote prefatory notes or introductions are listed below.

By Motherwell (chronologically)

433 'Notes on Mondrian and Chirico,' *VVV*, no. 1, June 1942, pp. 58–61 illus.

434 'The Modern Painters World,' *Dyn* vol. 1, no. 6, November 1944, pp. 8–14. (Lecture given to 'Pontigny en Amérique' at Mount Holyoke College, 10 August 1944.)

435 'Painter's Objects,' *Partisan Review*, vol. 11, no. 1, Winter 1944, pp. 93–97.

436 MILLER, DOROTHY C., ed. *Fourteen Americans,* Museum of Modern Art, New York, 1946, pp. 34–38 illus.

437 'Beyond the Aesthetic,' *Design*, vol. 47, no. 8, April 1946, pp. 14–15. (Excerpts reprinted in 1951 University of Illinois *Contemporary American Painting* catalogue, p. 201, and *bibl.* 1220.)

438 [Statement], in *Robert Motherwell*, Kootz Gallery, New York, 1947, pp. 2–3.

439 [Editorial Statement], in *Possibilities*, vol. 1, no. 1, Winter 1947–48, p. 1. (With co-editor, Harold Rosenberg.)

440 'Prefatory Note' in Jean Arp, *On My Way*, New York, Wittenborn, Schultz, 1948, p. 6.

441 'Prefatory Note' in Max Ernst, *Beyond Painting*, New York, Wittenborn, Schultz, 1948, pp. 5–6.

442 'A Tour of the Sublime,' *Tiger's Eye,* vol. 1, no. 6, 15 December 1948, pp. 46–48.

443 [Statement] in *Robert Motherwell: Collages 1943-1949*, Sidney Janis Gallery, New York, 1949, p. 1. (From *bibl.* 444.)

444 [Lecture], *Forum* 49, Provincetown, Massachusetts, 11 August 1949. (Excerpt in *bibl.* 443.)

445 'Preliminary Notice' in Guillaume Apollonaire, *The Cubist Painters*, New York, Wittenborn, Schultz, 1949, pp. 4–5.

446 'Preliminary Notice' in Daniel-Henry Kahnweiler, *The Rise of Cubism*, New York, Wittenborn, Schultz, 1949, pp. 6–8.

447 'Preface' in Georges Duthuit, *The Fauvist Painters*, New York, Wittenborn, Schultz, 1950, pp. 9–10.

448 'Preliminary Notice' in Marcel Raymond, *From Baudelaire to Surrealism*, New York, Wittenborn, Schultz, 1950, pp. 1–2.

449 *Black or White: Paintings by European and American Artists*, Kootz Gallery, New York, 28 February–20 March 1950, pp. 2–3. (Reprinted *bibl.* 1307.)

450 'A, B, C, D,' *Motherwell*, Kootz Gallery, New York, 14 November–4 December 1950, pp. 2–3 illus. (Excerpt reprinted *bibl.* 1310 p. 96.)

451 'Preface' and 'Introduction' in *Dada Painters and Poets,* New York, Wittenborn, Schultz, 1951, pp. 11–37.

452 'Preface' in Piet Mondrian, *Plastic Art and Pure Plastic Art*, New York, Wittenborn, Schultz, 1951, pp. 5–6.

453 'A Statement' and 'Introduction to the Illustrations' in *Modern Artists in America*, New York, Wittenborn, Schultz, 1951, pp. 6–7 (with Bernard Karpel and Ad Reinhardt), p. 40 (with Reinhardt).

454 'What Abstract Art Means to Me,' *Museum of Modern Art Bulletin,* vol. 18, no. 3, Spring 1951, pp. 12–13 illus. (Contribution to a symposium, 5 February 1951; revised version published in *Art Digest*, vol. 25, no. 10, 15 February 1951, pp. 12, 27–28.)

455 'The Public and the Modern Painter,' *Catholic Art Quarterly*, vol. 14, no. 2, Easter 1951, pp. 80–81.

456 'The Poetry of Abstract Painting,' lecture given at the Philadelphia Museum of Art,

Division of Education, 9 October 1951, in 'Fun With Art' series.

457 *The School of New York*, Frank Perls Gallery, Beverly Hills, 1951, pp. 2–5.

458 'The Rise and Continuity of Abstract Art,' *Arts and Architecture*, vol. 68, no. 9, September 1951, pp. 20–21, 41. (Lecture given at the Fogg Museum, Cambridge, Mass.; excerpt reprinted in University of Illinois *Contemporary American Painting* catalogue, 1952, p. 217.)

459 [Motherwell Seminar], mimeographed outline, Oberlin College, Spring 1952.

460 'Preface to a Joseph Cornell Exhibition,' unpublished typescript at Walker Art Center, Minneapolis, written for a proposed catalogue to the Cornell exhibition held 12 July–30 August 1953; dated 26 June 1953, 2 pp.

461 'Symposium: Is the French Avant-Garde Overrated?' *Art Digest*, vol. 27, no. 20, September 1953, pp. 13, 27.

462 'The Painter and the Audience,' *Perspectives U.S.A.*, no. 9, Autumn 1954, pp. 107–12. (Contribution to the symposium: 'The Creative Artist and His Audience'; excerpt, *bibl.* 994.)

463 [Letter to the editor], *Arts*, vol. 30, no. 7, April 1956, p. 8.

464 [On Tomlin], in *Bradley Walker Tomlin*, Whitney Museum of American Art, New York, 1957, pp. 11–12.

465 'The Significance of Miró,' *Art News*, vol. 58, no. 3, May 1959, p. 32.

466 [Letter to the editor], *Arts*, vol. 33, no. 8, May 1959, p. 8.

467 'Statement,' *It Is*, no. 3, Winter–Spring, 1959, p. 10.

468 'What Should a Museum Be?' *Art in America*, vol. 49, no. 2, 1961, pp. 32–35 illus. (Reprinted in *bibl.* 503.)

469 [Statement], in 'Something for All,' *Newsweek*, 31 July 1961, pp. 80–81 illus. (On Provincetown.)

470 [Statement] in Gay Talese, 'Yankee Stadium: Night of Idolatry,' *New York Times*, 2 September 1961, p. 10.

471 'Painting as Existence,' *Metro*, no. 7, 1962, pp. 94–97 illus. (Interview by David Sylvester, recorded and broadcast over BBC, 22 October 1960.)

472 [Statements] in Florence Berkman,

'Motherwell Opens Art Lecture Series,' *Hartford Times*, 24 March 1962. (Account of and includes long quotations from lecture given at the Burns School Auditorium, Hartford, Conn.)

473 [Letter to the editor], *Art News*, vol. 62, no. 1, March 1963, p. 6. (Reply to *bibl.* 487.)

474 'A Conversation at Lunch' and [Notes on Paintings], 1963, in *bibl.* 508, pp. 10–19. (Excerpt reprinted in *bibl.* 1310.)

475 'The Motherwell Collection,' *Vogue*, 15 January 1964, pp. 88–90, 118 illus.

476 [Statements] in Robert Ostermann, 'Men Who Lead an American Revolution,' *The National Observer* (London), 17 February 1964, p. 18.

477 [Statement] on jacket cover of May Natalie Tabak, *But Not For Love*, New York, Horizon Press, n.d.

See also bibls. 481, 984, 986, 987, 989, 991, 998, 1000, 1001, 1003, 1014 (p. 132), 1108, 1256, 1300.

Articles on Motherwell (alphabetically)

478 ASHTON DORE. 'Robert Motherwell: Passion and Transfiguration,' *Studio*, vol. 167, no. 851, March 1964, pp. 100–05 illus.

479 BIRD, PAUL. 'Motherwell: A Profile,' *Art Digest*, vol. 26, no. 1, 1 October 1951, pp. 6, 23.

480 COOK, JIM. 'An Incident in Manhattan,' *New York Post*, 9 April 1956. (2 pp. on false arrest for murder.)

481 'The Deepest Identity,' *Newsweek*, 10 December 1962, p. 94 illus. (Includes statement by the artist.)

482 FITZSIMMONS, JAMES. [Motherwell] in catalogue of *Robert Motherwell School of Fine Arts*, n.d., pp. 19–22 illus.

483 FITZSIMMONS, JAMES. 'Artists Put Faith in New Ecclesiastic Art,' *Art Digest*, vol. 26, no. 2, 15 October 1951, pp. 15, 23.

484 KEES, WELDON. 'A Pastiche for Eve,' *bibl.* 1007, pp. 45–47. (Poem on Motherwell painting.)

485 MOORE, MARIANNE. [Statement] in *Robert Motherwell: Collages 1943–1949*, Sidney Janis Gallery, New York, 1949.

179

486 MORITZ, CHARLES, ed. *Current Biography Yearbook*, New York, H. W. Wilson, 1962, pp. 308–10 illus.

487 VICENTE, ESTEBAN. [Letter to the editor], *Art News*, vol. 61, no. 10, February 1963, p. 6. (Concerning Motherwell and the Spanish Revolution.)

488 WEITZ, MORRIS. *Philosophy of the Arts*, New York, Russell and Russell, 1964, pp. 88–92. (Discussion of Motherwell's *The Spanish Prison*.)

Exhibition Catalogues and Reviews (chronologically)

489 STROUP, JAN. '. . . For Motherwell,' *Town and Country*, January 1946.

490 COATES, ROBERT. 'Art Galleries,' *New Yorker*, 12 January 1946.

491 GREENBERG, CLEMENT. 'Art,' *Nation*, 26 January 1946.

492 SWEENEY, JAMES JOHNSON. *Robert Motherwell*, Arts Club of Chicago, 7–27 February 1946, p. 2.

493 GREENBERG, CLEMENT. 'Art,' *Nation*, 29 May 1948.

494 FAISON, S. LANE, JR. 'Art,' *Nation*, 19 April 1952; 18 April 1953.

495 GOOSSEN, EUGENE C. *Robert Motherwell First Retrospective Exhibition*, Bennington College, 24 April–23 May 1959, pp. 1–3.

496 *Recent Paintings and Collages by Robert Motherwell*, Sidney Janis Gallery, New York, 10 April–6 May 1961, 20-p. cat. illus.

497 PORTER, FAIRFIELD, 'Art,' *Nation*, 29 April 1961.

498 ERIGERIO, SIMONE. 'Motherwell,' *Aujourd'hui*, no. 33, October 1961, p. 30.

499 HUNTER, SAM. *Motherwell: Collages 1958–60*, Berggruen, Paris, 1961, 2 pp. plus 24 plates.

500 O'HARA, FRANK. 'Robert Motherwell,' in *Estados Unidos, VI Bienal do museu de arte moderna*, São Paulo, 1961, pp. 4–11 illus. (Text in Portuguese and English.)

501 HUNTER, SAM. *Collages di Motherwell*, Galleria Odyssia, Rome, January 1962, pp. 2, 7 (*bibl.* 499).

502 BOATTO, ALBERTO. 'Motherwell,' *Le Arti*, February 1962.

503 *Robert Motherwell: A Retrospective Exhibition*, Pasadena Art Museum, 18 February–11 March 1962; texts by Thomas W. Leavitt, Frank O'Hara (*bibl.* 500), Sam Hunter (*bibl.* 499), Barbara Guest (a poem), and the artist (reprint of *bibl.* 468), 28-p. cat. illus.

504 LANGSNER, JULES. 'Los Angeles Letter,' *Art International*, vol. 6, no. 3, April 1962, p. 64 illus.

505 SECUNDA, ARTHUR. 'Motherwell,' *Artforum*, vol. 1, no. 1, June 1962, pp. 6–7 illus.

506 LANGSNER, JULES. 'Painting and Sculpture, The Los Angeles Season,' *Craft Horizons*, vol. 22, no. 4, July 1962, p. 41.

507 *New Paintings by Robert Motherwell*, Sidney Janis Gallery, New York, 4–29 December 1962, 20-p. cat. illus.

508 *Robert Motherwell*, Smith College Museum of Art, Northampton, Mass., 10–28 January 1963, 30-p. cat. illus.; texts by Motherwell, pp. 10–19; bibliography 22–27.

509 EDGAR, NATALIE. 'Motherwell,' *Art News*, vol. 61, no. 9, January 1963, p. 10 illus.

510 FRIED, MICHAEL. 'New York Letter,' *Art International*, vol. 7, no. 1, January 1963, pp. 68–69 illus.

511 TILLIM, SIDNEY. 'Month in Review,' *Arts*, vol. 37, no. 4, January 1963, pp. 40–42 illus.

512 ASHTON, DORE. 'Art: Robert Motherwell,' *Arts and Architecture*, vol. 80, no. 2, February 1963, p. 8 illus.

513 ASHTON, DORE. 'Motherwell Loves and Believes,' *Studio*, vol. 165, no. 839, March 1963, pp. 116–17 illus.

514 SANDLER, IRVING H. 'New York Letter,' *Quadrum*, no. 14, 1963, pp. 115–24 illus.

515 'A Portfolio of Recent Paintings,' *Arts Yearbook*, no. 7, 1964, p. 62 illus.

See also bibls. 1026, 1032, 1066, 1148, 1168, 1220, 1228, 1234, 1241, 1303, 1310, 1311.

Recent Writings 1965–69 (chronologically)

516 *Collages by Robert Motherwell*, The Philips

Collection, Washington DC, 2 January–15 February 1965, 12-p. cat.; text by Sam Hunter translated from Berggruen, Heinz Galerie, *Robert Motherwell Collages*, Paris, Berggruen, 1962.

517 *Robert Motherwell*, Museum of Modern Art, New York, 30 September–28 November 1965; introduction by Frank O'Hara, pp. 8–30; selections from the writings of Motherwell edited by William Berkson; chronology and bibliography; 96-p. cat. illus.

518 'An Interview with Robert Motherwell,' *Artforum*, vol. 4, no. 1, September 1965, pp. 33–37.

519 EDGAR, NATALIE. 'Satisfactions of Robert Motherwell,' *Art News*, vol. 64, no. 6, October 1965, pp. 38–41, 65–66 illus.

520 O'HARA, FRANK. 'Grand Manner of Motherwell,' *Vogue*, vol. 146, October 1965, pp. 206–09 illus.

521 'Lochinvar's Return,' *Time*, vol. 86, 8 October 1965, pp. 84–85.

522 'What a Gesture! Exhibition at New York's Museum of Modern Art,' *Newsweek*, vol. 66, 11 October 1965, pp. 98–99.

523 KOZLOFF, MAX. 'Motherwell Exhibition at Museum of Modern Art,' *Nation*, vol. 201, 18 October 1965, pp. 256–58.

524 TILLIM, SIDNEY. 'Motherwell, the Echo of Protest,' *Artforum*, vol. 4, no. 4, December 1965, pp. 34–36 illus.

525 LIPPARD, LUCY R. 'New York Letter: Miró and Motherwell,' *Art International*, vol. 9, nos. 9–10, 20 December 1965, pp. 33–35, illus. p. 39.

526 BARO, GENE. 'The Ethics of Risk,' *Arts Magazine*, vol. 40, no. 3, January 1966, pp. 36–41 illus.

527 *Robert Motherwell*, Amsterdam Stedelijk Museum, 8 January–20 February 1966, 50-p. cat. illus.; introduction by Frank O'Hara; chronology.

528 ARNASON, H.H. 'On Robert Motherwell and His Early Work,' *Art International*, vol. 10, no. 1, 20 January 1966, pp. 17–35 illus.

529 ARNASON, H.H. 'Robert Motherwell: 1948–1965,' *Art International*, vol. 10, no. 4, 20 April 1966, pp. 19–45 illus.

530 ROBERTSON, BRYAN. 'From a Notebook on Robert Motherwell,' *Studio International*, vol. 171, no. 875, March 1966, pp. 89–93 illus.

531 LYNTON, NORBERT. 'London Letter,' *Art International*, vol. 10, no. 5, 20 May 1966, pp. 52–53 illus.

532 MOTHERWELL, ROBERT. 'David Smith: A Major American Sculptor; a Personal Appreciation,' *Studio International*, vol. 172, no. 880, August 1966, pp. 65–68.

533 ROSE, BARBARA AND IRVING SANDLER. 'Sensibility of the Sixties,' *Art in America*, vol. 55, no. 1, January–February 1967, pp. 44–57 illus.; interviews with artists including Motherwell p. 47 illus.

534 *Robert Motherwell, 'Open' Series 1967–1969*, Marlborough-Gerson Gallery, New York, May–June 1969, 30-p. cat. illus.

535 KRAUSS, ROSALIND. 'Robert Motherwell's New Paintings,' *Artforum*, vol. 7, no. 9, May 1969, pp. 26–28 illus.

536 SIMON, RITA. 'Robert Motherwell,' *Arts Magazine*, vol. 43, no. 8, Summer 1969, pp. 34–35 illus.

Barnett Newman

By Newman (chronologically)

537 [Letter to the editor], *New York Times*, 13 June 1943, sec. 2, p. 9. (Signed by Gottlieb and Rothko, but Newman also collaborated.)

538 ADOLPH GOTTLIEB. Wakefield Gallery, New York, 7–19 February 1944, pp. 2–3.

539 'La Pintura de Tamayo y Gottlieb,' *La Revista Belga*, vol. 2, no. 4, April 1945, pp. 16–25 illus. (In Spanish.)

540 *Northwest Coast Indian Painting*, Betty Parsons Gallery, New York, 30 September–19 October 1946, p. 2.

541 *The Ideographic Picture*, Betty Parsons Gallery, New York, 20 January–8 February 1947, pp. 2–3. (Excerpts reprinted in *bibls.* 736, 1050, 1095.)

542 *Stamos*, Betty Parsons Gallery, New York, 10 February–1 March 1947, p. 2.

543 'The First Man Was an Artist,' *Tiger's Eye*, vol. 1, no. 1, October 1947, pp. 57–60. (Reprinted *bibl.* 1310, pp. 94–95.)

544 [Statement], in 'The Ides of Art,' *Tiger's Eye*, vol. 1, no. 2, December 1947, p. 43.

545 'Introduction,' *Herbert Ferber*, Betty Parsons Gallery, New York, December 1947.

546 'The Object and the Image,' *Tiger's Eye*, vol. 1, no. 3, March 1948, p. 111.

547 'The Sublime is Now,' *Tiger's Eye*, vol. 1, no. 6, 15 December 1948, pp. 51–53.

548 [Opinion] in 'To Be or Not/ 6 Opinions on Trigant Burrow's *The Neurosis of Man*,' *Tiger's Eye*, vol. 1, no. 9, October 1949, pp. 122–26.

549 [Statement], typescript at Betty Parsons Gallery, New York, dated January 1950, 1 p.

550 'Too Many Words – Rebuttal,' *Art Digest*, vol. 24, no. 12, 15 March 1950, p. 5. (In reply to Peyton Boswell's 'Too Many Words,' *Art Digest*, vol. 24, no. 10, 15 February 1950, p. 5, concerning a *New York Times* review of Newman's work.)

551 'Disclaimer,' *Art Digest*, vol. 29, no. 10, 15 February 1954, p. 3. (A letter to the editor.)

552 [Letter to the editor], *Art News*, vol. 58, no. 4, June–August 1959, p. 6. (In reply to *bibl.* 569.)

553 [Letter to the Editor], *Art News*, vol. 60, no. 3, May 1961, p. 6. (In reply to letters to the editor by Erwin Panofsky and Don David in *Art News*, April 1961, p. 6.)

554 'Frontiers of Space,' *Art in America*, vol. 50, no. 2, Summer 1962, pp. 82–87 illus. (Interview with Newman by Dorothy Gees Seckler.)

555 'Embattled Lamb,' *Art News*, vol. 61, no. 5, September 1962, pp. 35, 57–58. (Book review of *bibl.* 1226.)

556 *Amlash Sculpture from Iran*, Betty Parsons Gallery, New York, 23 September–19 October 1963, p. 2.

557 [Statement], in Arthur McKay, 'Emma Lake Artists' Workshop: An Appreciation,' *Canadian Art*, vol. 21, no. 93, September–October 1964, p. 281.

See also bibls. 987, 989, 994, 1001.

Articles on Newman (alphabetically)

558 ALLOWAY, LAWRENCE, 'The Paintings of Barnett Newman,' 1964. (Forthcoming in *Art International*; to include statements by the artist.)

559 ASHTON, DORE. 'Art,' *Arts and Architecture*, vol. 76, no. 5, May 1959, pp. 6–7.

560 GOOSSEN, EUGENE C. 'The Philosophic Line of Barnett Newman,' *Art News*, vol. 57, no. 4, Summer 1958, pp. 30–31, 62–63 illus.

561 ROSENBERG, HAROLD. 'Barnett Newman: Man of Controversy and Spiritual Grandeur,' *Vogue*, 1 February 1963, pp. 134–35, 163, 166 illus.

Exhibition Catalogues and Reviews (chronologically)

562 REED, JUDITH KAYE. 'Newman's Flat Areas,' *Art Digest*, vol. 24, no. 9, 1 February 1950, p. 16.

563 LOUCHHEIM, ALINE. 'Extreme Modernists,' *New York Times*, 9 January 1950, sect. II, p. 9, col. 5.

564 HESS, THOMAS B. 'Newman,' *Art News*, vol. 49, no. 1, March 1950, p. 48.

565 KRASNE, BELLE. 'The Bar Vertical on Fields Horizontal,' *Art Digest*, vol. 25, no. 15, 1 May 1951, p. 16.

566 HESS, THOMAS B. 'Newman,' *Art News*, vol. 50, no. 4, Summer 1951, p. 47.

567 GREENBERG, CLEMENT. *Barnett Newman: First Retrospective Exhibition*, Bennington College, 4–24 May 1958, pp. 1–2; also 'Catalogue Note' by E. C. Goossen, p. 3.

568 GREENBERG, CLEMENT. *Barnett Newman: A Selection 1946–1952*, French and

Company, New York, 11 March–4 April 1959, pp. 3–4. (Reprinted from *bibl.* 567; also poem by Howard Nemerov, p. 2.)

569 CREHAN, HUBERT. 'Barnett Newman,' *Art News*, vol. 58, no. 2, April 1959, p. 12 illus. (See *bibl.* 552 for Newman's reaction to this review.)

570 KRAMER, HILTON. 'Month in Review,' *Arts*, vol. 33, no. 7, April 1959, p. 45.

571 SCHWARTZ, MARVIN D. 'Newman at French and Co.,' *Apollo*, vol. 69, no. 410, April 1959, p. 124.

572 PRESTON, STUART. 'New York,' *Burlington Magazine*, vol. 101, no. 674, May 1959, p. 200.

573 SAWIN, MARTICA. 'New York Letter,' *Art International*, vol. 3, nos. 5–6, 1959, p. 48 illus.

574 STONE, ALLAN. *De Kooning – Newman*, Allan Stone Gallery, New York, 23 October–17 November 1962, p. 16 illus. (For reviews of this exhibition see *bibls.* 104–107.)

See also *bibls.* 1066, 1082, 1092, 1095, 1241, 1310, 1311.

Recent Writings 1965–69 (chronologically)

575 ALLOWAY, LAWRENCE. 'Barnett Newman,' *Artforum*, vol. 3, no. 9, June 1965, pp. 20–22 illus.

576 BARO, GENE. 'London Letter,' *Art International*, vol. 9, no. 5, June 1965, p. 67.

577 NEWMAN, BARNETT. 'New York School Question,' *Art News*, vol. 64, no. 5, September 1965, pp. 38–41 illus. Reply by Mrs Clyfford Still with rejoinder, *Art News*, vol. 64, no. 7, November 1965, p. 6.

578 HOPPS, WALTER. 'United States Exhibit, São Paulo Bienal,' *Art in America*, vol. 53, no. 5, October–November 1965, p. 82.

579 BAKER, ELIZABETH C. 'Brazilian Bouillabaisse,' *Art News*, vol. 64, no. 8, December 1965, p. 30.

580 KRAMER, HILTON. 'U.S. Art from São Paulo on View in Washington,' *New York Times*, 29 January 1966, p. 22.

581 KOZLOFF, MAX. 'São Paulo in Washington,' *Nation*, vol. 202, 28 February 1966, p. 250.

582 *Barnett Newman: the Stations of the Cross*, The Solomon R. Guggenheim Museum, New York, April–May 1966, 39 p. cat. illus.; text by Lawrence Alloway; statement by Newman, p. 9; bibliography, pp. 34–38.

583 LIPPARD, LUCY R. 'New York Letter: Off Color,' *Art International*, vol. 10, no. 4, 20 April 1966, p. 74 illus.

584 'Of a Different Stripe,' *Time*, vol. 87, 29 April 1966, p. 82.

585 NEWMAN, BARNETT. 'Fourteen Stations of the Cross, 1958–1966,' *Art News*, vol. 65, no. 3, 1966, pp. 26–28.

586 KOZLOFF, MAX. 'Guggenheim Museum Show,' *Nation*, vol. 202, 16 May 1966, p. 598.

587 ASHTON, DORE. 'Barnett Newman and the Making of Instant Legend,' *Arts and Architecture*, vol. 83, June 1966, pp. 4–5, 34 illus.

588 'USA Artists: Barnett Newman, One of the Founders of Contemporary American Painting,' New York, Channel 13, 12 July 1966.

589 HUDSON, ANDREW. 'Letter from Washington,' *Art International*, vol. 10, no. 6, Summer 1966, pp. 130–31, illus.

590 LIPPARD, LUCY R. 'Barnett Newman,' *Art International*, vol. 10, no. 6, Summer 1966, p. 108, illus. pp. 110–11.

591 CALAS, NICHOLAS. 'Subject Matter in the Work of Barnett Newman,' *Arts Magazine*, vol. 42, no. 2, November 1967, pp. 38–40 illus.

592 NEWMAN, BARNETT. 'For Impassioned Criticism,' *Art News*, vol. 67, no. 4, Summer 1968, pp. 26–27, 58–59. Text based on a paper delivered to Baudelaire Symposium, Paris.

593 HESS, THOMAS B. *Barnett Newman*, New York, Walker and Company, 1969, published in connection with the retrospective at M. Knoedler Gallery, New York, 25 March–19 April 1969, 92 pp. illus.; bibliography pp. 86–91.

594 BAKER, ELIZABETH. 'Barnett Newman in a New Light,' *Art News*, vol. 67, no. 10, February 1969, pp. 38–41, 60–62, 64 illus.

595 NEWMAN, BARNETT. 'Chartres and Jericho,' *Art News*, vol. 68, no. 2, April 1969, pp. 28–29 illus. and cover.

596 ALLOWAY, LAWRENCE. 'Barnett Newman: Some Notes on His Work,' *Art International*, vol. 13, no. 6, Summer 1969, pp. 35–39 illus.

597 SCHJELDAHL, PETER. 'New York Letter,' *Art International*, vol. 13, no. 6, Summer 1969, p. 65 illus.

Jackson Pollock

By Pollock (chronologically)

598 'Jackson Pollock' [Answers to a questionnaire], *Arts and Architecture*, vol. 61, no. 2, February 1944, p. 14. (Excerpts reprinted often; see *bibls*. 611, 626, 653, 722, 736, 744, 986, etc.)

599 'My Painting,' *Possibilities*, vol. 1, no. 1, Winter 1947–48, pp. 78–83 illus. (Excerpts reprinted often; see *bibls*. 611, 626, 653, 744, 994, 1003. German translation in *Du*, no. 236, October 1960, pp. 12–13 illus.)

600 'Unframed Space,' *New Yorker* vol. 26, no. 24, 5 August 1950, p. 16. (Brief interview with Pollock in Springs, L.I.)

601 [Statements from narration by the artist for the film *Jackson Pollock* by Hans Namuth and Paul Falkenberg, 1951]; excerpt reprinted in *bibl*. 653.

602 HIRSCH, OLIVIA. 'College Notes: Pollock, Greenberg and Tannenbaum,' *Evening Banner* (Bennington, Vt.), 20 November 1952. (Includes brief statements by the artist.)

See also *bibls*. 615, 984, 986, 987, 999, 1003, 1014 (p. 153), 1256, 1300.

Books and Articles on Pollock (alphabetically)

603 ALLOWAY, LAWRENCE. 'The Art of Jackson Pollock: 1912–1956,' *The Listener*, vol. 60, no. 1548, 27 November 1958, p. 888 illus.

604 ALLOWAY, LAWRENCE. 'Notes on Pollock,' *Art International*, vol. 5, no. 4, May 1961, pp. 38–41, 90 illus.

605 ASHTON, DORE. 'Pollock: le nouvel espace,' *XXe siècle*, no. 17, December 1961, pp. 75–80 illus.

606 BERGER, JOHN. 'The White Cell,' *New Statesman*, vol. 56, no. 1445, 22 November 1958, pp. 722–23.

607 CALVESI, MAURIZIO. 'Genio di Pollock,' *I 4 Soli*, vol. 5, no. 2, March–April 1958, pp. 19–21 illus.

608 CANDEE, MARJORIE DENT, ed. *Current Biography Yearbook*, New York, H. W. Wilson, 1956, pp. 496–98 illus.

609 'The Champ,' *Time*, vol. 61, no. 25, 19 December 1955, pp. 64, 66 illus.

610 CHOAY, FRANÇOISE. 'Jackson Pollock,' *L'Oeil*, no. 43/44, July–August 1958, pp. 42–45, 83 illus.

611 CRISPOLTI, E. 'Appunti su Jackson Pollock,' *I 4 Soli*, vol. 4, no. 1, January–February 1957, pp. 8–10. (Excerpts from *bibls*. 598, 599, p. 11.)

612 DREXLER, ARTHUR. 'Unframed Space: A Museum for Jackson Pollack's [*sic*] Paintings,' *Interiors*, vol. 110, no. 6, January 1950, p. 90 illus.

613 FRAMPTON, KENNETH. 'Jackson Pollock,' *Arts Review*, vol. 13, no. 10, 3–17 June 1961, p. 2. (Also review of *bibl*. 653.)

614 FRIEDMAN, B. H. 'Profile: Jackson Pollock,' *Art in America*, vol. 43, no. 4, December 1955, pp. 49, 58–59 illus.

615 GOODNOUGH, ROBERT. 'Pollock Paints a Picture,' *Art News*, vol. 50, no. 3, May 1951, pp. 38–41, 60–61 illus. (Includes brief statements by the artist.)

616 GREENBERG, CLEMENT. 'Jackson Pollock,' *Evergreen Review*, vol. 1, no. 3, 1957, pp. 95–100 illus. (Portrait on cover.)

617 GREENBERG, CLEMENT. 'The Jackson Pollock Market Soars,' *New York Times Magazine*, 16 April 1961, pp. 42–43, 132, 135 illus. (30 April 1961 issue, p. 6, contains letters to the editor concerning this article.)

618 GREENBERG, CLEMENT. 'Jackson Pollock's New Style,' *Harper's Bazaar*, vol. 85, no. 2883, February 1952, pp. 174–75 illus.

619 GREENBERG, CLEMENT. [Reviews of Pollock exhibitions in his 'Art' column], *Nation*, 27 November 1943; 7 April 1945; 13 April 1946; 28 December 1946; 1 February 1947; 24 January 1948.

620 GUÉGUEN, PIERRE. 'Pollock et la nouvelle peinture américaine,' *Aujourd'hui*, no. 21, March–April 1959, pp. 30–33 illus.

621 HALL, DOUGLAS. 'Recent Acquisitions of the Scottish National Gallery of Modern Art: II,' *Scottish Art Review*, vol. 9, no. 3, 1964, p. 10 illus.

622 HESS, THOMAS B. 'Jackson Pollock 1912–1956,' *Art News*, vol. 55, no. 5, September 1956, pp. 44–45, 57.

623 HESS, THOMAS B. 'Pollock: the Art of a Myth,' *Art News*, vol. 62, no. 9, January 1964, pp. 39–41, 62–65 illus. (February 1964 issue, p. 6; letter on article from Rosalind Browne.)

624 HULTÉN, K. G. 'Den Moderna Konsten: Pollock och Mondrian,' *Dagens Nyheter* (Stockholm), 9 September 1958.

625 HULTÉN, K. G. 'En Ny Expressionism: Pollock, Francis, Riopelle,' *Dagens Nyheter* (Stockholm), 1 December 1953.

626 HUNTER, SAM. *Jackson Pollock, Museum of Modern Art Bulletin*, vol. 24, no. 2, 1956–57, pp. 5–12. (36-p. exhibition catalogue, contains chronology, selected bibliography, plates, reprinted statements, from *bibls.* 598, 599; see also *bibl.* 722.)

627 HUNTER, SAM. 'Contributi alla conoscenza dell'opera di Jackson Pollock,' *I 4 Soli*, vol. 4, no. 1, January–February 1957, pp. 3–7 illus. (From *bibl.* 626.)

628 HUNTER, SAM. 'Jackson Pollock: The Maze and the Minotaur,' *New World Writing*, New York. Ninth Mentor Selection, New American Library of World Literature, 1956, pp. 174–92 illus.

629 IMBOURG, PIERRE. 'Avez-vous vu Pollock?' *Journal de l'amateur de l'art*, 25 January 1959.

630 'Jackson Pollock's Abstractions,' *Vogue*, 1 March 1951, pp. 159–62. (Fashions photographed by Cecil Beaton against Pollock paintings.)

631 JONES, THOMAS H. 'The Art of Jackson Pollock,' unpublished typescript at Betty Parsons Gallery, New York, 1949, 1 p.

632 KAPROW, ALLAN. 'The Legacy of Jackson Pollock,' *Art News*, vol. 57, no. 6, October 1958, pp. 24–26, 55–57, illus. (Letter from Irving H. Sandler concerning this article in December 1958 issue, p. 6; reply by Kaprow, February 1959, p. 6.)

633 KARP, IVAN C. 'In Memoriam: The Ecstasy and Tragedy of Jackson Pollock, Artist,' *The Village Voice*, 26 September 1956, pp. 8, 12 illus.

634 KOZLOFF, MAX. 'Art: Pollock,' *Nation*, vol. 198, no. 7, 10 February 1964, pp. 151–52.

635 KRAMER, HILTON. 'Jackson Pollock and Nicolas de Staël: Two Painters and Their Myths,' *Arts Yearbook*, no. 3, 1959, pp. 52–60 illus.

636 LAMBERT, JEAN-CLARENCE. 'Observations sur Jackson Pollock et la nouvelle peinture américaine,' *Cahiers du musée de poche*, no. 2, June 1959, pp. 108–12 illus.

637 LAVIN, IRVING. 'Abstraction in Modern Painting: a Comparison' [between paintings by Pollock and Joseph Stella], *Metropolitan Museum of Art Bulletin*, vol. 19, no. 6, February 1961, pp. 166–71 illus.

638 McCLURE, MIKE. 'Ode to Jackson Pollock,' *Evergreen Review*, vol. 2, no. 6, Autumn 1958, pp. 124–26.

639 MARCHIORI, GIUSEPPE. 'Jackson Pollock,' *Notiziario*, no. 5, April 1958, pp. 6–8 illus.

640 MARCHIORI, GIUSEPPE. 'Pollock,' *XXe siècle*, no. 8, January 1957, p. 86.

641 MENNA, FILIBERTO. 'L'Atrattismo romanticó di Jackson Pollock,' *Commentari*, vol. 9, no. 3, July–September 1958, pp. 206–15, plates 76–78.

642 MIDDLETON, MICHAEL. 'Pollock,' *Motif*, no. 2, February 1959, pp. 80–81 illus.

643 NAMUTH, HANS. 'Jackson Pollock,' *Portfolio: The Annual of the Graphic Arts*, 1951,

6 pp. illus. (Photographs by Namuth, text anonymous.)

644 NUGENT, JOSEPH F. 'Some Thoughts on Pollock,' *The New Bulletin* (Staten Island Institute of Arts and Sciences), vol. 11, no. 8, April 1962, pp. 94–95 illus.

645 O'CONNOR, FRANCIS V. 'The Life and Stylistic Development of Jackson Pollock.' [Dissertation in progress for Johns Hopkins University.]

646 O'HARA, FRANK. *Jackson Pollock*, New York, George Braziller, 1959, 'The Great American Artists' series, pp. 11–32 plus plates. (Selected bibliography, pp. 119–20; chronology, pp. 113–17.)

647 O'HARA, FRANK. 'Jackson Pollock,' in Peter Selz, ed., *New Images of Man*, Museum of Modern Art, New York, 1959, pp. 123–28 illus.

648 PIERRE, JOSÉ. 'Surrealism, Jackson Pollock and Lyric Abstraction,' in *The Surrealist Intrusion into the Enchanters' Domain*, D'Arcy Galleries, New York, May 1960, pp. 30–35 illus.

649 PLATSCHEK, HANS. 'Der Fall Pollock,' *Baukunst und Werkform*, vol. 13, no. 1, January 1960, pp. 43–44 illus. (From the book *Neue Figurationen*, Munich, Piper.)

650 'Posh Pollock,' *Time*, vol. 72, no. 24, 15 December 1958, p. 58.

651 'Rebel Artist's Tragic Ending,' *Life*, vol. 41, no. 9, 27 August 1956, p. 58 illus.

652 RESTANY, PIERRE. 'L'Art aux Etats-Unis: Jackson Pollock l'éclabousseur,' *Prisme des arts*, no. 15, 1957, p. 19 illus.

653 ROBERTSON, BRYAN. *Jackson Pollock*, New York, Harry N. Abrams, 1960, 215 pp. illus. ('Statements by Jackson Pollock,' pp. 193–94, reprints from *bibls.* 598, 599, 601; 'select bibliography,' pp. 195–96; reviewed *bibls.* 613, 654.)

654 ROSENBERG, HAROLD. 'The Search for Jackson Pollock,' *Art News*, vol. 59, no. 10, February 1961, pp. 35, 58–60. (Based on a review of *bibl.* 653.)

655 RUBIN, WILLIAM. 'Notes on Masson and Pollock,' *Arts*, vol. 34, no. 2, November 1959, pp. 36–43 illus.

656 SAWYER, KENNETH B. 'Jackson Pollock: 1912–1956,' *Cimaise*, series 4, no. 2, November–December 1956, pp. 22–23 illus. (English translation p. 10.)

657 SAWYER, KENNETH B. 'Jackson Pollock was unique,' *Baltimore Sun*, 19 August 1956.

658 SCHOENENBERGER, GUALTIERO. 'Jackson Pollock,' *Art International*, vol. 5, no. 10, December 1961, pp. 49–50 illus.

659 SEIXAS, FRANK A. 'Jackson Pollock: an Appreciation,' *Art Gallery*, vol. 7, no. 1, October 1963, pp. 11–13, 23 illus.

660 SIEGEL, ELI. 'Beauty – And Jackson Pollock, Too,' unpublished typescript at Betty Parsons Gallery, New York, 1955, 2 pp.

661 SMITH, RICHARD. 'Jackson Pollock 1912–1956,' *Art News and Review*, vol. 10, no. 22, 22 November 1958, p. 5 illus.

662 THARRATS, JOAN JOSEP. 'Artistas de hoy: Jackson Pollock,' *Revista* (Barcelona), 2 February 1957.

663 TILLIM, SIDNEY. 'Jackson Pollock: A Critical Evaluation,' *College Art Journal*, vol. 16, no. 3, Spring 1957, pp. 242–43.

664 TYLER, PARKER. 'Hopper and Pollock: The Loneliness of the Crowd and the Loneliness of the Universe: an Antiphonal,' *Art News Annual*, no. 26, 1957, pp. 86–107 illus.

665 TYLER, PARKER. 'Jackson Pollock: The Infinite Labyrinth,' *Magazine of Art*, vol. 43, no. 3, March 1950, pp. 92–93 illus.

666 WASHBURN, GORDON BAILEY. 'Three Gifts to the Gallery,' *Carnegie Magazine*, vol. 27, no. 10, December 1953, pp. 337–38 illus.

667 WILLING, VICTOR. 'Thoughts After a Car Crash,' *Encounter*, vol. 7, no. 4, October 1956, pp. 66–68 illus.

Exhibition Catalogues and Reviews (chronologically)

See also bibls. 619, 626.

668 'Young Man From Wyoming,' *Art Digest*, vol. 18, no. 3, 1 November 1943, p. 10.

669 SWEENEY, JAMES JOHNSON. *Jackson Pollock*, Art of This Century Gallery, New York, 9–27 November 1943, p. 3. (Reprinted in *Pollock*, Arts Club of Chicago, 5–31 March 1945, p. 2; *It Is*, no. 4, Autumn 1959, p. 56.)

670 RILEY, MAUDE. 'Explosive First Show,'

Art Digest, vol. 18, no. 4, 15 November 1943, p. 18.

671 'The Passing Shows,' *Art News*, vol. 43, no. 13, 15–30 November 1943, p. 23.

672 RILEY, MAUDE. 'Jackson Pollock,' *Art Digest*, vol. 19, no. 13, 1 April 1945, p. 59.

673 'The Passing Shows,' *Art News*, vol. 44, no. 4, 1–14 April 1945, p. 6.

674 FARBER, MANNY. 'Jackson Pollock,' *New Republic*, vol. 112, no. 26, 25 June 1945, pp. 871–72.

675 WOLF, BEN. 'By the Shores of Virtuosity,' *Art Digest*, vol. 20, no. 14, 15 April 1946, p. 16.

676 'Pollock,' *Art News*, vol. 45, no. 3, May 1946, p. 63 illus.

677 DAVIS, N. M. *Jackson Pollock*, Art of This Century Gallery, New York, 14 January–1 February 1947, p. 4.

678 WOLF, BEN. 'Non-Objectives by Pollock,' *Art Digest*, vol. 21, no. 8, 15 January 1947, p. 21.

679 'Pollock,' *Art News*, vol. 45, no. 12, February 1947, p. 45.

680 LANSFORD, ALONZO. 'Automatic Pollock,' *Art Digest*, vol. 22, no. 8, 15 January 1948, p. 19.

681 COATES, ROBERT M. 'Edward Hopper and Jackson Pollock,' *New Yorker*, vol. 23, no. 48, 17 January 1948, p. 57.

682 'Pollock,' *Art News*, vol. 46, no. 12, February 1948, pp. 58–59.

683 LOWENGRUND, MARGARET. 'Pollock Hieroglyphics,' *Art Digest*, vol. 23, no. 9, 1 February 1949, pp. 19–20.

684 DE KOONING, ELAINE. 'Jackson Pollack [sic],' *Art News*, vol. 48, no. 1, March 1949, p. 44.

685 'Jackson Pollock: Is He the Greatest Living Painter in the United States?,' *Life*, vol. 27, no. 6, 8 August 1949, pp. 42–43, 45 illus.

686 ROBINSON, AMY. 'Pollock,' *Art News*, vol. 48, no. 8, December 1949, p. 43.

687 ALFIERI, BRUNO. 'Guazzabugli di Jackson Pollock,' in *Jackson Pollock*, Le Tre Mani, Venice, 22 July–12 August 1950, pp. 3–6 illus. (Also brief text by Peggy Guggenheim, p. 2.)

688 *Jackson Pollock*, Galleria d'arte del Naviglio, Milan, 21 October 1950. (Biography.)

689 GOODNOUGH, ROBERT. 'Pollock,' *Art News*, vol. 49, no. 8, December 1950, p. 47 illus.

690 KRASNE, BELLE. 'Pollock,' *Art Digest*, vol. 25, no. 5, 1 December 1950, p. 16.

691 COATES, ROBERT M. 'Extremists,' *New Yorker*, vol. 26, no. 42, 9 December 1950, pp. 109–11.

692 OSSORIO, ALFONSO. *Jackson Pollock*, Betty Parsons Gallery, New York, 1951, pp. 3–4 plus plates (Reprinted bibls. 990, 994; translated *bibl.* 696.)

693 PORTER, FAIRFIELD. 'Pollock,' *Art News*, vol. 50, no. 8, December 1951, p. 48 illus.

694 FITZSIMMONS, JAMES. 'Pollock,' *Art Digest*, vol. 26, no. 6, 15 December 1951, p. 19 illus.

695 'Words,' *Time*, vol. 53, no. 6, 7 February 1952, p. 51 illus.

696 TAPIÉ, MICHEL. 'Jackson Pollock avec nous,' in *Jackson Pollock*, Paris, Paul Facchetti, March 1952, pp. 2, 4–5 illus. (Also translation of *bibl.* 692, pp. 7, 9.)

697 FITZSIMMONS, JAMES. 'Pollock,' *Art Digest*, vol. 27, no. 4, 15 November 1952, p. 17.

698 GREENBERG, CLEMENT. *Jackson Pollock*, Bennington College, 17–30 November 1952, p. 2.

699 COATES, ROBERT. 'From Ingres to Pollock, Direct,' *New Yorker*, 22 November 1952.

700 GOODNOUGH, ROBERT. 'Pollock,' *Art News*, vol. 51, no. 8, December 1952, pp. 42–43 illus.

701 FAISON, S. LANE, JR. 'Art,' *Nation*, 13 December 1952, p. 564.

702 EDWARDS, FOLKE. 'Made in U.S.A.?' *Paletten* (Stockholm), vol. 14, no. 4, 1953, p. 111–15 illus.

703 LINDWALL, BO. '12 Amerikanska målare och skulptorer på Liljevalch,' *Konstrevy* (Stockholm), vol. 30, no. 1, 1954, pp. 11–21 illus. (Also on Gorky.)

704 CREHAN, HUBERT. 'Pollock: A Janus-headed Show,' *Art Digest*, vol. 29, no. 10, 15 February 1954, pp. 15, 32 illus.

705 COATES, ROBERT. 'American and International,' *New Yorker*, 20 February 1954.

706 FAISON, S. LANE, JR. 'Art,' *Nation*, vol. 178, no. 8, 20 February 1954, pp. 154, 156.

707 FITZSIMMONS, JAMES. 'Art,' *Arts and Architecture*, vol. 71, no. 3, March 1954, pp. 7, 30 illus.

708 HESS, THOMAS B. 'Pollock,' *Art News*, vol. 53, no. 1, March 1954, pp. 40–41 illus.

709 *Fifteen Years of Jackson Pollock*, Sidney Janis Gallery, New York, 28 November–31 December 1955, 16 pp. illus. (Biography.)

710 STEINBERG, LEO. 'Month in Review . . . Fifteen Years of Jackson Pollock,' *Arts*, vol. 30, no. 3, December 1955, pp. 43–44, 46 illus.

711 TYLER, PARKER. 'Pollock,' *Art News*, vol. 54, no. 8, December 1955, p. 53 illus.

712 COATES, ROBERT M. 'Opposites,' *New Yorker*, vol. 32, no. 45, 29 December 1956, pp. 48–49.

713 HUNTER, SAM. *Pollock, IV Bienal do museu de arte moderna de São Paulo*, 1957, 36-p. cat. illus. (Text from *bibl.* 626) in English and Portuguese; same exhibition, organized by the Museum of Modern Art, New York, circulated in Europe with translations of Hunter text; see *bibl.* 722.

714 HESS, THOMAS B. 'Pollock,' *Art News*, vol. 55, no. 10, February 1957, pp. 8–9.

715 HOFFMAN, EDITH. 'New York,' *Burlington Magazine*, vol. 99, no. 647, p. 68.

716 KRAMER, HILTON. 'The Month in Review: Pollock,' *Arts*, vol. 31, no. 5, February 1957, pp. 46–48 illus.

717 ASHTON, DORE, 'Art,' *Arts and Architecture*, vol. 74, no. 3, March 1957, pp. 8, 10, 38 illus.

718 'Estados Unidos: Sala Jackson Pollock,' *Habitat* (São Paulo), no. 44, September 1957, pp. 43–44 illus.

719 COATES, ROBERT. 'Worldwide,' *New Yorker*, 16 November 1957.

720 S. G. 'Jackson Pollock Drawings,' *Arts*, vol. 32, no. 3, December 1957, p. 56.

721 SCHUYLER, JAMES. 'Pollock,' *Art News*, vol. 56, no. 8, December 1957, p. 10.

722 HUNTER, SAM. *Jackson Pollock 1912–1956*, Kunstalle, Basel, 19 April–26 May, 1958, 36-p. cat. illus. (Text from *bibl.* 626; also preface by Porter McCray; excerpts from *bibl.* 598.) This catalogue with variations also published for exhibitions at Stedelijk Museum, Amsterdam, 6 June–

7 July 1958; Whitechapel Art Gallery, London, November–December 1958; and combined with New American Painting catalogue at the Musée National d'art moderne, Paris, 16 January–15 February 1959, as 'Jackson Pollock et la nouvelle peinture américaine.'

723 *Jackson Pollock*, Sidney Janis Gallery, New York, 3–29 November 1958, 20-p. cat. illus., brief text p. 1.

724 WALLIS, NEVILE. 'Heroes of the Day,' *The Observer*, 9 November 1958, illus.

725 'The Hero-Figure of Action-Painting,' *The Times* (London), 11 November 1958.

726 SUTTON, DENYS. 'Arts and Entertainment: Jackson Pollock,' *The Financial Times* (London), no. 21,634, 25 November 1958, p. 13.

727 M. C. 'London,' *Burlington Magazine*, vol. 100, no. 669, December 1958, p. 450.

728 MOCK, JEAN YVES. 'Pollock at the Whitechapel,' *Apollo*, vol. 68, no. 406, December 1958, p. 221 illus.

729 SCHUYLER, JAMES. 'Pollock,' *Art News*, vol. 57, no. 8, December 1958, p. 12 illus.

730 TILLIM, SIDNEY. 'Pollock,' *Arts*, vol. 33, no. 3, December 1958, p. 53 illus.

731 ALLOWAY, LAWRENCE. 'London Chronicle,' *Art International*, vol. 2, nos. 9–10, December 1958–January 1959, pp. 33–34 illus. p. 73; also Rubin, William. 'Letter from New York,' pp. 27–28.

732 ASHTON, DORE. 'Art,' *Arts and Architecture*, vol. 76, no. 1, January 1959, p. 6.

733 MELVILLE, ROBERT. 'London . . . Pollock at the Whitechapel,' *Arts*, vol. 33, no. 4, January 1959, p. 16 illus.

734 MELVILLE, ROBERT. 'Exhibitions,' *Architectural Review*, vol. 125, no. 745, February 1959, p. 139 illus.

735 WHITTET, G. S. 'London Commentary,' *Studio*, vol. 157, no. 791, February 1959, p. 58.

736 ALLOWAY, LAWRENCE. 'Introduction' and 'Catalogue Notes,' in *Jackson Pollock*, Marlborough Fine Art Ltd, London, June 1961, pp. 3–8; 64-p. cat. illus.; bibliography. (Includes excerpts from *bibl.* 598.)

737 REICHARDT, JASIA. 'Londres,' *Aujourd'hui*, no. 32, July 1961, p. 56 illus.

738 STRAUSS, MICHEL. 'London,' *Burlington*

Magazine, vol. 103, no. 700, July 1961, p. 327, illus. p. 329.

739 MELVILLE, ROBERT, 'Exhibitions,' *Architectural Review*, vol. 130, no. 774, August 1961, pp. 130–31 illus.

740 CURJEL, HANS. 'Zürich: Jackson Pollock,' *Werk*, vol. 48, no. 12, December 1961, pp. 274, 276 illus.

741 FRIGERIO, SIMONE. 'Zürich: Pollock,' *Aujourd'hui*, no. 34, December 1961, pp. 60–61 illus.

742 ALLOWAY, LAWRENCE. 'Introduzione,' in *Jackson Pollock*, Tonelli arte moderna, Milan, November–December 1962, pp. 3–7; *bibliography*. p. 8; 28–p. cat. illus. (Translation of *bibl.* 736.)

743 'Pollock,' *Domus*, no. 400, March 1963, p. 41 illus.

744 HULTEN, K. G. *Jackson Pollock*, Moderna Museet, Stockholm, February–April 1963, pp. 4–5; 34–p. cat. illus.; translation *bibls.* 598, 599, 601, pp. 6–8.

745 GENAUER, EMILY. 'Jackson Pollock's Endless Search,' *New York Herald Tribune*, Magazine Section, 19 January 1964, p. 29 illus.

746 TILLIM, SIDNEY. 'Month in Review: Pollock,' *Arts*, vol. 38, no. 6, March 1964, pp. 55–59 illus.

747 FRIED, MICHAEL. 'New York Letter,' *Art International*, vol. 8, no. 3, April 1964, pp. 57–58; also Rose, Barbara, 'New York Letter,' p. 52.

748 *American Masters from Eakins to Pollock*, Art Students League, New York, 7 July– 26 August 1964, pp. 42–43 illus.

See also reviews of New American Painting exhibition in Paris, *bibl.* 1281; and *bibls.* 1004, 1022, 1026, 1082, 1099, 1161, 1168, 1187, 1203, 1311.

Recent Writings 1965–69 (chronologically)

749 FRIED, MICHAEL. 'Jackson Pollock,' *Artforum*, vol. 4, no. 1, September 1965, pp. 14–17 illus.

750 O'CONNOR, FRANCIS. *Jackson Pollock*, The Museum of Modern Art, New York,

20 March–30 May 1967, 148–p. cat. illus.; chronology by Francis O'Connor, pp. 11–78; interview by William Wright, pp. 79–81; bibliography pp. 137–43.

751 ASHTON, DORE. 'Retrospective at the Museum of Modern Art,' *Studio International*, vol. 174, no. 891, July 1967, pp. 46–48 illus.

752 GLASER, BRUCE. 'Jackson Pollock, an Interview with L. Krasner,' *Arts Magazine*, vol. 41, no. 6, April 1967, pp. 36–39 illus.

753 GREY, CLEVE AND FRANCINE DU PLESSIX. 'Who Was Jackson Pollock?' *Art in America*, vol. 55, no. 3, May–June 1967, pp. 48–59 illus.; interviews with Lee Krasner, Anthony Smith, Betty Parsons, Alfonso Ossorio.

754 JUDD, DONALD. 'Jackson Pollock,' *Arts Magazine*, vol. 41, no. 6, April 1967, pp. 32–35 illus.

755 RUBIN, WILLIAM. 'Jackson Pollock and the Modern Tradition,' *Artforum*, vol. 5, no. 6, February 1967, pp. 14–22 illus.; part II, vol. 5, no. 7, March 1967, pp. 28–37 illus.; part III, vol. 5, no. 8, April 1967, pp. 18–31 illus.; part IV, vol. 5, no. 9, May 1967, pp. 28–33 illus.

756 'Jackson Pollock An Artist's Symposium, Part I,' *Art News,* vol. 66, no. 2, April 1967; editorial note by Thomas B. Hess, p. 27; statements by Newman, Motherwell, Gottlieb, among others, pp. 28–33, 59, 61, 63–64 illus.; Part II, vol. 66, no. 3, May 1967, pp. 26–29, 66, 69, 70, 72. Reply with rejoinder William Rubin, vol. 66, no. 3, May 1967, p. 6. Discussion, vol. 66, no. 5, Summer 1967, p. 6.

757 GREENBERG, CLEMENT. 'Jackson Pollock: Inspiration, Vision, Intuitive Decision,' *Vogue*, vol. 149, 1 April 1967, pp. 158–61.

758 KROLL, J. 'Magic Life,' *Newsweek*, vol. 69, 17 April 1967, pp. 96–98 illus.

759 GETLEIN, F. 'God Made Manifest: Show at the Museum of Modern Art,' *New Republic*, vol. 156, 22 April 1967, pp. 26–27.

760 O'CONNOR, FRANCIS. 'The Genesis of Jackson Pollock,' *Artforum*, vol. 5, no. 9, May 1967, pp. 16–23 illus.

761 ROSENBERG, HAROLD. 'Exhibition at the Museum of Modern Art,' *New Yorker*, vol. 43, 6 May 1967, p. 162.

762 LEVINE, E. 'Mythical Overtones in the Work of Jackson Pollock,' *Art Journal*, vol. 26, no. 4, Summer 1967, pp. 366–68, 374 illus.

763 ALLOWAY, LAWRENCE. 'Pollock's Black Paintings,' *Arts Magazine*, vol. 43, no. 7, May 1969, pp. 40–43 illus.

764 ASHTON, DORE. 'New York Commentary,' *Studio International*, vol. 177, no. 911, May 1969, pp. 243–45 illus.

765 SCHJELDAHL, PETER. 'New York Letter,' *Art International*, vol. 13, no. 5, 20 May 1969, pp. 35–36 illus.

Richard Pousette-Dart

Supplement to bibliography in *bibl.* 776.

By Pousette-Dart (chronologically)

766 [Statement] in *Richard Pousette-Dart*, Willard Gallery, New York, 1945.

767 [Statement] in *Pousette-Dart*, Art of This Century Gallery, New York, 4–22 March 1947, p. 1. (Reprinted *bibl.* 776, p. 9.)

768 [Lecture], typescript at Betty Parsons Gallery, New York; address given at the Boston Museum School, 1951, 8 pp. (Excerpt reprinted *bibl.* 769.)

769 [Statement], *Contemporary American Painting*, University of Illinois, Urbana, 1952, pp. 221–22, illus. plate 46.

770 'What Is the Relationship Between Religion and Art?' typescript of lecture given at Union Theological Seminary, 2 December 1952; Betty Parsons Gallery, New York, 3 pp.

771 [Statement], *Contemporary American Painting and Sculpture*, University of Illinois, Urbana, 1953, p. 209, illus. plate 18.

772 [Statement], typescript at Whitney Museum, New York, 1955, 2 pp.

773 WILLARD, CHARLOTTE. 'In the Art Galleries,' *New York Post*, 29 November, 1964, p. 44. (Includes statements by the artist.)

774 [Statements: 'How Does the Artist Create,' poems, etc.] unpublished typescripts in the artist's possession.

See also bibls. 776, 987, 989, 991.

Articles and Books on Pousette-Dart (alphabetically)

775 CAMPBELL, LAWRENCE. 'Pousette-Dart: Circles and Cycles,' *Art News*, vol. 62, no. 3, May 1963, pp. 42–45, 56–57 illus.

776 GORDON, JOHN. *Richard Pousette-Dart*, New York, Whitney Museum of American Art, 1963, 55 pp. illus. (Foreword by Lloyd Goodrich; selected bibliography pp. 54–55; includes statements by the artist.)

777 'A Portfolio of Recent Paintings,' *Arts Yearbook*, no. 7, 1964, pp. 64–65 illus.

778 SAWIN, MARTICA. 'Richard Pousette-Dart,' unpublished manuscript at Betty Parsons Gallery, New York, *c.* 1960, 14 pp.

779 'Spontaneous Kaleidoscopes,' *Look*, 9 October 1951, p. 96–98 illus.

Exhibition Catalogues and Reviews (chronologically)

See also bibl. 776.

780 'Pousette-Dart,' *Art News*, vol. 42, no. 12, 1–14 November 1943, p. 23.

781 LOWENGRUND, MARGARET. 'Surface Manipulations,' *Art Digest*, vol. 23, no. 12, 15 March 1949, p. 15.

782 BREUNING, MARGARET. 'Pousette-Dart's Neutral Flamboyance,' *Art Digest*, vol. 24, no. 13, 1 April 1950, p. 21.

783 FITZSIMMONS, JAMES. 'Pousette-Dart,' *Art Digest*, vol. 25, no. 9, 1 February 1951, p. 18.

784 ASHTON, DORE. 'Effluvia,' *Art Digest*, vol. 26, no. 1, 1 October 1951, p. 18.

785 FARBER, MANNY. 'Art,' *Nation*, 13 October 1951, p. 314.

786 GOODNOUGH, ROBERT. 'Pousette-Dart,' *Art News*, vol. 50, no. 7, November 1951, p. 47.

787 ASHTON, DORE. 'Pousette-Dart,' *Art*

Digest, vol. 27, no. 13, 1 April 1953, pp. 18–19.

788 GUEST, BARBARA. 'Pousette-Dart,' *Art News*, vol. 52, no. 2, April 1953, p. 38.

789 GAGE, OTIS. 'Four Artists as Jewellers,' *Craft Horizons*, vol. 15, no. 3, May-June 1955, pp. 14–17 illus.

790 ADLOW, DOROTHY. 'Pousette-Dart,' *Christian Science Monitor*, 28 March 1958, illus.

791 PORTER, FAIRFIELD. 'Pousette-Dart,' *Art News*, vol. 57, no. 2, April 1958, p. 13.

792 ADLOW, DOROTHY. 'Pousette-Dart,' *Christian Science Monitor*, 13 January 1959, p. 8 illus.

793 SCHUYLER, JAMES. 'Pousette-Dart,' *Art News*, vol. 58, no. 4, May 1959, p. 15 illus.

794 TILLIM, SIDNEY. 'Pousette-Dart,' *Arts*, vol. 33, no. 8, May 1959, p. 55 illus.

795 RAYNOR, VIVIEN. 'Pousette-Dart,' *Arts*, vol. 35, no. 7, April 1961, p. 53 illus.

796 KRAMER, HILTON. 'Art,' *Nation*, vol. 196, no. 20, 18 May 1963, p. 429.

797 ADLOW, DOROTHY. 'Pousette-Dart,' *Christian Science Monitor*, 15 July 1963, illus.

798 EDGAR, NATALIE. 'Pousette-Dart,' *Art News*, vol. 63, no. 8, December 1964, p. 15 illus.

799 PERREAULT, JOHN. 'Yankee Vedanta,' *Art News*, vol. 66, no. 7, November 1967, pp. 54–55, 74–75 illus.

Ad Reinhardt

By Reinhardt (chronologically)

800 'How to Look,' [a series of cartoons on art and the art world], *PM*, 1946–48. (Several reprinted in *bibl.* 836.)

801 [Statement] in *Ad Reinhardt*, Betty Parsons Gallery, New York, 18 October–6 November 1948, p. 1.

802 'Incidental Note,' in *Ad Reinhardt*, Betty Parsons Gallery, New York, 31 October–19 November 1949, p. 4.

803 'Museum Landscape'; 'Museum Racing Form'; 'Art of Life of Art,' *trans/formation*, vol. 1, no. 1, pp. 30–31; no. 2, pp. 88–89; no. 3, pp. 148–49, 1950, 1951, 1952. (Cartoons.)

804 'A Statement' and 'Introduction to the Illustrations,' in *Modern Artists in America*, Wittenborn Schultz, New York, 1951, pp. 6–7 (with Motherwell and Bernard Karpel), p. 40 (with Motherwell).

805 'Our Favourites' [cartoon], *Art News*, vol. 51, no. 1, March 1952, pp. 28–29.

806 [Statement], *Contemporary American Painting*, University of Illinois, Urbana, 1952, p. 226.

807 'Artist in Search of an Academy,' *College Art Journal*, vol. 12, no. 3, Spring 1953, pp. 249–51 (excerpt from a panel discussion on 'The Education of the Artist in Colleges,' at the annual CAA meeting, Cleveland, 31 January 1953); 'Part II: Who Are the Artists?' vol. 13, no. 4, Summer 1954, pp. 314–15 (from August 1953 symposium, Woodstock, New York); 'Reply to Ad Reinhardt' by Sibyl Moholy-Nagy, vol. 14, no. 1, 1954, pp. 60–61.

808 [Letter to the editor], *Art News*, vol. 53, no. 1, March 1954, p. 6.

809 'Foundingfathersfollyday' [cartoon], *Art News*, vol. 53, no. 2, April 1954, pp. 24–25.

810 'Cycles Through the Chinese Landscape,' *Art News*, vol. 53, no. 8, December 1954, pp. 24–27 illus. (On exhibition of Chinese painting at Cleveland Museum; excerpt reprinted in *bibls.* 860, 865.)

811 'A Portend of the Artist as a Yhung Mandala' [cartoon], *Art News*, vol. 55, no. 3, May 1956, pp. 36–37.

812 'The Art-Politics Syndrome: A Project In Integration,' *Art News*, vol. 55, no. 7, November 1956, pp. 34–35. (Selection of newspaper political cartoons with art subject-matter, 'collated' by Reinhardt.)

813 [Statement on the exhibition; selected by Reinhardt], *Eleven Young Painters*, Mills College of Education Gallery, New York, 2–30 April 1957.

814 'Twelve Rules for a New Academy,' *Art News*, vol. 56, no. 3, May 1957,

pp. 37–38, 56. (Reprinted in *bibl.* 860; excerpts in *bibl.* 868.)

815 '25 Lines of Words on Art,' *It Is*, no. 1, Spring 1958, p. 42; also '44 Titles for Articles for Artists Under 45,' pp. 22–23.

816 'Is Today's Artist With or Against the Past?' *Art News*, vol. 57, no. 4, Summer 1958, pp. 26–28, 56–58. (Contribution to an inquiry.)

817 [Letter to the editor], *Art News*, vol. 57, no. 9, January 1959, p. 6.

818 [Letter to the editor], *Art News*, vol. 58, no. 2, April 1959, p. 6.

819 'Discussion: Is There a New Academy?' *Art News*, vol. 58, no. 4, June 1959, p. 34. (Contribution to a symposium.)

820 'Seven Quotes,' *It Is*, no. 4, Autumn 1959, p. 25.

821 'Timeless in Asia,' *Art News*, vol. 58, no. 9, January 1960, pp. 32–35 illus., reprinted in *bibls.* 860, 865.

822 [Letter to the editor], *Art News*, vol. 60, no. 2, April 1961, p. 6.

823 'How to Look at Modern Art in America,' *Art News*, vol. 60, no. 4, Summer 1961, pp. 36–37. (Two cartoons; 1946 version reprinted from *PM*.)

824 'Angkor and Art,' in *Khmer Sculpture*, Asia House Gallery, New York, 1961, pp. 5–10. (Reprinted in *Art News*, vol. 60, no. 8, December 1961, pp. 43–45, 66–67 illus.)

825 [Three Statements, 1955–61], *Pax*, no. 18, 1962 (broadside; reprinted in *bibls.* 828, 868.)

826 'Who is Responsible for Ugliness?' *American Institute of Architects Journal*, vol. 47, no. 6, June 1962, pp. 60–61. (Contribution to the 'First Conference on Aesthetic Responsibility,' Plaza Hotel, New York, 3 April 1962; reprinted as 'What is Ugly?' in *The Village Voice*, 19 April 1962, and in *ICA Bulletin* (London), nos. 138–39, August–September 1964, pp. 14–15.)

827 'Art-as-Art,' *Art International*, vol. 6, no. 10, December 1962, pp. 36–37. (See *bibl.* 829 for Part II; excerpts, *bibl.* 868.)

828 'Autocritique de Reinhardt,' *Iris-Time* (Galerie Iris Clert, Paris), no. 7, 10 June 1963, pp. 1, 3. (On occasion of Reinhardt exhibition, 10 June–10 July; state-ment in facsimile; also reprint of *bibl.* 825.)

829 'The Next Revolution in Art: art-as-art dogma Part' II,' *Art International*, vol. 8, no. 2, March 1964, pp. 57–58; also published in *Art News*, vol. 62, no. 10, February 1964, pp. 48–49. (Part I, *bibl.* 827.)

See also bibls. 833, 836, 984, 987, 989, 991, 996, 997, 998, 999, 1018, 1256.

Articles on Reinhardt (alphabetically)

830 'Ad Absurdam,' *Time*, 11 January 1963, p. 68.

831 BARR, ALFRED H., JR., AND SOBY, JAMES THRALL. 'Letter to the editor,' *Art in America*, vol. 51, no. 5, October 1963, p. 143.

832 COLT, PRISCILLA. 'Notes on Ad Rein-hardt,' *Art International*, vol. 8, no. 8, October 1964, pp. 32–34.

833 HESS, THOMAS B. 'The "Phony Crisis in American Art,"' *Art News*, vol. 62, no. 4, Summer 1963, pp. 24–28, 59–60 illus. (Includes statement by the artist.)

834 HESS, THOMAS B. 'Reinhardt: The Posi-tion and Perils of Purity,' *Art News*, vol. 52, no. 8, December 1953, pp. 26–27, 59 illus.

835 JAMES, MARTIN. 'Today's Artists: Rein-hardt,' *Portfolio and Art News Annual*, no. 3, 1960, pp. 48–63, 140–46 illus.

836 'Reinhardt,' *Arts and Architecture*, vol. 64, no. 1, January 1947, pp. 20–27 illus. (Statement, p. 20; brief anonymous text, p. 21; pp. 22–27, cartoons reprinted from *PM*.)

837 TILLIM, SIDNEY. 'What Happened to Geometry?' *Arts*, vol. 33, no. 9, June 1959, pp. 38–44 illus.

Exhibition Catalogues and Reviews (chronologically)

838 RILEY, MAUDE. 'Reinhardt,' *Art Digest*, vol. 18, no. 10, 15 February 1944, p. 20.

839 'Reinhardt,' *Art News*, vol. 43, no. 1, 15 February 1944, p. 23.

840 'Reinhardt,' *Art News*, vol. 45, no. 9, November 1946, p. 45.

841 LANSFORD, ALONZO. 'Variations on Reinhardt,' *Art Digest*, vol. 21, no. 3, 1 November 1946, p. 21.

842 REED, JUDITH KAYE. 'Abstracts by Reinhardt,' *Art Digest*, vol. 22, no. 5, 1 December 1947, pp. 22–23.

843 'Ad Reinhardt,' *Art News*, vol. 46, no. 10, December 1947, p. 60.

844 'Reinhardt,' *Art News*, vol. 47, no. 6, October 1948, p. 47.

845 P. F. C. 'Painted Patterns,' *Art Digest*, vol. 23, no. 3, 1 November 1948, p. 19.

846 HESS, THOMAS B. 'Reinhardt,' *Art News*, vol. 48, no. 7, November 1949, p. 50.

847 REED, JUDITH KAYE. 'Without Subjects,' *Art Digest*, vol. 24, no. 3, 1 November 1949, p. 26.

848 KRASNE, BELLE. 'Reinhardt,' *Art Digest*, vol. 25, no. 17, 1 June 1951, p. 19.

849 GOODNOUGH, ROBERT. 'Reinhardt,' *Art News*, vol. 50, no. 4, Summer 1951, p. 47.

850 FITZSIMMONS, JAMES. 'Reinhardt,' *Art Digest*, vol. 26, no. 8, 15 January 1952, p. 20.

851 PORTER, FAIRFIELD. 'Reinhardt,' *Art News*, vol. 50, no. 10, February 1952, p. 41.

852 ARNASON, H.H. *The Classic Tradition in Contemporary Art*, Walker Art Center, Minneapolis, 24 April–28 June 1953, pp. 5–9, 55 p. cat. illus.

853 SAWIN, MARTICA. 'Reinhardt,' *Art Digest*, vol. 28, no. 5, 1 December 1953, p. 21.

854 CREHAN, HUBERT. 'Reinhardt,' *Arts*, vol. 29, no. 10, 15 February 1955, pp. 25–26.

855 CAMPBELL, LAWRENCE. 'Reinhardt,' *Art News*, vol. 54, no. 1, March 1955, p. 52.

856 POLLET, ELIZABETH. 'Reinhardt,' *Arts*, vol. 31, no. 3, December 1956, p. 54.

857 CAMPBELL, LAWRENCE. 'Reinhardt,' *Art News*, vol. 57, no. 10, February 1959, p. 10 illus.

858 TILLIM, SIDNEY. 'Reinhardt,' *Arts*, vol. 33, no. 5, February 1959, p. 54.

859 CHEVALIER, DENYS. 'Reinhardt,' *Aujourd'hui*, no. 28, September 1960, p. 45.

860 *Ad Reinhardt: Twenty-Five Years of Abstract Painting*, Betty Parsons Gallery, New York, 17 October–5 November 1960, 17 pp. illus. plus poster. (Reprints *bibls.* 810, 814, 821.)

861 CAMPBELL, LAWRENCE. 'Reinhardt,' *Art News*, vol. 59, no. 6, October 1960, p. 12.

862 ASHTON, DORE. 'Art,' *Arts and Architecture*, vol. 77, no. 12, December 1960, pp. 4–5 illus.

863 SANDLER, IRVING H. 'New York Letter,' *Art International*, vol. 4, no. 9, December 1960, pp. 24–25, illus.

864 TILLIM, SIDNEY. 'Month in Review,' *Arts*, vol. 35, no. 3, December 1960, p. 47 illus.

865 REINHARDT, LO SAVIO, VERHEYEN, Städtisches Museum, Leverkusen, 27 January–19 March 1961, pp. 3–12. (Includes excerpts from *bibls.* 810, 821.)

866 FRIGERIO, SIMONE. 'Leverkusen,' *Aujourd'hui*, no. 30, February 1961, p. 53.

867 LANGSNER, JULES. 'Los Angeles Letter,' *Art International*, vol. 6, no. 3, April 1962, p. 65 illus.

868 MILLER, DOROTHY C., ed. *Americans 1963*, Museum of Modern Art, New York, 1963, pp. 80–86, 110 illus. (Reprint *bibl.* 825 and excerpts from *bibls.* 814, 827.)

869 [REINHARDT], *Art International*, vol. 7, no. 6, 25 June 1963, pp. 71, 73–74 and cover.

870 ROSE, BARBARA. 'Americans 63,' *Art International*, vol. 7, no. 7, 25 September 1963, pp. 77–79 illus.

871 LANGSNER, JULES. 'Art News from Los Angeles,' *Art News*, vol. 62, no. 9, January 1964, p. 50.

See also bibl. 1234.

Recent Writings 1965–69 (chronologically)

872 REINHARDT, AD. 'Art in Art is Art as Art,' *The Lugano Review*, nos. 5–6, 1965, pp. 85–89. Also printed in Kepes, Gyorgy, *Sign, Image, Symbol,* New York, George Braziller, 1966, pp. 180–83.

873 REINHARDT, AD. 'The Artists Say . . . Ad Reinhardt: 39 Planks,' *Art Voices*, Spring 1965, pp. 86–87.

874 REINHARDT, AD. 'Reinhardt Paints a Picture,' *Art News*, vol. 64, no. 1, March 1965, pp. 39–41, 66 illus.

875 LIPPARD, LUCY R. 'New York Letter,' *Art International*, vol. 9, no. 4, May 1965, pp. 52–53. Slightly revised and reprinted in Battock, Gregory, ed. *The New Art*, New York, 1966, pp. 187–92.

876 ROSE, BARBARA. 'ABC Art,' *Art in America*, vol. 53, no. 5, October–November 1965, pp. 58, 62, 65.

877 REINHARDT, AD. 'Art vs. History: *The Shape of Time* by George Kubler,' *Art News*, vol. 64, no. 9, January 1966, pp. 19, 61–62.

878 REINHARDT, AD. 'Ad Reinhardt: Three Statements, *Artforum*, vol. 5, no. 7, March 1966, pp. 34–35 illus.

879 SOWERS, ROBERT. 'Art and the Temptation of Ad Reinhardt,' *ARC Directions*, June 1966, pp. 3, 4, 6.

880 Jewish Theological Seminary of America, *Ad Reinhardt: Paintings*, The Jewish Museum, New York, 23 November 1966– 15 January 1967, 76-p. cat. illus.; text by Lucy R. Lippard; preface by Sam Hunter; chronology by the artist.

881 MICHELSON, ANNETTE. 'Ad Reinhardt or the Artist as Artist,' *Harper's Bazaar*, November 1966, p. 176.

882 ROSE, BARBARA. 'Reinhardt.' *Vogue*, vol. 148, 1 November 1966, p. 183.

883 ROSENSTEIN, HARRIS. 'Black Pastures,' *Art News*, vol. 65, no. 7, November 1966, pp. 33–35, 72–73 illus.

884 SANDLER, IRVING. 'Reinhardt: the Purist Blacklash,' *Artforum*, vol. 5, no. 4, December 1966, pp. 40–47 illus.

885 BOURDON, DAVID. 'Master of the Minimal'. *Life*, vol. 62, 3 February 1967, pp. 45–51.

886 ROSENBERG, HAROLD. 'Exhibition of All Black Paintings at Jewish Museum,' *New Yorker*, vol. 43, 25 February 1967, pp. 99–109.

887 'Chronology,' *Artforum*, vol. 6, no. 2, October 1967, pp. 46–47.

888 LIPPARD, LUCY R. 'Ad Reinhardt: 1913–1967,' *Art International*, vol. 11, no. 8, 20 October 1967, p. 19.

889 DENNY, R. 'Ad Reinhardt: An Appreciation,' *Studio International*, vol. 174, no. 895, December 1967, p. 264.

890 KALLICK, PHYLLISANN. 'Interview with Ad Reinhardt,' *Studio International*, vol. 174, no. 895, December 1967, pp. 264–65 illus.

891 'Ad Reinhardt on His Art,' *Studio International*, vol. 174, no. 895, December 1967, pp. 265–73 illus. Excerpts from an unpublished recording of a talk by Reinhardt at The Institute of Contemporary Arts in London, 28 May 1964 entitled 'Art as Art Dogma.'

Mark Rothko

Supplement to bibliography in *bibl.* 912.

By Rothko (chronologically)

892 [Letter to the editor], *New York Times*, 13 June 1943, sec. 2, p. 9. (With Adolph Gottlieb and Barnett Newman; excerpts *bibls.* 1014, 1083.)

893 'The Portrait and the Modern Artist,' mimeographed script of broadcast by Rothko and Gottlieb–*Art in New York*, program, H. Stix, director, WNYC, New York, 13 October 1943, 4 pp.

894 [Statement] in 'Ides of Art,' *Tiger's Eye*, vol. 1, no. 2, December 1947, p. 44. (Reprinted *bibl.* 990.)

895 'The Romantics Were Prompted,' *Possibilities*, vol. 1, no. 1, Winter 1947–48, pp. 84–86 illus. (Excerpt *bibl.* 1003.)

896 [Statement], *Tiger's Eye*, vol. 1, no. 9, October 1949, p. 114. (Reprinted *bibls.* 990, 994.)

897 [Statement delivered from the floor at symposium on 'How to Combine Architecture, Painting, and Sculpture,' Museum of Modern Art], *Interiors*, vol. 110, no. 10, May 1951, p. 104 illus.

898 ASHTON, DORE. 'Art: Lecture by Rothko,' *New York Times*, 31 October 1958. (Includes quotations from the lecture, at Pratt Institute.)

899 ASHTON, DORE. 'Letter from New York,' *Cimaise*, series 6, no. 2, December 1958, pp. 38–39. (Further quotations from Pratt lecture; see also *bibl.* 843.)

See also bibls. 908, 984, 986, 987, 999, 1000, 1003, 1256, 1299.

Articles on Rothko (alphabetically)

900 ALLOWAY, LAWRENCE. 'Notes on Rothko,' *Art International*, vol. 6, nos. 5–6, Summer 1962, pp. 90–94 illus.

901 BUTOR, MICHEL. 'Les Mosquées de New-York ou l'art de Mark Rothko,' *Revue Critique Editions de Minuit*, no. 173, [1961], pp. 843–60. (Includes review of *bibl.* 912.)

902 'A Certain Spell,' *Time*, 3 March 1961, pp. 72–73, 75 illus.

903 DENNISON, GEORGE. 'The Painting of Mark Rothko,' unpublished typescript at Betty Parsons Gallery, New York, n.d., 5 pp.

904 GEIST, SIDNEY. '"Moodily Dare"· IFP a critique of Criticism: Mark Rothko,' *Scrap*, no. 4, 16 February 1961, pp. 1–3. (Criticism of *bibl.* 912.)

905 GOLDWATER, ROBERT. 'Reflections on the Rothko Exhibit,' *Arts*, vol. 35, no. 6, March 1961, pp. 42–45 illus. (Reprinted *bibl.* 892.)

906 GOOSSEN, EUGENE C. 'Rothko: The Omnibus Image,' *Art News*, vol. 59, no. 9, January 1961, pp. 38–40, 60–61 illus.

907 KOZLOFF, MAX. 'Mark Rothko's New Retrospective,' *Art Journal*, vol. 20, no. 3, Spring 1961, pp. 148–49 illus.

908 MORITZ, CHARLES, ed. 'Rothko,' *Current Biography Yearbook*, New York, H. W. Wilson, 1961, pp. 397–99 illus. (Includes statements by the artist.)

909 OERI, GEORGINE. 'Mark Rothko,' *Quadrum*, no. 10, 1961, pp. 65–74 illus.

910 'A Portfolio of Recent Paintings,' *Arts Yearbook*, no. 7, 1964, pp. 75 illus.

911 'Rothko Murals for Harvard,' *Art Journal*, vol. 22, no. 4, Summer 1963, p. 254.

912 SELZ, PETER. *Mark Rothko*, Museum of Modern Art, New York, 1961, pp. 9–14 plus plates; bibliography pp. 40–42. (Reviewed *bibls.* 901, 904.)

913 SELZ, PETER. 'Mark Rothko,' *L'Oeil*, no. 76, April 1961, pp. 36–43, 82 illus. (Excerpt from *bibl.* 912.)

Exhibition Catalogues and Reviews (chronologically)

914 LOWE, JEANNETTE. 'Three Moderns: Rothko, Gromaire, and Solman,' *Art News*, vol. 38, no. 16, 20 January 1940, p. 12.

915 *Mark Rothko*, Art of This Century Gallery, New York, 9 January–4 February 1945, anonymous text, p. 3 illus.

916 PRESTON, STUART. 'Mark Rothko,' *New York Times*, 8 April 1951.

917 REYNOLDS, NANCY. 'Rothko Paintings at RISD,' *Pembroke Record*, vol. 35, no. 26, 8 February 1955, p. 1.

918 MELVILLE, ROBERT. 'Exhibitions,' *Architectural Review*, vol. 122, no. 729, October 1957, p. 270 illus.

919 LONNGREN, LILLIAN. 'Abstract Expression in the American Scene,' *Art International*, vol. 2, no. 1, 1958, pp. 54–56.

920 GOOSSEN, EUGENE C. 'The End of the Winter in New York,' *Art International*, vol. 2, nos. 2–3, 1958, p. 37.

921 ASHTON, DORE. 'New York,' *Cimaise*, series 5, no. 4, March–April 1958, pp. 30–31 illus.

922 GENAUER, EMILY. 'They're All Busy Drawing Blanks,' *New York Herald Tribune*, 22 January 1961, p. 21 illus.

923 GETLEIN, FRANK. 'The Ordeal of Mark Rothko,' *New Republic*, 6 February 1961, pp. 28, 30.

924 PORTER, FAIRFIELD. 'Art,' *Nation*, vol. 192, no. 8, 25 February 1961, p. 176.

925 HESS, THOMAS B. 'Rothko,' *Art News*, vol. 60, no. 1, March 1961, p. 16.

926 PRESTON, STUART. 'New York,' *Burlington Magazine*, vol. 103, no. 696, March 1961, p. 116.

927 SANDLER, IRVING H. 'New York Letter· Rothko,' *Art International*, vol. 5, no. 2, March 1961, pp. 40–41 illus.

928 PICARD, LIL. 'Rothko,' *Kunstwerk*, vol. 14, nos. 10–11, April–May 1961, pp. 39–40 plus 5 plates.

929 *Arte e Contemplazione*, Palazzo Grassi, Centro delle arti e del costume, Venice, July–October 1961, plates 31–33 plus biography.

930 CAMPBELL, LAWRENCE. 'Paintings from WPA,' *Art News*, vol. 60, no. 5, September 1961, p. 14 illus.

931 FRIGERIO, SIMONE. 'Art et contemplation au Palais Grassi, Venise,' *Aujourd'hui*, no. 33, October 1961, pp. 35–37 illus.

932 *Mark Rothko*, Whitechapel Art Gallery, London, 11 October–8 November 1961; exhibition circulated in Europe by Museum of Modern Art, New York; London showing reviewed by: John Russell, *The Sunday Times*, 15 October; Keith Sutton, *The Listener*, 19 October; David Sylvester, *New Statesman*, 20 October; Alan Bowness, *The Observer*, 15 October; Pierre Jeanneret, *The Daily Mail*, 11 October; J. Harrison, *The Times*, 13 October; Eric Newton, *Manchester Guardian*, 14 October; Peter Stone, *Jewish Chronicle*, 20 October; Jasper Rose, *Time and Tide*, 26 October; *Evening Standard*, 11 October; *The Scotsman* (Edinburgh), 16 October; *Yorkshire Post* (Leeds), 17 October.

933 HARRISON, JANE. 'Rothko,' *Arts Review*, vol. 13, no. 20, 21 October–4 November 1961, pp. 2, 18.

934 BROOKNER, ANITA. 'London,' *Burlington Magazine*, vol. 103, no. 704, November 1961, p. 477.

935 *Mark Rothko*, Stedelijk Museum, Amsterdam, 24 November–27 December 1961; 20-p. cat. with reprinted texts by Goldwater (*bibl.* 905), Selz (*bibl.* 912) and Villa.

936 FRIED, MICHAEL. 'Visitors From America,' *Arts*, vol. 36, no. 3, December 1961, pp. 38–39 illus.

937 REICHARDT, JASIA. 'Londres,' *Aujourd'hui*, no. 34, December 1961, pp. 64–65 illus.

938 ASHBERY, JOHN. 'Paris Notes,' *Art International*, vol. 7, no. 2, February 1963, pp. 72–73 illus.

939 DIENST, ROLF-GUNTER. 'Pariser Kunstwinter,' *Kunstwerk*, vol. 16, no. 8, February 1963, p. 23.

940 WATT, ALEXANDER. 'Paris Commentary,' *Studio*, vol. 165, no. 839, March 1963, pp. 120–22 illus.

941 FRIED, MICHAEL. 'New York Letter,' *Art International*, vol. 7, no. 5, 25 May 1963, pp. 70–72 illus.

942 JUDD, DON. 'Mark Rothko,' *Arts*, vol. 37, no. 10, September 1963, pp. 57–58 illus.

943 *Mark Rothko*, Marlborough Fine Art Ltd, London, February–March 1964, 34 pp. illus.; bibliography; chronology.

944 ROBERT, KEITH. 'London,' *Burlington Magazine*, vol. 106, no. 733, April 1964, p. 194.

945 RYKWERT, JOSEPH. 'Mostre a Londra,' *Domus*, no. 413, April 1964, p. 47.

946 WHITTET, G. S. 'London Commentary,' *Studio*, vol. 167, no. 853, May 1964, p. 216.

947 KOZLOFF, MAX. 'Color Light in Mark Rothko,' *Artforum*, vol. 4, no. 1, September 1965, pp. 38–44 illus.

See also bibls. 1026, 1032, 1076, 1095, 1203, 1226, 1241.

Clyfford Still

By Still (chronologically)

948 [Statement] Betty Parsons Gallery, New York, 1950. (Typescript.)

949 [Letter to Gordon Smith], in *Paintings by Clyfford Still*, The Buffalo Fine Arts Academy and Albright Art Gallery, Buffalo, 5 November–13 December 1959, pp. 6–8; biography pp. 9–10 plus 40 plates.

950 'Comments,' *Gallery Notes*, Albright Art Gallery, vol. 23, no. 2, Summer 1960,

pp. 12–13 illus. (Reprinted from *Gallery Notes*, November 1959.)

951 'An Interview with Clyfford Still' by Benjamin J. Townsend, *Gallery Notes*, Albright–Knox Art Gallery, vol. 24, no. 2, Summer 1961, pp. 8–16 illus. (Revised and enlarged version of article originally printed in *Audit*, Winter–Spring 1961.)

952 'An Open Letter to an Art Critic,' *Artforum*, vol. 2, no. 6, December 1963, p. 32 plus 3 plates.

953 [Letter to the editor], *Artforum*, vol. 2, no. 8, February 1964, p. 2.

See also bibls. 962, 990.

Articles on Still (alphabetically)

954 ASHTON, DORE. 'Clyfford Still,' *New York Times*, 16 November 1959, sec. 2, p. 19.

955 CREHAN, HUBERT. 'Clyfford Still: Black Angel in Buffalo,' *Art News*, vol. 58, no. 9, December 1959, pp. 32, 58–60 illus.

956 'Entering Public Domain – Chicago: Epic in Black,' *Art News*, vol. 62, no. 10, February 1964, p. 35 illus.

957 GOOSSEN, EUGENE C. 'Painting as Confrontation: Clyfford Still,' *Art International*, vol. 4, no. 1, 1960, pp. 39–43 illus.

958 'The Image and the Void,' *Time*, vol. 74, no. 19, 9 November 1959, pp. 80–82 illus.

959 KOZLOFF, MAX. 'Art: Clyfford Still,' *Nation*, vol. 198, no. 2, 6 January 1964, pp. 39–40.

960 SAWYER, KENNETH B. 'U.S. Painters Today: No. 1: Clyfford Still,' *Portfolio and Art News Annual*, no. 2, 1960, pp. 74–87 illus.

961 SHARPLESS, TI–GRACE. *Clyfford Still*, Institute of Contemporary Art, University of Pennsylvania, Philadelphia, 18 October–29 November 1963, pp. 5–10 plus 26 plates. (Statements by the artist, pp. 9–10.)

962 SHARPLESS, TI–GRACE. 'Freedom . . . Absolute and Infinitely Exhilarating,' *Art News*, vol. 62, no. 7, November 1963, pp. 36–39, 60 illus., cover. (Excerpts from *bibl. 961*.)

Exhibition Catalogues and Reviews (chronologically)

See also bibls. 949–61.

963 *Contemporary Art of the United States*, International Business Machines Corporation, San Francisco, 1940, unpaged. (Portrait, biography, brief anonymous text, illus.)

964 'Still,' *Art News*, vol. 44, no. 20, February 1946, p. 92.

965 REED, JUDITH KAYE. 'Extending a Myth,' *Art Digest*, vol. 20, no. 11, 1 March 1946, p. 17.

966 LANSFORD, ALONZO. 'Still's Legerdemain,' *Art Digest*, vol. 21, no. 14, 15 April 1947, p. 22.

967 'Still,' *Art News*, vol. 46, no. 3, May 1947, p. 50.

968 'Still,' *Magazine of Art*, vol. 41, no. 3, March 1948, p. 96 illus.

969 KRASNE, BELLE. 'Still's Non–Objective Cartography,' *Art Digest*, vol. 24, no. 15, 1 May 1950, pp. 22, 33.

970 GOODNOUGH, ROBERT, 'Still,' *Art News*, vol. 49, no. 4, Summer 1950, p. 49.

971 LORAN, ERLE. 'Art News from San Francisco . . . Clyfford Still,' *Art News*, vol. 49, no. 6, October 1950, pp. 58–59.

972 FITZSIMMONS, JAMES. 'Clyfford Still,' *Art Digest*, vol. 25, no. 9, 1 February 1951, pp. 17–18.

973 'The Aloof Abstractionist,' *Time*, vol. 82, no. 22, 29 November 1963, pp. 76–77 illus.

974 *Clyfford Still*, Albright–Knox Art Gallery, Buffalo, New York, 1966, 87–p. cat. illus.; foreword by Katharine Kuh, pp. 10–11; biographical notes, pp. 13–15 by Ethel Moore; statement by the artist, pp. 16–18.

See also bibls. 1026, 1082, 1095, 1203, 1241.

Bradley Walker Tomlin

Supplement to bibliography in *bibl.* 981.

By Tomlin (chronologically)

975 [Foreword], *Frank London*, Woodstock Art Association Gallery, Woodstock, New York, 1948, pp. 2–3.
976 [Foreword], *Judson Smith Retrospective Exhibition*, Woodstock Art Association Gallery, Woodstock, New York, 1952, pp. 2–3.
977 [Letter to the editor], *Art News*, vol. 52, no. 3, May 1963, p. 6.

See also bibls. 989, 991, 994, 1256.

Articles, Exhibition Catalogues and Reviews on Tomlin (alphabetically)

978 ARNASON, H. H. *The Classic Tradition in Contemporary Art*, Walker Art Center, Minneapolis, 24 April–28 June 1953, pp. 5–9, 55 p. cat. illus.
979 ASHBERY, JOHN. 'Tomlin: The Pleasures of Color,' *Art News*, vol. 56, no. 6, October 1957, pp. 28–29, 54 illus.
980 ASHTON, DORE. 'Art,' *Arts and Architecture*, vol. 74, no. 12, December 1957, pp. 32–33 illus.
981 BAUR, JOHN I. H. *Bradley Walker Tomlin*, Whitney Museum of American Art, New York, 1957, pp. 15–39 plus plates pp. 40–55. (Selected bibliography pp. 60–61; texts by Philip Guston, p. 9; Robert Motherwell, p. 11–12; Duncan Phillips, p. 12; F. S. Wight, p. 13.)
982 FAISON, S. LANE, JR. 'Art,' *Nation*, vol. 174, 10 May 1952, p. 458; and vol. 176, 18 April 1953, p. 334.
983 SAWIN, MARTICA. 'Bradley Walker Tomlin,' *Arts*, vol. 32, no. 2, November 1957, pp. 22–25 illus.

See also bibls. 990, 1148, 1168.

GROUPED STATEMENTS
(symposia, collections, etc.)

(chronologically)

See also individual bibliographies and *bibls.* 1043, 1050, 1053, 1256.

984 JANIS, SIDNEY. *Abstract and Surrealist Art in America*, New York, Reynal and Hitchcock, 1944. (Plate captions consist of artists' statements, including Baziotes, Gorky, Gottlieb, Hofmann, Motherwell, Pollock, Reinhardt, Rothko.)
985 *Possibilities*, vol. 1, no. 1, Winter 1947–48, 112 pp. illus. (Only issue published; edited by Motherwell, Harold Rosenberg, Pierre Chareau, and John Cage; includes writings by Motherwell, Baziotes, Pollock, Rothko, and David Smith.)
986 PORTER, DAVID, ed. *Personal Statement: Painting Prophecy 1950*, Washington DC, David Porter Gallery, 1950. (Statements in pamphlet written by the artists in 1945; Baziotes, Gottlieb, Motherwell, Pollock from *bibl.* 598, Rothko.)

987 [Open letter to Roland L. Redmond, President of the Metropolitan Museum of Art, concerning the American painting exhibition there], *Art News*, vol. 49, no. 4, Summer 1950, p. 15. (Mimeographed original dated 20 May 1950; signed by the so-called 'Irascibles,' including Baziotes, De Kooning, Gottlieb, Hofmann, Motherwell, Newman, Pollock, Pousette-Dart, Reinhardt, Rothko, Still, Tomlin; covered in *Time*, 5 June 1950; *Life*, 15 January 1951.)

988 *What Abstract Art Means to Me, Museum of Modern Art Bulletin*, vol. 18, no. 3, Spring 1951, 15 pp. illus. (Statements by six American artists, including De Kooning, Motherwell; symposium held 5 February 1951 at the Museum.)

989 MOTHERWELL, ROBERT AND REINHARDT, AD, eds. *Modern Artists in America*, New York, Wittenborn, Schultz, 1951, 200 pp. illus. (Most important document of the period, originally planned as an annual edition. Includes Museum Acquisitions, 'Art in the World of Events: A Calendar of Excerpts'; reprint of *bibl.* 1136; bibliography, essay, and index by Bernard Karpel; statements by the editors; and 'Artists' Sessions at Studio 35,' edited by R. Goodnough, symposia held 21–23 April 1950 by, among others, Baziotes, De Kooning, Gottlieb, Hofmann, Motherwell, Newman, Pousette-Dart, Reinhardt, Tomlin.)

990 MILLER, DOROTHY C., ed. *Fifteen Americans*, Museum of Modern Art, New York, 1952. (Includes statements by Baziotes from *bibl.* 2, Rothko from *bibls.* 894, 896; Still on Pollock from *bibl.* 692, and Tomlin.)

991 *The New Decade: 35 American Painters and Sculptors*, Whitney Museum of American Art, New York, 1955. (Includes statements by Baziotes, De Kooning from *bibl.* 55, Gottlieb, Kline, Motherwell, Pousette-Dart, Reinhardt, Tomlin.)

992 CELENTANO, FRANCIS. *The Origins and Development of Abstract Expressionism in the United States*, unpublished Master's Thesis, New York University, 1957. (Includes statements drawn from questionnaires sent to the artists.)

993 BAUR, JOHN I. H. *Nature in Abstraction*, Whitney Museum of American Art, New York, 1958. (Text primarily on abstract expressionism and based on statements by the artists taken from answers to questionnaires; includes Baziotes, Gottlieb, Guston, Hofmann.)

994 BARR, ALFRED H., JR., ed. *The New American Painting*, Museum of Modern Art, New York, 1959. (Includes biographies and reprinted statements on or by: Baziotes from *bibl.* 2, Gorky, *bibls.* 53, 157, Gottlieb, *bibl.* 993, Guston, *bibl.* 271, Kline, *bibl.* 372, De Kooning, *bibl.* 44, Motherwell, *bibl.* 462, Newman, Pollock, *bibls.* 599, 692, Rothko, *bibl.* 896, Still, *bibl.* 990, Tomlin, *bibl.* 272; 'Introduction' by A. H. Barr; selected critiques of the exhibition as shown in Europe. For catalogues and reviews of the European showing, see *bibl.* 1281.)

995 *The Museum and Its Friends*, Whitney Museum of American Art, New York, 5 March–12 April 1959. (Statements by De Kooning, Guston, Kline.)

996 'Discussion: Is There a New Academy?' *Art News*, vol. 58, no. 4, Summer 1959, pp. 34–35, 58–59; no. 6, September 1959, pp. 36–37, 58–60. (Contributions by Reinhardt and other abstract expressionist artists.)

997 'Panel: All-over Painting,' *It Is*, no. 2, Autumn 1958, pp. 72–77 illus. (Participants: Martin James, Elaine de Kooning, Ad Reinhardt.)

998 'The Philadelphia Panel,' *It Is*, no. 5, Spring 1960, pp. 34–38. (Panel on 'The Concept of the New,' held at the Philadelphia School of Art; edited by P. G. Pavia and Irving Sandler; participants: Guston, Motherwell, Reinhardt, Rosenberg, with Jack Tworkov as moderator; reported in *New York Times*, 3 April 1964 by John Canaday.)

999 RODMAN, SELDEN. *Conversations with Artists*, New York, Capricorn Books, 1961. (Includes interviews with De Kooning, Gottlieb, Kline, Pollock, Rothko, and an excerpt from Reinhardt's *bibl.* 807.)

1000 'In Support of the French Intellectuals,' *Partisan Review*, vol. 28, no. 1, January–February 1961, pp. 144–45. (Group

statement signed by, among others, De Kooning, Guston, Kline, Motherwell, Rothko, Rosenberg, Schapiro.)

1001 [Letter to the editor protesting the criticism of *New York Times* art critic, John Canaday], *New York Times*, 26 February 1961, sec. 2. (Signed by, among others, De Kooning, Gottlieb, Hofmann, Motherwell, Newman, T. B. Hess, S. Hunter, H. Rosenberg, I. Sandler, K. Sawyer, M. Schapiro; reprinted as an appendix in *bibl.* 1168 with a selection from the 52 letters of reply printed in the *New York Times*, 5 March, 12 March 1961.)

1002 KUH, KATHERINE. *The Artist's Voice: Talks With Seventeen Artists*, New York, Evanston, Harper and Row, 1962. (Includes extensive interviews with Hofmann and Kline.)

1003 PROTTER, ERIC, ed. *Painters on Painting*, New York, Grosset and Dunlap, Universal Library, 1963. (Includes bibliography and reprints of statements by Gorky from *bibl.* 146, Hofmann, Kline from *bibls.* 991, 999, De Kooning from *bibls.* 55, 999, Motherwell from *bibl.* 991, Pollock from *bibl.* 599, Rothko from *bibl.* 895.)

WRITINGS BY CRITICS

on the New York School

(chronologically)

See also bibls. 984–1003.

1004 TYLER, PARKER. 'Nature and Madness Among the Younger Painters,' *View*, series 5, no. 2, May 1945, pp. 30–31. (On Gorky and Pollock.)

1005 GREENBERG, CLEMENT. 'The Present Prospects of American Painting and Sculpture,' *Horizon* (London), nos. 93–94, October 1947, pp. 20–30.

1006 ROSENBERG, HAROLD. 'Introduction to Six American Artists,' *Possibilities*, vol. 2, no. 1, Winter 1947–48, p. 75. (From the catalogue of an exhibition at the Galerie Maeght, Paris, Spring 1947, which included Baziotes, Gottlieb, and Motherwell.)

'Attached neither to a community nor to one another, these painters experience a unique loneliness. . . . From the four corners of their vast land they have come to plunge themselves into the anonymity of New York. . . . Estrangement from American objects here reaches the level of pathos. It accounts for certain harsh tonalities, spareness of composition, aggressiveness of statement.'

1007 KOOTZ, SAMUEL M., ed. *Women: A Collaboration of Artists and Writers*, New York, Kootz Editions, 1948. (Painter-poet combinations include: Baziotes and Rosenberg, Gottlieb and V. Wolfson, Hofmann and Tennessee Williams, Motherwell and Weldon Kees.)

1008 GREENBERG, CLEMENT. 'The Situation at the Moment,' *Partisan Review*, vol. 15, no. 1, January 1948, pp. 81–84.

1009 GREENBERG, CLEMENT. 'A Symposium: The State of American Art,' *Magazine of Art*, vol. 42, no. 3, March 1949, p. 92.

'There is, in my opinion, a definitely American trend in contemporary art, one that promises to become an original contribution to the mainstream. . . . An expressionist ingredient is usually present . . . and cubist discipline is used as an armature upon which to body forth

emotions whose extremes threaten . . . to dissolve plastic structure. . . .'

1010 GREENBERG, CLEMENT. 'Art,' *Nation*, vol. 168, no. 24, 11 June 1949, pp. 669–70. (On the general situation of advanced American painting.)

1011 SUTTON, DENYS. 'The Challenge of American Art,' *Horizon* (London), vol. 20, no. 118, October 1949, pp. 268–84.

1012 BARR, ALFRED H., JR. '7 Americans Open in Venice: Gorky, De Kooning, Pollock,' *Art News*, vol. 49, no. 4, Summer 1950, pp. 22–23, 60 illus.

1013 TWORKOV, JACK. 'The Wandering Soutine,' *Art News*, vol. 49, no. 7, part 1, November 1950, pp. 30–33, 62.

'Viewed from the standpoint of certain painters, like De Kooning and perhaps Pollock . . . certain qualities of composition, certain attitudes toward paint . . . are expressed in Soutine in unpremeditated form . . .: the way his picture moves towards the edge of the canvas in centrifugal waves . . . his impulsive use of pigment as a material . . .; the absence of any effacing of the tracks bearing the imprint of energy passing over the surface.'

1014 HESS, THOMAS B. *Abstract Painting: Background and American Phase*, New York, Viking Press, 1951, 162 pp. illus. ('This was the first substantial book on abstract painting in New York and in the eyes of the artists easily a prime mover of the fifties,' P. G. Pavia, *bibl.* 1075, p. 8.)

'. . . something new in art history . . . appears with these painters . . . not a program or a movement. . . . Rather, in their work a new interpretation of nature and of man is made. Paintings epitomize the sensation of the artist, aware and at work; absorb and reflect it as human inspiration; its mysteries and grandeurs become the heroes.'

1015 RITCHIE, ANDREW CARNDUFF. *Abstract Painting and Sculpture in America*, New York, Museum of Modern Art, 1951, 159 pp. illus. (Reviewed *bibl.* 1252.)

1016 SORZANO, MARGO. '17 Modern American Painters: A Recent Exhibition at the Frank Perls Gallery,' *Arts and Architecture*, vol. 68, no. 1, January 1951, pp. 26–28, 42 illus.

1017 LANGSNER, JULES. 'More About the School of New York,' *Arts and Architecture*, vol. 68, no. 5, May 1951, pp. 20, 46. (See also Motherwell preface for this exhibition, *bibl.* 457.)

1018 'La Peinture aux Etats-Unis,' *Art d'aujourd'hui*, series 2, no. 6, June 1951, pp. 1–25 illus. (Special issue on American art, includes article by M. Seuphor, excerpts from *bibl.* 988, statement by Gottlieb, and a Reinhardt cartoon.)

1019 COATES, ROBERT M. 'The Abstract Expressionists and Others,' *New Yorker*, vol. 27, no. 46, 29 December 1951, pp. 58–59.

1020 MATHIEU, GEORGES. *Declaration to the American Avant-Garde Painters*, April 1952, 3 pp. mimeographed. (Concerning Parisian tachisme and American abstract expressionism.)

1021 SCHAPIRO, MEYER. 'Rebellion in Art,' in Daniel Aron, ed., *America in Crisis*, New York, Alfred A. Knopf, 1952, pp. 203–42.

1022 GREENBERG, CLEMENT. 'Feeling is All,' *Partisan Review*, vol. 19, no. 1, January–February 1952, pp. 97–102. (Reprinted as 'Art Chronicle' in *bibl.* 1079.)

1023 SEITZ, WILLIAM C. 'Spirit, Time, and Abstract Expressionism,' *Magazine of Art*, vol. 46, no. 2, February 1953, pp. 80–87 illus.

'Far from aiming at a programmatic abstraction of dehumanization, *human content* – interpreted in terms of a reality that is felt, rather than experienced visually or tactilely – is a central concern of American art today. . . . We have often failed to realize that the painters' and sculptors' empathetic identification with materials, technical processes, and structure is a symbolic function of the entire personality.'

1024 KRAMER, HILTON. 'The New American Painting,' *Partisan Review*, vol. 20, no. 4, July–August 1953, pp. 421–27.

1025 GREENBERG, CLEMENT in 'Symposium: Is the French avant-garde overrated?' *Art Digest*, vol. 27, no. 20, September 1953, pp. 12–13, 27. (Greenberg's contribution compares French and American abstract expressionism.)

1026 HAMILTON, GEORGE HEARD. 'Object

and Image: Aspects of the Poetic Principle in Modern Art' in *Object and Image in Modern Art and Poetry*, Yale University Art Gallery, New Haven, 1954, pp. 4–8. (35-p. cat., illus., includes poems by Cummings, Maritain, Stevens, Pound, Williams, Warren, Auden, Eliot, Thomas, and paintings by Gottlieb, Motherwell, Pollock, Rothko, Still.)

1027 WAGNER, GEOFFREY. 'The New American Painting,' *Antioch Review*, vol. 14, no. 1, March 1954, pp. 3–13; vol. 14, no. 2, June 1954, 'Art, Art Writing, and Mr Wagner,' pp. 249–55. (Letters on the Wagner article by C. Greenberg, H. Rosenberg, and reply by the author.)

1028 SAWYER, KENNETH B. 'L'Expressionisme Abstrait: La Phase du Pacifique,' *Cimaise*, series 1, no. 7, June 1954, pp. 3–5 illus.

1029 FRIEDMAN, B. H. 'The New Baroque,' *Art Digest*, vol. 28, no. 20, 15 September 1954, pp. 12–13 illus.

1030 HUNTER, SAM. 'Painting by Another Name,' *Art in America*, vol. 42, no. 4, December 1954, pp. 291–95 illus. (Reprinted in *Art in America*, vol. 51, no. 4, August 1963.)

1031 SEITZ, WILLIAM C. *Abstract-Expressionist Painting in America: An Interpretation Based on the Work and Thought of Six Key Figures*, unpublished Doctoral Dissertation, Princeton University, 1955, 495 pp. typescript in Museum of Modern Art Library, New York; bibliography pp. 482–95. (Includes De Kooning, Gorky, Hofmann, Motherwell, Rothko.)

1032 O'HARA, FRANK. 'Nature and the New Painting,' *Folder*, no. 3, 1954–55. (Reprint by Tiber Press.)

1033 DE KOONING, ELAINE. 'Subject: What, How or Who?' *Art News*, vol. 54, no. 2, April 1955, pp. 26–29, 61–62 illus.

1034 SWEENEY, JAMES JOHNSON. 'Recent Trends in American Painting,' *Bennington College Alumnae Quarterly*, vol. 7, no. 1, Fall 1955, pp. 8–11.

1035 GOLUB, LEON. 'A Critique of Abstract Expressionism,' *College Art Journal*, vol. 14, no. 2, Winter 1955, pp. 142–47.

1036 READ, HERBERT. 'An Art of Internal Necessity,' *Quadrum*, no. 1, 1956, pp. 7–22 illus.

'[This] type of artist is searching for forms behind the veil of consciousness, . . . irrespective of any representational significance. . . . Such forms need not be figurative . . . the deeper we penetrate the cloud of unknowing . . . the less likely are we to find the shapes and images of our waking world. . . . In the deeper layers of the unconscious there is a formative principle at work, moulding some primordial material of the psyche into icons . . . rather than symbols. . . .'

1037 ALLOWAY, LAWRENCE. 'Introduction to "Action",' *Architectural Design*, vol. 26, no. 1, January 1956, p. 30 illus. (On the American exhibition, *bibl.* 1267.)

'The problem is to establish an iconography that will stand up to the violence of their technique, a tough image that can survive the battering it gets in the act of painting. . . . By their equation of technique and action, secondly by their foundation of an iconography capable of repetition without, however, destroying the early freedom, American painters have led the world.'

1038 SCHAPIRO, MEYER. 'The Younger American Painters of Today,' *The Listener*, 26 January 1956, pp. 146–47. (Originally delivered as a talk on BBC on the occasion of the American exhibition, *bibl.* 1198.)

1039 ASHTON, DORE. 'L'Apport artistique des Etats-Unis,' *XXe siècle*, no. 7, June 1956, pp. 69–72 illus.

1040 SAWYER, KENNETH. 'The Century Plant: A Dialogue on Current Painting,' *Hudson Review*, vol. 9 no. 3, Autumn 1956, pp. 431–37.

1041 MELVILLE, ROBERT. 'Action Painting: New York, Paris, London,' *Ark*, no. 18, November 1956, pp. 30–33 illus.

1042 [Special issue on New York], *Cimaise*, series 4, no. 2, November–December 1956, pp. 7–31 illus. (Includes 'La Peinture actuelle à New York,' by Dore Ashton; 'Les Galeries de New York' by Kenneth Sawyer, and 'Potentiel américain,' by Julien Alvard: texts in English and French.)

1043 PASLOFF, PATRICIA, ed. *The 30's: Painting in New York*, Poindexter Gallery, New York, 1957, 11 pp. plus plates. (Includes statements by participating artists, texts by Patricia Pasloff, Agnes Gorky Phillips, and Edwin Denby on De Kooning.)

1044 READ, HERBERT. 'A Seismographic Art' in his *The Tenth Muse*, London, Routledge and Kegan Paul, 1957, pp. 297–303 plus illus.

1045 SCHAPIRO, MEYER. 'The liberating quality of avant-garde art,' *Art News*, vol. 56, no. 4, Summer 1957, pp. 36–42 illus.
'Paintings and sculptures are the last handmade, personal objects within our culture. . . . The object of art is, therefore, more passionately than ever before, the occasion of spontaneity. . . . The consciousness of the . . . spontaneous . . . stimulates the artist to invent devices of handling, processing, surfacing, which confer to the utmost degree the aspect of the freely made. Hence the great importance of the mark, the stroke, the brush, the drip . . . and the surface of the canvas as a texture and field of operation.'

1046 GREENBERG, CLEMENT. 'New York Painting Only Yesterday,' *Art News*, vol. 56, no. 4, Summer 1957, pp. 58–59, 84–86 illus. (Reprinted in *bibl.* 1079.)

1047 JARRELL, RANDALL. 'The Age of the Chimpanzee: A Poet argues as Devil's Advocate Against the Canonization of Abstract Expressionism,' *Art News*, vol. 56, no. 4, Summer 1957, pp. 34–35 illus.
'One sees in abstract-expressionism the terrible esthetic disadvantages of directness and consistency. Perhaps painting can do without the necessity of imitation; can it do without the possibility of distortion?'

1048 ALLOWAY, LAWRENCE. 'Background to Action: A series of Six Articles on Post-War Painting, I: Ancestors and Revaluations,' *Art News and Review*, vol. 9, no. 19, 12 October 1957, pp. 1, 2; 'II: The Marks,' vol. 9, no. 20, 26 October 1957, pp. 1–2 illus.; 'IV: The Shifted Centre,' vol. 9, no. 23, 7 December 1957, pp. 1, 2; 'VI: The Words,' vol. 9, no. 26, 18 January 1958, pp. 3–4. (Articles III and V on Paris and *Cobra*.)
'Whatever terms go into the history books, here is a warning. Action painting may be part of a general increase in painterliness, but in its pure form it is very much more than that. Remember: action is not just a new word for painterly. It involves a new idea about art.'

1049 GOODALL, DONALD B. *Partial Bibliography of American Abstract-Expressive Painting, 1943–1958*, University of Southern California Department of Fine Arts, Spring 1958, 23 pp., mimeographed.

1050 HUNTER, SAM. 'USA' in *Art Since 1945*, New York, Harry N. Abrams, 1958, pp. 283–348 illus. (Includes numerous quotations from the artists.)
'The plastic vigor of American abstract expressionism stems from a heightened consciousness of the act of creation. It is an art of origins, young, intense, harsh, and new; its emotional force derives from the identification of an abstract means, of the painting process itself, with passion, with disquiet, with problems of existence and being . . . the radical new painting has taught a whole generation in America how to "think" directly in paint, and administered a valuable lesson of sensuality.'

1051 ASHTON, DORE. 'La Signature Américaine,' *XXe siècle*, no. 10, March 1958, pp. 62–64 illus. (English original p. 90.)
'The climate today is different from the rebellious, fretful climate of the early fifties. An interiorization process is taking place. The identity of the artist is not expressed so much in his "sign" but in his manner of articulating paint. . . . Symbolism has taken an advanced form in current painting . . . the autographic lines which weave into a painting are taken as parts adding up to a whole, and the *whole* becomes a symbol.'

1052 RUBIN, WILLIAM. 'The New York School – Then and Now,' Part I, *Art International*, vol. 2, nos. 2–3, 1958, pp. 23–26 plus illus.; Part II, vol. 2, nos. 4–5, 1958, pp. 19–22.

1053 *It Is*, nos. 1–5, Spring 1958–Spring 1960. (A magazine of abstract art edited by sculptor P. G. Pavia and oriented to abstract expressionism; includes numerous writings by the 'Tenth Street Artists.')

1054 RUDIKOFF, SONIA. 'Space in Abstract Painting,' *Partisan Review*, vol. 25, no. 2, Spring 1958, pp. 297–304.

1055 ROSENBLUM, ROBERT. 'Unité et divergences de la peinture américaine: la peinture américaine depuis la seconde guerre mondiale,' *Aujourd'hui*, no. 18, July 1958, pp. 12–18 illus.; followed by Rachel Jacobs, 'Jazz ou la peinture investie,' pp. 19–21.

1056 ALLOWAY, LAWRENCE. 'Art in New York Today,' *The Listener*, vol. 60, no. 1543, 23 October 1958, pp. 647–48 illus.

1057 FERREN, JOHN. 'On Innocence in Abstract Painting,' *It Is*, no. 2, Autumn 1958, p.12.

1058 FERREN, JOHN. 'Epitaph for an Avante-Garde: The Motivating Ideas of the Abstract Expressionist Movement as seen by an artist active on the New York scene,' *Arts*, vol. 33, no. 2, November 1958, pp. 24–26, 68. (Originally given as a lecture at the University of Florida, Gainesville, 1958.)

'Around the club in the late forties the word "evaluation" was taboo. We looked, and we liked it or did not; we did not give it a value. We took it as part of the search. . . . We faced the canvas with the Self, whatever that was, and we painted. . . . The only control was that of truth, intuitively felt . . . painters boasted of their paintings as a tangible record of a series of errors. . . . Abstract expressionism solves the dichotomy of reality and abstraction by ignoring it. There is no longer a belief in an objective reality out *there* and a pure arrangement of lines and colors right *here*; there is instead the fact of a painted surface where both these elements meet with a third; the artist's emotion.'

1059 JACOBS, RACHEL AND HAGEN, YVONNE. 'L'Académie délinquante,' *Aujourd'hui*, no. 20, December 1958, pp. 36–38 illus.

1060 HODIN, J.P. 'The Fallacy of Action Painting,' *Art News and Review*, vol. 10, no. 24, 20 December 1958, pp. 2–3, 10.

1061 ALLOWAY, LAWRENCE. 'The New American Painting,' *Art International*, vol. 3, nos. 3–4, 1959, pp. 21–26 illus.

1062 ROSENBERG, HAROLD. 'Tenth Street: A geography of Modern Art,' *Art News Annual*, no. 28, 1959, pp. 120–43, 184, 186, 188, 190, 192 illus.

1063 ROSENBERG, HAROLD. *The Tradition of the New*. New York, Horizon Press, 1959. ('American Painting Today,' pp. 13–83, includes: 'Parable of American Painting,' 'The American Action Painters,' 'Extremist Art,' 'Virtual Revolution,' 'Everyman a Professional,' and 'Revolution and the Concept of Beauty.')

1064 ROSEN, ISRAEL. 'Toward a Definition of Abstract Expressionism,' *Baltimore Museum of Art News*, vol. 22, no. 3, February 1959, pp. 3–13 illus. (Includes an anthology of writings on abstract expressionism by Hess, Barr, Hartigan, Ashton, Rosenberg, Ferren.)

1065 ALLOWAY, LAWRENCE. 'Paintings *From* the Big Country,' *Art News and Review*, vol. 11, no. 4, 14 March 1959, pp. 3, 6–11, 17 illus.

1066 LANES, JERROLD. 'Reflections on Post-Cubist Painting,' *Arts*, vol. 33, no. 8, May 1959, pp. 24–29 illus. (Primarily on Newman and Motherwell.)

1067 REXROTH, KENNETH. 'Americans Seen Abroad,' *Art News*, vol. 58, no. 4, June 1959, pp. 30–33, 52, 54 illus.

1068 KRAMER, HILTON. 'The End of Modern Painting,' *The Reporter*, vol. 21, no. 2, 23 July 1959, pp. 41–42.

'This is the real meaning of the abstract expressionist movement in New York: that it has promised a liberation from culture in the name of an art which, whether violent or serene, resigns from all the complexities of mind which Europe still regards as the *sine qua non* of artistic seriousness. It has thus brought modern painting to an end.'

1069 GOLDWATER, ROBERT. 'Everyone knew what everyone else meant,' *It Is*, no. 14, Autumn 1959, p. 35. (On 'The Club.')

'The proceedings always had a curious air of unreality. One had a terrible time following what was going on. The assumption was that everyone knew what everyone else meant, but it was never put to the test. . . . Communication was always verbal. For artists, whose first (if not final) concern is with the visible

and the tangible, this custom assumed the proportions of an enormous hole at the center.'

1070 PORTER, FAIRFIELD. 'Art,' *Nation,* vol. 189, no. 10, 3 October 1959, pp. 197–98.

'As painting reveals, like handwriting, the state of the artist's soul, so a national school shows the strength and weakness of the class that produces it. . . . The impressionists taught us to look at nature very carefully; the Americans teach us to look very carefully at the painting. Paint is as real as nature and the means of a painting can contain its ends. . . . The non-intellectuality of a self-sufficient art is quite different from the anti-intellectuality of the Nazis or the Communists. . . .'

1071 ALLOWAY, LAWRENCE. 'Sign and Surface: Notes on Black and White Painting in New York,' Quadrum, no. 9, 1960, pp. 49–62 illus.

1072 ASHTON, DORE. 'Perspective de la peinture Américaine,' *Cahiers d'art,* vols. 33–35, 1960, pp. 203–21 illus.

1073 GOLDWATER, ROBERT. 'Reflections on the New York School,' *Quadrum,* no. 8, 1960, pp. 17–36, illus.

1074 ARNASON, H.H. 'Abstract Expressionism in 1960' in *60 American Painters 1960: Abstract Expressionist Painting of the Fifties,* Walker Art Center, Minneapolis, 3 April–8 May 1960, pp. 11–23; 79-p. cat. illus.; extensive bibl. pp. 54–78.

'I was impressed by the sense of control and structure that underlies so much of the most violent action painting. So much has been written by critics and the artists themselves of action painting as an art of "becoming" . . . that the spectator tends to lose perspective. . . . We forget the fact that all of these artists are highly skilled in their craft . . . so that their attempts at pure automatism, their pursuit of the irrational are controlled by the experience and the tradition of form which pervade their subconscious.'

1075 PAVIA, PHILIP G. 'The Unwanted Title: Abstract Expressionism,' *It Is,* no. 5, Spring 1960, pp. 8–11. (Concerning seven panel discussions at 'The Club' in 1952 on the title 'Abstract Expressionism.')

1076 MATHIEU, GEORGES. 'Towards a New Convergence of Art, Thought, and Science,' *Art International,* vol. 4, no. 4, May 1960, pp. 26–47 illus.

1077 READ, HERBERT AND ARNASON, H.H. 'Dialogue on Modern U.S. Painting,' *Art News,* vol. 59, no. 3, May 1960, pp. 32–36 illus. (On the exhibition at Walker Art Center, *bibl.* 1074.)

1078 HESS, THOMAS B. 'Editorial: The Many Deaths of American Art,' *Art News,* vol. 59, no. 6, October 1960, p. 25.

1079 GREENBERG, CLEMENT. *Art and Culture,* Boston, Beacon Press, 1961. (Includes 'American Type Painting,' pp. 208–29, and other early articles on abstract expressionism, reviewed *bibl.* 1080.)

1080 GOLDWATER, ROBERT. 'Art and Criticism,' *Partisan Review,* vol. 28, nos. 5–6, 1961, pp. 688–90, 692–94. (Review of *bibl.* 1079.)

1081 HELLER, BEN. 'The Roots of Abstract Expressionism,' *Art in America,* vol. 49, no. 4, 1961, pp. 40–50 illus.

1082 ROSENBLUM, ROBERT. 'The Abstract Sublime,' *Art News,* vol. 59, no. 10, February 1961, pp. 38–41, 56–57 illus. (On Still, Rothko, Pollock, and Newman.)

1083 ASHTON, DORE. *The Unknown Shore: A View of Contemporary Art,* Boston, Toronto Little, Brown and Co., 1962, 265 pp. illus. (primarily on New York painting).

'It is significant that the aspect of surrealist imagery that most interested American painters was metamorphosing form. The initial experiment with metamorphic symbols in the United States was to lead directly to abstraction. A form if it appears to be in an intermediate stage implies *time.* The idea that forms could shift and grow on a canvas, that time itself could be suggested by forms, eventually developed in American painting into the abstract expressionist notion of "all-over" space.'

1084 JACOBS, RACHEL. 'L'Ideologie de la peinture américaine,' *Aujourd'hui,* no. 37, June 1962, pp. 6–19 illus.

1085 GREENBERG, CLEMENT. 'After Abstract Expressionism,' *Art International,*

vol. 6, no. 8, 25 October 1962, pp. 24–32 illus. (See *bibl.* 1096 for response.)

'The whole evolution of abstract expressionism could be described as a devolution from a synthetic kind of abstract cubism to an analytical kind. . . . Whereas analytical cubism had arrived at the brink of outright abstraction by pursuing both art and nature, abstract expressionism returned to the verge of nature by pursuing apparently, art alone. . . . Like so much of the painterly art before it, abstract expressionism has worked . . . to reduce the role of colour; . . . Still, Newman and Rothko turn away from the painterliness of abstract expressionism as though to save the objects of painterliness – colour and openness – from painterliness itself.'

1086 HESS, THOMAS B. 'Editorial: Of Chimps and Chumps,' *Art News*, vol. 61, no. 6, October 1962, pp. 23, 54.

1087 ROSENBERG, HAROLD. 'A Risk for the Intelligence,' *New Yorker*, 27 October 1962, pp. 152–54, 157–63.

1088 ROSENBERG, HAROLD. 'Action Painting: A Decade of Distortion,' *Art News*, vol. 61, no. 8, December 1962, pp. 42–45, 62–63 illus. (Reprinted as 'The Premises of Action Painting' in *Encounter*, vol. 20, no. 5, May 1963, pp. 47–50.)

1089 FEIBLEMAN, JAMES K. 'Concreteness in Painting: Abstract Expressionism and After,' *The Personalist*, vol. 43, no. 1, Winter 1962, pp. 70–83.

1090 ALLOWAY, LAWRENCE. 'The American Sublime,' *Living Arts*, no. 2, 1963, London, pp. 11–22 illus.

1091 READ, HERBERT. 'The Principle of Speculative Volition' in *The Form of Things Unknown*, Cleveland, New York, Meridian Books, World Publishing Co., 1963, pp. 157–69 plus illus.

1092 KAPROW, ALLAN. 'Impurity,' *Art News*, vol. 61, no. 9, January 1963, pp. 30–33, 52–55 illus.

1093 GAUL, WINFRED. 'Amerika, hast du es besser?' *Kunstwerk*, vol. 16, no. 9, March 1963, pp. 2–9, 13 illus.

1094 KAVOLIS, VYTANTAS. 'Abstract Expressionism and Puritanism,' *Journal of Aesthetics and Art Criticism*, vol. 21, no. 3, Spring 1963, pp. 315–19.

1095 ALLOWAY, LAWRENCE. 'The American Sublime,' *Living Arts*, vol. 1, no. 2, June 1963, pp. 11–22 illus. (On Newman Rothko, and Still.)

'[In the American sublime] there is no sense of occasion . . . but neither is there a sense of impersonality. . . . The work of art . . . is itself the product of an intense moral act . . . the subject is non-verbal but deeply human. The artist is not concerned with diversification or elaboration; his concern is the monumentalizing of his own emotion. . . . Uniqueness is born from monotony, drama from privacy.'

1096 KOZLOFF, MAX. 'A Letter to the Editor,' *Art International*, vol. 7, no. 6, June 1963, pp. 88–92. (Response to *bibl.* 1085.)

1097 GREENBERG, CLEMENT. 'The "Crisis" of Abstract Art,' *Arts Yearbook*, no. 7, 1964, pp. 89–92.

'Painterly abstraction has collapsed not because it has become dissipated in formlessness, but because in its second generation it has produced some of the most mannered, imitative, uninspired, and repetitious art in our tradition . . . far from being formless, second-generation painterly abstraction is overformed, choked with form, the way all academic art is.'

1098 KRAMER, HILTON. 'Notes on Painting in New York,' *Arts Yearbook*, no. 7, 1964, pp. 10–20 illus.

1099 READ, HERBERT. 'The Limits of Painting,' *Studio*, vol. 167, no. 849, January 1964, pp. 2–11.

1100 ROSENBERG, HAROLD. 'After Next What?' *Art in America*, vol. 52, no. 2, April 1964, pp. 65–73 illus.

'The New American painting could not be apprehended without an intuition of its pathos. In the lofts of downtown Manhattan that pathos consisted not only of the social isolation of painting, but the painful awareness of the artist that art could not reach beyond the gesture of the canvas without being transformed into something unintended.'

1101 ASHTON, DORE. 'La Voix du tourbillon dans l'Amérique de Kafka,' *XXe siècle*, no. 23, May 1964, pp. 92–96 illus. (In French and English.)

1102 HESS, THOMAS B. 'A Tale of Two

Cities,' *Location*, vol. 1, no. 2, Summer 1964, pp. 37–42. (On the Schools of Paris and New York.)

1103 GREENBERG, CLEMENT. 'Post Painterly Abstraction,' *Art International*, vol. 8, nos. 5–6, Summer 1964, pp. 63–65 illus. (The preface to an exhibition selected by Greenberg and held at the Los Angeles County Museum of Art, 23 April–7 June 1964.)

1104 ARMSTRONG, RICHARD. 'Abstract Expressionism was an American Revolution,' *Canadian Art*, vol. 21, no. 93, September–October 1964, pp. 262–65 illus.

1105 HUNTER, SAM. 'Abstract Expressionism Then – and Now,' *Canadian Art*, vol. 21, no. 93, September–October 1964, pp. 266–69 illus.

1106 SMITH, DAVID. 'The Secret Letter' in *David Smith*, Marlborough-Gerson Gallery, New York, October 1964, pp. 3–9. (An interview by Thomas B. Hess.)
'We had no group identity in the 1930s. In the 1940s it developed when Pollock and Motherwell and Rothko were showing and seemed to become a kind of group.... We were all individuals, sort of expatriates in the United States and New York.... The chance then wasn't a sale, the chance was only the privilege to exhibit. Nobody I knew made a living from sales. Artists showed their work to other artists.'

1107 SANDLER, IRVING H. [Forthcoming book on abstract expressionism, on a grant provided by Guggenheim Foundation, 1964.]

1108 'Sharks, Go Home,' *Newsweek*, vol. 64, no. 8, 24 August 1944, p. 78 illus. (On Provincetown: includes statements by Hofmann and Motherwell.)

Recent Writings 1965–69 (chronologically)

1109 KOZLOFF, MAX. 'The New American Painting,' in Kostelanetz, R., ed., *The New American Arts*, New York, Horizon Press, 1965.

1110 ROSENBERG, BERNARD AND FLIEGEL, NORRIS. *The Vanguard Artist: Portrait and Self-Portrait*, Chicago, Quadrangle Press, 1965. Chapter 1, 'The New York School: Emergence and Triumph,' pp. 11–38.

1111 SYLVESTER, DAVID. *Modern Art: From Fauvism to Abstract Expressionism*, New York, Franklin Watts, 1965.

1112 GREENBERG, CLEMENT. 'America Takes the Lead, 1945–65,' *Art in America*, vol. 53, no. 4, July–August 1965, pp. 108–09 illus.

1113 ALLOWAY, LAWRENCE. 'The Biomorphic Forties,' *Artforum*, vol. 4, no. 1, September 1965, pp. 18–22 illus.

1114 BRACH, PAUL. 'Postscript: the Fifties,' *Artforum*, vol. 4, no. 1, September 1965, p. 32.

1115 GOODNOUGH, ROBERT. 'Postscript: the Forties,' *Artforum*, vol. 4, no. 1, September 1965, p. 32.

1116 SANDLER, IRVING H. 'The Club,' *Artforum*, vol. 4, no. 1, September 1965, pp. 27–31 illus.

1117 TILLIM, SIDNEY. 'The Figure in Abstract Expressionism,' *Artforum*, vol. 4, no. 1, September 1965, pp. 45–48 illus.

1118 KOZLOFF, MAX. 'The Critical Reception of Abstract Expressionism,' *Arts Magazine*, vol. 40, no. 2, December 1965, pp. 27–32 illus. Based on a lecture at the Los Angeles County Museum of Art in connection with the New York School exhibition, 1 August 1965.

1119 HUNTER, SAM. 'American Art Since 1945,' in *New Art Around the World: Painting and Sculpture*, New York, Harry N. Abrams, 1966, pp. 9–58.

1120 BAIGELL, MATTHEW. 'American Abstract Expressionism and Hard Edge: Some Comparisons,' *Studio International*, vol. 171, no. 873, January 1966, pp. 11–15 illus. Discusses Motherwell, De Kooning, Still, Rothko, Pollock, Newman, among others.

1121 FRANKENSTEIN, ALFRED. 'American Art and American Moods,' *Art in America*, vol. 54, no. 2, March–April 1966, pp. 76–87 illus. Discusses Pollock, Kline, and others.

1122 PAVIA, PHILLIP. 'Polemic on One-Eye Formats,' *Art News*, vol. 65, no. 9,

December 1966, pp. 28–31, 62–64 illus.

1123 FELDMAN, EDMUND BURKE. *Art as Image and Idea*, Englewood Cliffs, N.J., Prentice-Hall, 1967.

1124 ROSE, BARBARA. *American Art Since 1900: A Critical History*, New York and Washington, Frederick A. Praeger, 1967.

1125 SWENSON, G.R. 'Peinture américaine, 1946–1966,' *Aujourd'hui*, vol. 10, January 1967, p. 156 illus. Discusses De Kooning, Pollock, Motherwell, and younger artists.

1126 BOWNESS, ALAN. 'American Invasion and the British Response,' *Studio International*, vol. 173, no. 890, June 1967, pp. 285–93 illus. Discusses Pollock, Mother-

well, Kline, De Kooning, Rothko, Newman, among others.

1127 'Concerning the Beginnings of the New York School: 1939–43,' *Art International*, vol. 11, no. 6, Summer 1967, pp. 17–20, an interview with Peter Busa and Matta, conducted by Sidney Simon; pp. 20–22, an interview with Motherwell conducted by Sidney Simon.

1128 SOLOMON, ALAN. 'The New York Art Scene: Who Makes It?' *Vogue*, vol. 149, 1 August 1967, p. 102.

1129 ROSE, BARBARA, ed. *Readings in American Art Since 1900: A Documentary Survey*, New York and Washington, Frederick A. Praeger, 1968.

RELATED CONTEMPORARY WRITINGS

1130 TYLER, PARKER. 'The Limit of the Probable in Modern Painting,' *View*, series 5, no. 1, March 1945, pp. 39, 41. (Based on review of *bibl.* 984.)

1131 'Kootz' Kaleidoscopes,' *Newsweek*, 30 July 1945.

1132 GUGGENHEIM, PEGGY. *Out of This Century*, New York, Dial Press, 1946. ('Informal memoirs.')

1133 'Modern Art' and the American Public statement by the Institute of Contemporary Art, Boston, 17 February 1948, 2 pp. (Concerning the change of the Institute's name from 'modern' to 'contemporary' art; see also comment in *Newsweek*, 1 March 1948, and *An Institute is an Institute*, symposium at Bard College, 1 August 1948, a 7-p. mimeographed pamphlet; and *A Statement on Modern Art*, issued jointly by the Institute of Contemporary Art, Boston, the Museum of Modern Art, and the Whitney Museum of American Art, New York, March 1950, 3 pp.

1134 SOBY, JAMES THRALL. 'Some Younger American Painters' in *Contemporary Painters*, Museum of Modern Art, New York, 1948, pp. 69–84. (Includes Baziotes,

Gottlieb, Motherwell, Pollock, Rothko.)

1135 DAVENPORT, RUSSELL, ed. 'A Life Round Table on Modern Art,' *Life*, vol. 25, no. 15, 11 October 1948, pp. 56–79 illus. (Symposium held at Museum of Modern Art, participants including Greenberg, Schapiro, Sweeney, Soby; section on 'Young American Extremists,' pp. 62–63.)

1136 MACAGY, DOUGLAS, ed. *Western Round Table on Modern Art*, San Francisco Art Association, 1949, 71-p. mimeographed synopsis of the proceedings. (Participants include Duchamp, Goldwater, Ritchie, Tobey, F. L. Wright; reprinted *bibl.* 989.)

1137 PARSONS, BETTY. [Statement] *c.* 1949, unpublished typescript at Betty Parsons Gallery, New York, 1 p.
'The problem of being an American is unimportant. They could paint their pictures anywhere. But it is important that they have the background of the American Dream.'

1138 GREENBERG, CLEMENT. 'The European View of American Art,' *Nation*, 25 November 1950, pp. 490–93. (Includes a 'Reply' by David Sylvester.)

1139 TANNENBAUM, LIBBY. 'Notes at Mid-Century,' *Magazine of Art*, vol. 43, no. 8, December 1950, pp. 289–92 illus.

1140 HESS, THOMAS B. 'Introduction to Abstract,' *Art News Annual*, vol. 49, no. 7, part II, November 1950, pp. 158, 186–87 illus.

1141 BAUR, JOHN I. H. *Revolution and Tradition in Modern American Art*, Cambridge, Harvard University Press, 1951, p. 170 illus.

1142 BLANC, PETER. 'The Artist and the Atom,' *Magazine of Art*, vol. 44, no. 4, April 1951, pp. 145–52 illus.

1143 LOUCHHEIM, ALINE B. 'L'Arte in America, Oggi,' *Biennale*, no. 4, April 1951, pp. 20–24 illus.

1144 LOUCHHEIM, ALINE B. 'Betty Parsons: Her Gallery, Her Influence,' *Vogue*, vol. 118, no. 6, 1 October 1951, pp. 150–51, 194–97 illus.

1145 FITZSIMMONS, JAMES. 'Art for Export: Will It Survive the Voyage?' *Art Digest*, vol. 26, no. 7, 1 January 1952, p. 9 illus.

1146 'Abstraction for Export.' *Time*, vol. 59, no. 6, 11 February 1952, p. 71 illus.

1147 RITCHIE, ANDREW CARNDUFF. 'Maturité de l'art américaine,' *Arts* (Paris), no. 407, 17–23 April 1953, p. 9.

1148 FAISON, S. LANE, JR. 'Art,' *Nation*, vol. 176, no. 16, 18 April 1953, pp. 333–34. (On Motherwell, De Kooning, Tomlin.)

1149 BARR, ALFRED H., JR. 'Recent American Abstract Art' in *Masters of Modern Art*, New York Museum of Modern Art, 1954, pp. 174–81 illus.

1150 HESS, THOMAS B. 'The New York Salon,' *Art News*, vol. 52, no. 10, February 1954, pp. 24–25, 56–57 illus.

1151 HESS, THOMAS B. 'American Abstract Art,' *U.S. Lines Paris Review*, June 1954.

1152 'L'Ecole du Pacifique,' *Cimaise*, series 1, no. 7, June 1954, pp. 6–9. (Symposium comparing Schools of Pacific and New York; participants: J. Alvard, C. Falkenstein, S. Francis, J. Fitzsimmons, M. Tapié; letter in reply by Paul Wescher, *Cimaise*, series 2, no. 5, April 1955, pp. 3–5.)

1153 TURNBULL, MURRAY. 'Notes on a New Naturalism,' *College Art Journal*, vol. 13, no. 2, Winter 1954, pp. 113–17 illus.

1154 FERREN, JOHN. 'Stable State of Mind,' *Art News*, vol. 54, no. 3, May 1955, pp. 22–23, 63–64 illus.

1155 TAPIÉ, MICHEL. 'Messages sans Etiquette,' *XXe siècle*, no. 5, June 1955, pp. 17–24 illus.

1156 SEIBERLING, DOROTHY. 'The Most Talked-About Painters in the World,' *Life* (International Edition), 12 December 1955, pp. 37 ff. illus.

1157 BLESH, RUDI. *Modern Art USA: Men, Rebellion, Conquest, 1900–1956*, New York, Alfred A. Knopf, 1956, pp. 222–81 illus.

1158 KOOTZ, SAMUEL. [Letter to the editor], *Art News*, vol. 55, no. 7, November 1956, p. 6. (Concerning the New York School and the School of Paris; criticism of *bibl.* 1157.)

1159 HESS, THOMAS B. 'U.S. Painting: Some Recent Directions,' *Art News Annual*, no. 25, 1956, pp. 74–98, 174, 176, 178, 180, 192, 194, 196, 198 illus.

1160 SWEENEY, JAMES JOHNSON. 'The Cat That Walks by Itself,' *Quadrum*, no. 2, 1956, pp. 17–28 illus. (Address given at the Art Institute of Chicago, 11 June 1954.)

1161 ASHTON, DORE. 'Art,' *Arts and Architecture*, vol. 73, no. 1, January 1956, pp. 10, 32–33 illus.

1162 MacANDREW, JOHN. 'Die Moderne Amerikanische Kunst und Europa,' *Werk*, vol. 43, no. 2, February 1956, pp. 52–59 illus.

1163 'The Wild Ones,' *Time*, vol. 67, no. 8, 20 February 1956, pp. 70–75 illus.

1164 FINKELSTEIN, LOUIS. 'New Look: Abstract-Impressionism,' *Art News*, vol. 55, no. 1, March 1956, pp. 36–39, 66–68 illus.

1165 SELZ, PETER. 'A New Imagery in American Painting,' *College Art Journal*, vol. 15, no. 4, Summer 1956, pp. 290–301 illus.

1166 GROSSER, MAURICE. 'Art,' *Nation*, vol. 183, no. 9, 1 September 1956, pp. 186–87. (On abstract expressionists as muralists and decorators.)

1167 SYLVESTER, DAVID. 'Expressionism, German and American,' *Arts*, vol. 31, no. 3, December 1956, pp. 25–27 illus.

1168 BAUR, JOHN I. H., ed. 'The Widening Search, 1940–1955' in *New Art in America*,

Greenwich, Conn., New York Graphic Society and New York, Frederick Praeger, 1957, pp. 220–81 illus. (Includes essays by Soby, D. C. Miller, and F. Wight on Baziotes, De Kooning, Motherwell, Pollock, Tomlin.)

1169 ELIOT, ALEXANDER. 'Adventures in Space' in *300 Years of American Painting*, New York, Time Inc., 1957, pp. 271–83 illus.

1170 GREENE, BALCOMB. 'The Artist's Reluctance to Communicate,' *Art News*, vol. 55, no. 9, January 1957, pp. 44–45, 60. (Based on a lecture given at a meeting of the Institute for Psychotherapy, New York.)

1171 RUDIKOFF, SONYA. 'Tangible Abstract Art,' *Partisan Review*, vol. 24, no. 2, Spring 1957, pp. 275–81.

1172 GROSSER, MAURICE. 'Art,' *Nation*, vol. 184, no. 21, 25 May 1957, pp. 464–65. (On Hofmann and abstract expressionism.)

1173 HAWKINS, ROBERT B. 'Contemporary Art and the Orient,' *College Art Journal*, vol. 16, no. 2, Winter 1957, pp. 118–31 illus.

1174 FAHLSTROM, OYVIND. '"Spontanism": slump, vision, tecken,' *Paletten*, vol. 19, no. 2, 1958, pp. 28–52 illus.

1175 GOOSSEN, EUGENE C. 'The Big Canvas,' *Art International*, vol. 2, no. 8, 1958, pp. 45–47 illus.

1176 RODITI, EDUARD. 'Peinture ou non-peinture Américaine ou non-Américaine,' *Présence*, nos. 7–8, 1958, pp. 108–10.

1177 TRIER, EDUARD. 'Neue Tendenzen der Amerikanischer Kunst,' *Kunstwerk*, vol. 1, no. 8, February 1958, pp. 3–22 illus.

1178 'A Boom in U.S. Art Abroad,' *Life*, vol. 44, no. 20, 19 May 1958, pp. 76, 78, 80 illus.

1179 CARDAZZO, CARLO. 'Viaggio a New York: Alla Ricera dell arte moderna,' *Le Arti*, nos. 6–7, July–August 1958, pp. 3–4 illus.

1180 'American Abstraction Abroad,' *Time*, vol. 72, no. 5, 4 August 1958, pp. 40–45 illus.

1181 BRUSTEIN, ROBERT. 'The Cult of Unthink,' *Horizon* (New York), vol. 1, no. 1, September 1958, pp. 38–45, 134–35 illus.

1182 GLASER, LUDWIG. 'Malerei der Neuen Welt,' *Herrenjournal*, no. 10, October 1958, pp. 146–47, 172–73 illus.

1183 ALLOWAY, LAWRENCE. 'Here It Is,' *Art News and Review*, vol. 10, no. 22, 22 November 1958, p. 8. (Review of *bibl*. 1053.)

1184 ASHTON, DORE. 'Some Lyricists in the New York School,' *Art News and Review*, vol. 10, no. 22, 22 November 1958, pp. 3, 8 illus.

1185 WILSON, FRANK AVRAY. 'Approaches to Contemporary Art: IV, An Interpretation of Non-Figurative Tendencies,' *Apollo*, vol. 68, no. 406, December 1958, pp. 217–19 illus.

1186 GETLEIN, FRANK. 'Art News Sees a Conspiracy,' *New Republic*, vol. 138, no. 8, 24 February 1958, p. 21. (On German expressionism, favorably compared with abstract expressionism.)

'One thing is never found in [German expressionism] and that is complete self-sufficiency. Its absence, I think, is what caused the shock and dismay at *Art News*. For all the "expressionism" of German art, there is never a hint of the current American theory employing the same name and seriously convinced that the sole relationship in art is one between the artist and his materials. . . .'
(Editorial note on this article no. 10, 10 March 1958, pp. 7–8, and letter from Norman James pp. 3, 23–24; reply to Getlein by Dorothy Goldberg, 'Liberals and Modern Art' in no. 12, 24 March 1958, pp. 3, 23–24.)

1187 HESS, THOMAS B. 'Art Criticism – "Advanced" or "Retardataire"' *New Republic*, vol. 140, no. 4, 26 January 1959, pp. 8–9. (Protesting article in editorial section of 15 December 1958 issue, vol. 139, no. 24, p. 6, 'Art Buccaneering,' on the high prices brought by Pollock's work; other letters on the subject from A. U. Pope, Len Lye, G. Tyler, and P. Groff, vol. 140, no. 5, 2 February 1959, pp. 3, 31, and no. 7, 16 February, p. 23 by Norman James.)

1188 GETLEIN, FRANK. 'The Same Old

Schmeerkunst,' *New Republic*, vol. 140, no. 4, 26 January 1959, pp. 21–22; 'Schmeerkunst and Politics,' no. 6, 9 February 1959, p. 29. (Also letters protesting 26 January article from Fred Mitten and Donald S. Baird, p. 23 of 2 February issue.)

'In the exaltation of an undefined Americanism as a supreme value, in the preference for simple existence to any meaning, and in the cherishing of sincerity without regard to results, I find abstract expressionism and its prophets to be a splendid artistic equivalent of Eisenhower Republicanism in politics.' 'The Schmeerkunst Controversy,' *New Republic*, vol. 140, no. 8, 23 February 1959, pp. 3, 23–24. (Letters from D.S. Baird, Fairfield Porter, reply by Getlein, who continues the attack in 'Man's Image at Urbana,' vol. 140, no. 11, 16 March 1959, and condemns Hess, Rosenberg, Hunter, etc. in 'Schmeerkunstkrieg Continued,' no. 17, 27 April 1959, pp. 21–22.)

Hunter, Sam, 'Jingoism in Reverse?' *New Republic*, vol. 140, no. 15, 13 April 1959, p. 23. (Letter protesting 'Schmeerkunst and Politics.')

'I should like to report my findings. Pollock and his related American contemporaries are profoundly admired, have become an important source of new artistic energies and hope and have, indeed, replaced Picasso as the symbol of liberation for a new European generation of artists.'

1189 ALDAN, DAISY. ed. *A New Folder*, New York Folder Editions, 1959. (Anthology of New York poetry illustrated by drawings by New York painters including De Kooning, Guston, Kline, Motherwell, Pollock, and others.)

1190 ALLOWAY, LAWRENCE. 'Before and After 1945: Reflections on Documenta II,' *Art International*, vol. 3, no. 7, 1959, pp. 28–36, 79 illus.

1191 HUNTER, SAM. 'Into the Forties: The Crisis in Painting' and 'Search for the Absolute' in *Modern American Painting and Sculpture*, New York, Dell Publishing Co., 1959, pp. 131–61 illus. (Bibliography by Bernard Karpel pp. 221–49.)

1192 LEGRAND, F. C. 'La Nouvelle Peinture Américaine,' *Quadrum*, no. 6, 1959, pp. 174–75 illus.

1193 RESTANY, PIERRE. 'U.S. Go Home and Come Back Later,' *Cimaise*, series 6, no. 3, January–March 1959, pp. 36–37. (Text in French and English.)

1194 CHARMENT, RAYMOND. 'La Nouvelle peinture Américaine: une reaction plastique contre le puritanisme Anglo-Saxon,' *Arts* (Paris), no. 707, 28 January–3 February 1959, p. 16 illus.

1195 RAGON, MICHEL. 'L'Art actuel aux Etats-Unis,' *Cimaise*, series 6, no. 3, January–March 1959, pp. 6–35 illus. (Text in French and English.)

1196 SAWYER, KENNETH. 'The Importance of a Wall: Galleries,' *Evergreen Review*, vol. 2, no. 8, Spring 1959, pp. 122–35 illus.

1197 GRAY, CLEVE. 'Narcissus in Chaos: Contemporary American Art,' *The American Scholar*, vol. 28, no. 4, Autumn 1959, pp. 433–43.

1198 LICHTENSTEIN, GENE. '10th Street: Main Street of the Art World,' *Esquire*, September 1959, pp. 102–07 illus.

1199 HABASQUE, GUY. 'Au-delà de l'informel,' *L'Oeil*, no. 59, November 1959, pp. 62–71, 75 illus.

1200 RUBIN, WILLIAM. 'Notes on Masson and Pollock,' *Arts*, vol. 34, no. 2, November 1959, pp. 36–43 illus.

'If surrealist art was too often content to rest on the level of happy accident, chance served for Pollock only as an operative element in the work. What counted was what he did in the face of the unexpected. The finished picture, when successful, demonstrated not the accident but its resolution.'

1201 RUSSELL, JOHN. 'The "New American Painting" Captures Europe,' *Horizon* (New York), vol. 2, no. 2, November 1959, pp. 32–41, 120–21 illus.

'In an age when the image, as such, is everywhere debased, we can be grateful to the new American painters for proving that paint on canvas can still be one of the most exciting and controversial forms of human expression.'

1202 *The Times Literary Supplement* (London), Special Number: *The American Imagination*, vol. 58, no. 3,010, 6 November

1959, 'Taking Stock: A Scattered Abundance of Creative Riches,' pp. 11–12; 'The Abstract Image: Diversity of Aim and Technique in the Non-Figurative Mode,' p. 26.

1203 SEIBERLING, DOROTHY. 'Abstract Expressionists,' 'Part I: Baffling U.S. Art: What It Is About,' *Life*, vol. 47, no. 19, 9 November 1959, pp. 68–80 illus. (On Pollock); 'Part II: The Varied Art of Four Pioneers,' no. 20, 16 November, pp. 74–83, 85–86 illus. (On Still, Kline, De Kooning, Rothko.)

1204 ASHTON, DORE. 'La Section Américaine,' *XXe siècle*, no. 14, 1960, pp. 118–19 illus. (Hofmann, Guston Kline at Venice Biennale; English text pp. 31–32–34.)

1205 GREENBERG, CLEMENT. 'Modernist Painting,' *Arts Yearbook*, no. 4, 1960, pp. 102–08 illus.

1206 GUGGENHEIM, PEGGY. *Confessions of an Art Addict*, New York, MacMillan, 1960. (Revised version of *bibl*. 1132; see 'Art of This Century,' pp. 99–114.)

1207 'Psychic Improvisation in American Painting' in Werner, Haftmann, *Painting in the Twentieth Century*, New York, Frederick A. Praeger, 1960, vol. 1, pp. 347–53; vol. 2, plates 461, 466–67, 496–515.

1208 LARKIN, OLIVER. *Art and Life in America*, New York, Holt, Rinehart and Winston, 1960, pp. 481–84 illus.

1209 LINDE ULF. 'Rosenberg och action painting,' *Konstrevy*, vol. 36, nos. 5–6, 1960, pp. 204–07 illus.

1210 NORDLAND, GERALD. [Editorial on abstract expressionism and the new figurative art], *ORB* (Chouinard Art Institute), vol. 1, no. 2, [1960?].

1211 PONENTE, NELLO. *Modern Painting: Contemporary Trends*, Geneva, Skira, 1960, chapters 4–9.

1212 RESTANY, PIERRE. 'L'Amérique aux Américains,' *Ring des Arts*, no. 1, 1960, pp. 22–31 illus.

1213 TALPHIR, GABRIEL. 'Modern Art in U.S.A.: Abstract Expressionism,' *Gazith*, vol. 17, nos. 199–204, 1960, pp. 1–2 plus 40 plates. (Summarized from article in Hebrew.)

1214 HESS, THOMAS B. 'U.S. Art, Notes from 1960,' *Art News*, vol. 58, no. 9, January 1960, pp. 24–29, 56–58 illus.

1215 MYERS, JOHN BERNARD. 'The Impact of Surrealism on the New York School,' *Evergreen Review*, vol. 4, no. 12, March–April 1960, pp. 75–85 illus.

1216 GREENBERG, CLEMENT. 'Distorted Evidence,' *New York Times*, 29 May 1960. (Reply to article on Harry Jackson and the New York School.)

1217 'International Look at the USA,' special issue of *Art in America*, vol. 48, no. 2, Summer 1960. 'Crisis and Creation' by Otto Bihalji-Merin, pp. 48–53; 'The Challenge of Contemporary Art' by Hans Theodor Fleming, pp. 60–65; 'A New Discipline' by Stanely Burke, pp. 44–47; 'Plus and Minus at the Moscow Show' by Vladimir Kemenov, pp. 34–39; 'From a Gulliver's Point of View' by Yoshiaki Tono, pp. 54–59; illus.

1218 WAGNER, GEOFFREY. 'The Organized Heresy – Abstract Art in the United States,' *Modern Age: A Conservative Review*, vol. 4, no. 3, Summer 1960, pp. 260–68; VIVAS, ELISEO, 'A Rejoinder: In Defense of Non-Objective Art,' vol. 4, no. 4, Fall 1960, pp. 412–15.

1219. McDARRAH, FRED W. *The Artist's World in Pictures*, New York, E. P. Dutton, 1961, 192 pp. (On the New York Scene; introduction by Thomas B. Hess, commentary by Gloria McDarrah.)

1220 SEITZ, WILLIAM C. *The Art of Assemblage*, Museum of Modern Art, New York, 1961, 176 pp. illus. (Includes Motherwell and De Kooning.)

1221 WARSHAW, HOWARD. 'The Return of Naturalism as the "Avant-Garde",' *Nation*, 22 May 1961, p. 347.

1222 BAKER, RICHARD BROWN. 'Notes on the Formation of My Collection,' *Art International*, vol. 5 no. 7, September 1961, pp. 40–47 illus.

1223 GELDZAHLER, HENRY. 'Heller: New American-Type Collector,' *Art News*, vol. 60, no. 5, September 1961, pp. 28–31, 58 illus.

1224 ALFORD, JOHN. 'Problems of a Humanistic Art in a Mechanistic Culture,' *Journal of Aesthetics and Art Criticism*, vol.

20, no. 1, Fall 1961, pp. 37–47 illus. ('Abstract Expressionist Painting and Humanism,' pp. 41–47.)

1225 KROLL, JACK. 'American Painting and the Convertible Spiral,' Art News, vol. 60, no. 7, November 1961, pp. 34–37, 66, 68–69 illus.

1226 CANADAY, JOHN. Embattled Critic, New York, Noonday Press, 1962. (Reprints of columns from the New York Times, including 'New York U.S.A.: The City and "The New York School",' pp. 24–29; 'In the Gloaming: Twilight Seems to be Settling Rapidly for Abstract Expressionism,' pp. 37–41; 'Jack Levine and Philip Guston,' pp. 137–41; 'Renunciation as Esthetics: Mark Rothko,' pp. 141–46; see also bibl. 1001; reviewed bibl. 555.)

1227 'The New American Painting Abroad,' Arts Yearbook, no. 6, 1962, pp. 83–94. (Selected reviews of the New American Painting Exhibition in London and Paris (bibl. 1281) by Patrick Heron, Robert Melville, and Annette Michaelson.)

1228 HENNING, EDWARD B. 'Some Contemporary Paintings,' Bulletin of the Cleveland Museum of Art, vol. 49, no. 3, March 1962, pp. 46–54, illus. covers. (Includes Motherwell and Guston.)

1229 REICHARDT, JASIA. 'Peinture Américaine,' Aujourd'hui, no. 36, April 1962, pp. 54–55.

1230 'The Dilemma of Success in American Painting,' The Times (London), 5 June 1962. ('From a Correspondent.')
'. . . "style" has an almost wholly pejorative meaning in many New York studios. To detect "style" or comment on it in a painter's work is tantamount to accusing him of being more concerned with manner than matter. . . . It is a quality he is often impatient with in European painting, a sort of Un-American activity. . . . "Style" would imply some slowing down, some "qualification" of the creative process, a fussing around the centre of the business instead of pushing intuitively outwards to its edges.'

1231 ASHTON, DORE. 'Abstract Expressionism Isn't Dead,' Studio, vol. 164, no. 883, September 1962, pp. 104–07 illus.

1232 'Art Since 1950: American,' Artforum, vol. 1, no. 4, September 1962, pp. 30–36 (illus. only.)

1233 McCOUBREY, JOHN W. 'The New Image' in American Tradition in Painting, New York, George Braziller, 1963, pp. 113–24 plus plates.

1234 NORDNESS, LEE, ed. Art U.S.A. Now, New York, Viking Press, 1963, 2 vols., illus. (Biographies, illus., brief texts, and occasional reprinted statements by the artists, including: Baziotes by M. Benedikt, De Kooning by D. Abramson, Gottlieb by J. Gollin, Guston by K. Levin, Hofmann by K. Levin, Kline by G. Swenson, Motherwell by J. Gollin, Pousette-Dart by R. Pease, Reinhardt by A. Grey.)

1235 ASHTON, DORE. 'Seven American Decades,' Studio, vol. 165, no. 840, April 1963, pp. 148–53 illus.

1236 SEITZ, WILLIAM C. 'The Rise and Dissolution of the Avant-Garde,' Vogue, vol. 142, no. 1, 1 September 1963, pp. 182, 230 illus.

1237 ASHTON, DORE. 'A to B,' Studio, vol. 166, no. 847, November 1963, pp. 194–97. (Reply to Leonard Baskin on originality in art, in Show, August 1963.)

1238 ROSE, BARBARA. 'New York Letter,' Art International, vol. 7, no. 9, December 1963, p. 61 illus. (On bibl. 1309.)

1239 SECKLER, DOROTHY GEES. 'The Artist in America: Victim of the Culture Boom,' Art in America, vol. 51, no. 6, December 1963, pp. 27–39 illus.

1240 KOZLOFF, MAX. 'The Impact of De Kooning,' Arts Yearbook, no. 7, 1964, pp. 76–88 illus.
'Part of the strength of recent American art has been its capacity to over-simplify experience, but to do so past the point of naïveté into fantasy and obsession. Yet the real depth of our art has more often been contained in its sometimes involuntary, or last-minute betrayal of its own restrictedness. De Kooning . . . was not merely saved by his anxiety, but had come early to realize that his art was premised on it.'

1241 Metro International Directory of Contemporary Art: 1964, Milan, Editoriale Metro, 1964. (Biographies, plates, portraits,

exhibition lists, and brief biographies; includes De Kooning, Gottlieb, Guston, Hofmann, Motherwell, Newman, Rothko, Still.)

1242 GREENBERG, CLEMENT. 'The Greenberg Collection,' *Vogue*, 15 January 1964, pp. 92–94 illus.

1243 'Auction Trends: The New York School on the Block,' *Art in America*, vol. 52, no. 2, April 1964, p. 105 plus illus.

1244 FRIED, MICHAEL. 'The Confounding of Confusion,' *Arts Yearbook*, no. 7, 1964,

pp. 35–37 illus.; also Judd, Donald, 'Local History,' pp. 23–35 illus.

1245 HOPKINS, HENRY T. 'Abstract Expressionism,' *Artforum*, vol. 2, no. 12, Summer 1964, p. 59 illus. (In relation to the California School.)

1246 KOZLOFF, MAX. 'The Dilemma of Expressionism,' *Artforum*, vol. 3, no. 2, November 1964, pp. 32–35 illus.

1247 O'DOHERTY, BRIAN. 'Vanity Fair: The New York Art Scene,' *Newsweek*, 4 January 1965, pp. 54–59 illus.

CATALOGUES AND REVIEWS OF GROUP EXHIBITIONS

(chronologically)

More extensive articles dealing wholly or partially with specific exhibitions are listed in previous sections. For a less specialized coverage of general exhibitions, see bibliographies in *bibls*. 1027, 1216; for additional group exhibition catalogues, see *bibls*. 457, 541, 990, 991, 993, 995, 1006, 1015, 1026, 1043, 1074, 1220.

1248 ROSENBERG, HAROLD. *Introduction à la peinture moderne Américaine*, sous le patronage de United States Information Services /and Kootz Gallery/, Galerie Maeght, Paris, March–April 1947, 12-p. cat. illus. (Includes Baziotes, Gottlieb, Motherwell; reviewed by Jean Cassou, *Art News*, July 1947; by Jean-Jose Marchand in *Combat*, 9 April 1947; also in *Carrefour*, 9 April, *Liberation*, 9 April, *London Daily Mail*, 12 April, *Cette Semaine*, 16 April, *La France au Combat*, 17 April, *Lettres Françaises*, 18 April, *Time*, 21 April, *Arts* (Paris), *Art Digest*, 1 May.)

1249 *The Intrasubjectives*. Kootz Gallery, New York, 14 September–3 October 1949, 4 pp. with colored illus. by Gottlieb, Baziotes, Hofmann; texts by Harold

Rosenberg and Samuel M. Kootz, pp. 2–3; exhibition also included De Kooning, Gorky, Motherwell, Pollock, Reinhardt, Rothko, Tomlin.

'The modern painter is not inspired by anything visible, but only by something he hasn't seen yet. . . . Things have abandoned him . . . he begins with nothingness. . . . The nothing the painters begins with is known as Space.' (Rosenberg.)

'Intrasubjectivism is a point of view in painting, rather than an identical painting style. . . . The artists in this exhibition have been among the first to paint within this new realm of ideas. As their work is seen and understood, we should have more additions to their ranks, until the movement of Intrasubjectivism becomes one of the most important to emerge in America.' (Kootz.)

1250 *The Muralist and the Modern Architect*, Kootz Gallery, New York, 3–23 October 1950, 12-p. cat. illus. (The muralists are Baziotes, Gottlieb, Hofmann, Motherwell.)

1251 *Young Painters in U.S. and France*, Sidney

214

Janis Gallery, New York, 23 October–
11 November 1950. (Compared Ameri-
can and French artists as follows: Brooks-
Wols, Cavallon-Coulon, De Kooning-
Dubuffet, Ferren-Goebel, J. Ernst-Singier,
Gatch-Pallut, Gorky-Matta, Graves-
Manessier, Kline-Soulages, Pollock-
Lonskoy, Reinhardt-Nejad, Rothko-de
Stael, Sterne-Da Silva, Tobey-Bazaine,
Tomlin-Ubac. Reviewed by Devree, *New
York Times*, 29 October 1950, Krasne, *Art
Digest*, 1 November, Coates, *New Yorker*,
4 November, Farber, *Nation*, 11 Novem-
ber; an informal discussion meeting took
place at the gallery 10 November 1950, on
the topic 'Parallel Trends in Vanguard
Art in the U.S. and France'; participants
included C. Greenberg, F. Kiesler, A.
Ritchie, H. Rosenberg, Theodore Bren-
son, moderator.)

1252 HESS, THOMAS B. 'Is Abstraction un-
American?' *Art News*, vol. 49, no. 10,
February 1951, pp. 38–41 illus. (On *bibl.*
1015.)

1253 SOBY, JAMES THRALL. 'Bellicose Fish
and a Steady Pulse,' *Saturday Review*, vol.
34, no. 5, 3 February 1951, pp. 28–29
illus. (On *bibl.* 1015.)

1254 TAPIÉ, MICHEL. *Véhémances Confron-
tées*, Galerie Nina Dausset, Paris, 8–31
March 1951, 8-p. broadside illus. (Exhi-
bition included Bryen, Capogrossi, De
Kooning, Hartung, Mathieu, Pollock,
Riopelle, A. Russell, Wols; writings by
Tapié, Bryen, Picabia, Jaguer, Russell,
Riopelle, Ballocce, Burri, Capogrossi,
Colla, Mathieu.)
 'For the first time the confrontation of
the most advanced American, Italian, and
French painters of today. . . .'

1255 *Ninth Street Exhibition*, May 1951. (Broad-
side designed by Franz Kline, with list of
artists; exhibition organized by Leo Cas-
telli.)

1256 ARNASON, H.H. 'Preface,' *40 American
Painters*, University of Minnesota Gallery,
Minneapolis, 4 June–30 August 1951,
pp. 1–3; 96-p. cat. illus. (Includes state-
ments by the artists: Baziotes, Gottlieb,
Guston, Hofmann, Motherwell, Pollock,
Reinhardt, Rothko, Tomlin.)

1257 *Regards sur la peinture Américaine*, Galerie

de France, Paris, 26 February–15 March
1952, 6-p. cat. with statements by the
artists and text by Leon Degan. (Organ-
ized by Sidney Janis 'with the advice of
New York art critics' and shown first at
the Janis Gallery as *American Vanguard Art
for Paris*, 26 December 1951–5 January
1952; participants: Albers, Baziotes,
Brooks, De Kooning, Goodnough,
Gorky, Gottlieb, Guston, Hofmann,
Kline, Matta, MacIver, Motherwell, Pol-
lock, Russell, Reinhardt, Tobey, Tomlin,
Tworkov, Vicente.)

1258 HESS, THOMAS B. 'The Modern Mus-
eum's Fifteen: Where U.S. Extremes
Meet.' *Art News*, vol. 51, no. 2, April
1952, pp. 17–19, 65–66 illus.

1259 FITZSIMMONS, JAMES. 'Fifteen More
Questions Posed at the Modern Museum,'
Art Digest, vol. 26, no. 15, 1 May 1952,
pp. 11, 24 illus. (On *bibl.* 990.)

1260 MYERS, BERNARD. 'Introduction,' *Ex-
pressionism in American Painting*, Albright
Art Gallery, Buffalo, 10 May–29 June
1952, pp. 9–31; 63-p. cat. illus. (Includes
Gorky, Hofmann, Tomlin, De Kooning,
Guston.)

1261 *Four Abstract Expressionists*, Walker Art
Center, Minneapolis, February 1953.
(Baziotes, Gottlieb, Hofmann, Mother-
well.)

1262 FITZSIMMONS, JAMES. 'Art,' *Arts and
Architecture*, vol. 71, no. 2, February 1954,
pp. 4, 6.

1263 KRASNE, BELLE. 'Nine American
Painters, Nine American Worlds,' *Art
Digest*, vol. 28, no. 8, 15 January 1954,
pp. 10–12 illus.

1264 SWEENEY, JAMES JOHNSON. 'Preface,'
Younger American Painters: A Selection,
Solomon R. Guggenheim Museum, New
York, 12 May–12 July 1954, pp. 7–11;
57-p. cat. illus. (includes Baziotes, De
Kooning, Gottlieb, Guston, Kline,
Motherwell, Pollock.)

1265 HUNTER, SAM. 'Guggenheim Sampler,'
Art Digest, vol. 28, no. 16, 15 May 1954,
pp. 8–9, 31 illus. (On *bibl.* 1264.)

1266 ROSENBLUM, ROBERT. 'The New De-
cade,' *Art Digest*, vol. 29, no. 16, 15 May
1955, pp. 20–23 illus. (On *bibl.* 991.)

1267 CAHILL, HOLGER. *Modern Art in the*

United States: A Selection from the Collections of the Museum of Modern Art, Tate Gallery, London, 5 January–12 February 1956, 51 pp. plus 44 plates; 'Abstract Expressionism,' pp. 21–24. (Exhibition also circulated elsewhere in Europe by the Museum of Modern Art; includes Baziotes, De Kooning, Gorky, Guston, Kline, Motherwell, Pollock, Rothko, Still, Tomlin.)

1268 LUSINCHI, J. 'Les Écoles étrangères: Cinquante ans de peinture aux États-Unis,' *Cimaise*, series 2, no. 6, May 1955, pp. 8–10 illus. (On *bibl.* 1267.)

1269 *Ten Years*, Betty Parsons Gallery, New York, 19 December 1955–14 January 1956, 4 pp. (Preface by Clement Greenberg.)

'Whether or not the public acknowledges it, the status of American art vis-à-vis that of the rest of the world has radically changed in the last ten years. No longer in tutelage to Europe, it now radiates influence and no longer merely receives it. This is a triumph, and I do not see why we should not celebrate it without too many qualms about chauvinism.'

1270 ALLOWAY, LAWRENCE. 'U.S. Modern: Paintings,' *Art News and Review*, vol. 12, no. 26, 21 January 1956, pp. 1, 9. (On *bibl.* 1267.)

1271 HERON, PATRICK. 'The Americans at the Tate Gallery,' *Arts*, vol. 30, no. 6, March 1956, pp. 15–17 illus. (On *bibl.* 1267.)

'I was instantly elated by the size, energy, originality, economy, and inventive daring of many of the paintings. Their creative emptiness represented a radical discovery. . . . These American painters were so direct in the execution of the *idea* that their paint-gestures, their statement on the canvas had an almost over-dry immaculateness. . . . We shall now watch New York as eagerly as Paris for new developments.'

1272 *Large Scale Paintings II*, Contemporary Arts Association, Houston, 30 October–5 November 1956. 4-p. cat. with anonymous text.

1273 *American Paintings: 1945–1957*, Minneapolis Institute of Arts, 1957, 32-p. cat.

illus. (Includes Baziotes, De Kooning, Gorky, Gottlieb, Guston, Hofmann, Kline, Motherwell, Newman, Pollock, Reinhardt.)

1274 *Eight Americans*, Sidney Janis Gallery, New York, 1–20 April 1957, 12-p. cat. illus. (De Kooning, Gorky, Guston, Kline, Motherwell, Pollock, Rothko, and Albers.)

1275 SAWYER, KENNETH B. 'Art Chronicle,' *Hudson Review*, vol. 10, no. 1, Spring 1957, pp. 111–16.

1276 *Albers, De Kooning, Gorky, Guston, Kline, Motherwell, Pollock, Rothko; An Exhibition in Tribute to Sidney Janis*, Hetzel Union Gallery, Pennsylvania State University, Philadelphia, 3–24 February 1958, 8-p. cat.; text by Clement Greenberg, 2-p. insert, illus.

1277 HESS, THOMAS B. AND ROSENBERG, HAROLD. 'Some Points about Action Painting,' *Action Painting . . . 1958*, Dallas Museum for Contemporary Arts, 5 March –13 April 1958, pp. 2–5; 12-p. cat. illus.

1278 ALLOWAY, LAWRENCE. 'Notes on the Paintings,' *Some Paintings from the E.J. Power Collection*, ICA Gallery, London, 13 March–19 April 1958, pp. 1–2, 15–16. (Collection consisted primarily of American abstract expressionist work.)

1279 ROUVE, PIERRE. 'Witness for the Defence,' *Art News and Review*, vol. 10, no. 5, 29 March 1958, pp. 1, 12. (On *bibl.* 1278.)

1280 HERON, PATRICK. 'London,' *Arts*, vol. 32, no. 8, May 1958, pp. 22–23 illus. (On *bibl.* 1278.)

1281 *The New American Painting*, Museum of Modern Art Circulating Exhibition in Europe (see *bibl.* 994 for New York catalogue); exhibition shown in Switzerland, Italy, Spain, Germany, Holland, Belgium, France, and England, May 1958 –September 1959; catalogues issued in French, German, Italian, Spanish, and Dutch: titled 'New American Painting' in translation, except for Dutch: *Jong Amerika Schildert*. Contents approximately the same as New York catalogue with introductions by the various Museum directors. Exhibition combined in Paris with Museum of Modern Art *Jackson Pollock* exhibition (*bibl.* 722). Reviewed

as follows (see also *bibls.* 1055, 1067, 1070, 1182, 1192, 1193, 1194, 1201, 1227 for more extensive reviews):

SWITZERLAND: Margot Seidenberg, *Neue Zurcher Nachrichtung*, 30 March 1958; A. R., *Die Schweiz*, April; G. B. in *National Zeitung* (Basel), 20 April; *Basler Nachrichten*, 21, 26 April; N. A., *Basler Folksblatt*, 22 April; Yvonne Hagen, *New York Herald Tribune* (Paris), 23 April; *Basler Arbeiterzeitung*, 25 April; *Der Bund* (Bern), 25 April; Peter Pesel, *Tages-Anzeiger* (Zürich), 28 April; *Basilisk* (Basel), 2 May; André Kuenzi, *Gazette de Lausanne*, 3 May; E. M. Landau, *Deutsches Tagespost* (Wurzburg), 5 May; Emile Biollay, *Nouvelliste Valaisan* (St Maurice), 7 May; H. R., *Der Landbote* (Winterthur), 8 May; Eberhard Meckel, *Badische Zeitung* (Freiburg), 8 May; Gerhard Schon, *Suddeutsche Zeitung*, 11 May; Ulrich Seelman-Eggebert, *Mannheimer Morgen*, 13 May; Maria Netter, *St Gallen Tageblatt*, 16 May; A. S. Vellinghausen, *Frankfurt Allgemeine*, 16 May; M. E., *Die Tat* (Zürich), 16 May; C. Scheiss, *Luzerner Tagblatt*, 17 May; Helmi Gasser, *Neue Zurcher Zeitung*, 23 May; H. Zehder, *Die Welt*, 9 June; Maria Netter, *Werk*, June 1958.

ITALY: *L'Italia*, 2 June 1958; Mario de Micheli, *L'Unità*, 4 June; A. M., *La Provincia Pavese*, 6 June; *Gazetta i Parma*, 6 June; Jason Vella, *L'Ordine*; Leonardo Borgese, *Corriere della Sera*, 8 June; Marco Valsecchi, *Il Giorno*, 10 June; Franco Zoccoli, *Unione Sarda-Cagliari*, 11 June; Giorgio Kaisserlain, *Il Popolo*, 13 June; Giorgio Mascherpa, *L'Italia*, 13 June; Mario Lepore, *Visto*, 14 June and *La Tribuna*, 15 June; Mario Portalupi, *La Notte*, 18 June; *Le Arti*, May–June; *Italian Moderna Produce*, May–June; Franco Zoccoli, *Iniziative*, July–August; radio talk by Raffaele de Grada, 6 June, on radio televisione Italiana.

SPAIN: *SP*, 8 March 1958; Muñoz Garcia-Vaso, *Informaciones*, 19 July; José Camon Aznar, *ABC*, 26 July; Joaquin de la Puente, *La Estafeta Literaria*, 2 August; L. Figuerola-Ferretti, *Arriba*, 10 August; José M. Galvan, *Gaceta Illus-*

trada, 23 August; Mercedes Molleda, *Revista*, 30 August–5 September; Antonio Saura, *El Paso*, no. 3, November.

GERMANY: Arnold Bauer, *Der Kurier*, 4 September 1958; H. Kotschenreuther, *Berlin Morgenpost*, 4 September; Klaus Gerner, *Der Tag*, 5 September; W. G., *Spandauer Volksblatt*, 5 September; Will Grohmann, *Der Tagesspiegel*, 7 September; F. A. Dargel, *Telegrat*, 10 September.

HOLLAND: Ber Hulsing, *Waarheid*, 10 October 1958; Georg Lampe, *Vrij Nederland*, 8 November; H. R., *Algemeen Handelblad*, 13 November; *Nieuw Rotterdamse Courant*, 15 November.

BELGIUM: R. M. T., *La Dernière Heure*, 7–8 December 1958; Paul Caso, *Le Soir*, 11 December; L. D. H., *La Libre Belgique*, 12 December; *La Metropole*, 13–14 December; *Le Phare*, 14 December; André Marc, *La Lanterne*, 27 December.

FRANCE: Alain Jouffroy, *Arts*, 13–19 January 1960; Yvonne Hagen, *Herald Tribune*, 16 January; Claude Roger-Marx, *Le Figaro Litteraire*, 17 January; André Chastel, *Le Monde*, 17 January; J. A. C., *Combat*, 19 January and 26 January; Frank Elgar, *Carrefour*, 21 January; René Massat, *La Nation Française*, 21 January; Jean-François Chabrun, *L'Express*, 22 January; Raymond Cogniat, *Le Figaro*, 22 January; Georges Boudaille, *Lettres Françaises*, 22 January; Robert Rey, *Nouvelles Littéraires*, 22 January; Jean-Clarence Lambert, *France Observateur*, 22 January; Pierre d'Espezel, *Aspects de la France*, 23 January; Pierre Imbourg, *Journal de l'amateur de l'art*, 25 January; J. P. Crespelle, *Journal du Dimanche*, 26 January; Jean-Jacques Levêque, *L'Information*, 27 January; Yvonne Hagen, *Herald Tribune*, 28 January; Bernard Dorival, *Arts*, 28 January–3 February; Joseph Pichard, *La Croix*, 29 January; Françoise Choay, *France Observateur*, 29 January; Pierre Schneider, *Arts* (New York), March 1959, p. 47; Annette Michelson, *Arts* (New York), June 1959, pp. 17–18; San Lazzaro, *XXe siècle*, no. 12, May–June, pp. 81–83.

ENGLAND: *The Times*, 24 February 1959; *Yorkshire Post*, 24 February; *Evening Standard*, 24 February; Pierre Jeannerat, *Daily*

Mail, 24 February; Terence Mullaly, *Daily Telegraph*, 25 February; G. S. S., *The Scotsman*, 25 February; Frederick Laws, *Manchester Guardian*, 27 February; Nevile Wallis, *Sunday Observer*, 1 March; *The Tatler*, 4 March; C. S., *Jewish Chronicle*, 6 March; John Russell, *The Sunday Times*, 8 March; Alan Clutton-Brock, *The Listener*, 19 March; Horace Shipp and Jean Yves Mock, *Apollo*, April; David Sylvester, *New York Times*, 12 April; Robert Melville, *Architectural Review*, May, p. 355.

1282 *Eight American Painters*. Sidney Janis Gallery, New York, 5–31 January 1959, 12-p. cat. illus. (Same painters included as *bibl.* 1274.)

1283 ASHTON, DORE AND DORIVAL, BERNARD. *New York and Paris: Painting in the Fifties*, Museum of Fine Arts, Houston, 16 January–8 February 1959; 46-p. cat. illus.

1284 HENNING, EDWARD B. *Paths of Abstract Art*, Cleveland Museum of Art and Harry N. Abrams, New York, 1960, 89 pp. illus. (Includes De Kooning, Guston, Hofmann, Kline, Motherwell, Pollock, Rothko.)

1285 ATKINSON, TRACY. 'Introduction,' *Contemporary American Painting*, Columbus Gallery of Fine Arts, 14 January–18 February 1960, 14-p. cat. illus. (Made up entirely of first and second generation abstract expressionists.)

1286 *Nine American Painters*, Sidney Janis Gallery, New York, 4–23 April 1960, 12-p. cat. illus. (Same painters included as *bibl.* 1274, plus Baziotes.)

1287 BAYL, FRIEDRICH. *Neue Malerei: Form, Struktur, Bedeutung*, Städtische Galerie, Munich, 10 June–28 August 1960, pp. 6–10; 92-p. cat. illus.; also texts by H. K. Röthel and M. Tapié, pp. 2–5. (Includes De Kooning, Gorky, Hofmann, Kline, Pollock.)

1288 ARNASON, H. H. *American Abstract Expressionists and Imagists*, Solomon R. Guggenheim Museum, New York, 1961, pp. 23–31; 131-p. cat. illus.; bibliography pp. 97–131; 'Foreword on Art and Terminology,' by Arnason, pp. 12–13.

'The question today is not whether abstract expressionism is dead or alive. It is: "What and how well is de Kooning – or Motherwell – or Guston . . . painting now?" In a sense there are no art movements. There are only artists.' (*Bibls.* 1289–1297 are reviews of this exhibition; see also *bibl.* 1225.)

1289 'Expressionistas e imagistas abstratos Americanos no Museu Guggenheim, Nova York,' *Habitat*, vol. 12, no. 66, 1961, p. 53 illus.

1290 PICARD, LIL. 'New Yorker Kunstbrief,' *Kunstwerk*, vol. 15, nos. 5–6, November-December 1961, pp. 55–56 plus 3 plates.

1291 ALLOWAY, LAWRENCE. 'Easel Painting at the Guggenheim,' *Art International*, vol. 5, no. 10, December 1961, pp. 26–34 illus.

1292 ASHTON, DORE. 'Art,' *Arts and Architecture*, vol. 78, no. 12, December 1961, pp. 4–5 illus.

1293 FRIGERIO, SIMONE. 'Abstraits Américains expressionistes et imagistes,' *Aujourd'hui*, no. 34, December 1961, pp. 56–59 illus. (d'après H. H. Arnason).

1294 TILLIM, SIDNEY. 'Month in Review,' *Arts*, vol. 36, no. 3, December 1961, pp. 42–43 illus.

1295 BUTLER, BARBARA. 'New York Fall 1961 . . . American Abstract Expressionists and Imagists . . .,' *Quadrum*, no. 12, 1962, pp. 137–40 illus.

1296 GOLDWATER, ROBERT. 'A Surfeit of the New,' *Partisan Review*, vol. 29, no. 1, Winter 1962, pp. 116–21.

1297 O'HARA, FRANK. 'Art Chronicle,' *Kulchur*, vol. 2, no. 5, Spring 1962, pp. 80–86.

1298 HELLER, BEN. 'Collector's Viewpoint' in *The Collection of Mr. and Mrs. Ben Heller*, Museum of Modern Art, New York, 1961, pp. 3–6 illus.; also 'Preface' by Alfred H. Barr, Jr., pp. 1–2 and 'Introduction' by W. C. Seitz, pp. 7–11. (Catalogue of a circulating exhibition.)

1299 COE, RALPH T. *The Logic of Modern Art*, Nelson Gallery and Atkins Museum, Kansas City, Mo.; 19 January–26 February 1961, pp. 5–11 illus.; 'Painting Since World War II,' pp. 31–38. (Includes De Kooning, Kline, Pollock, Rothko, Still.)

1300 ASHTON, DORE. 'Introduction,' *The Sidney Janis Painters*, John and Mable Ringling Museum of Art, Sarasota, *Bul-*

letin, vol. 1, no. 3, April 1961, pp. 4–5; also 'Foreword: Tribute to Sidney Janis,' by Kenneth Donahue, pp. 1–3. (Reprinted statements by the artists: Baziotes, Gorky, Gottlieb, Guston, Kline, De Kooning, Motherwell, Pollock, Rothko.)

1301 *Ten American Painters*, Sidney Janis Gallery, New York, 8 May–3 June 1961, 12-p. cat. illus. (Same painters as *bibl.* 1286, plus Gottlieb.)

1302 BOURAS, HARRY. *Drawings: Five Contemporary Masters*, Holland-Goldowsky Gallery, Chicago, 22 September–26 October 1961. (Includes Guston, De Kooning, Kline.)

1303 WAGSTAFF, SAMUEL, JR. 'Introduction,' *Continuity and Change*, Wadsworth Atheneum, Hartford, 12 April–27 May 1962, pp. 3–6; 55-p. cat. illus.

1304 'How They Got That Way,' *Time*, 13 April 1962, 4 pp. illus. (Concerning *bibl.* 1303.)

1305 *Ten American Painters*, Sidney Janis Gallery, New York, 7 May–2 June 1962, 12-p. cat. illus. (Same painters as *bibl.* 1301.)

1306 ROBBINS, DANIEL. 'Continuity and Change,' *Art International*, vol. 6, no. 8, October 1962, pp. 59–65 illus. (On *bibl.* 1303.)

1307 HELLER, BEN. 'Introduction,' *Black and White*, Jewish Museum, New York, 1963, pp. 4–8; also Preface by Alan R. Solomon. (Includes De Kooning, Gorky, Hofmann, Kline, Motherwell, Newman, Pollock, Tomlin; reprint of *bibl.* 449, p. 9.)

1308 KOZLOFF, MAX. 'The Many Colorations of Black and White,' *Artforum*, vol. 2, no. 8, February 1964, pp. 23–25 illus. (On *bibl.* 1307.)

1309 *Eleven Abstract Expressionist Painters*, Sidney Janis Gallery, New York, 7 October–2 November 1963; 24-p. cat. illus.; anonymous text p. 2 (Includes De Kooning, Gorky, Gottlieb, Guston, Kline, Motherwell, Newman, Pollock, Rothko, Still.)

1310 ALLOWAY, LAWRENCE. 'Introduction,' *Guggenheim International Award 1964*, Solomon R. Guggenheim Museum, New York, 1964, pp. 12–15; 122-p. cat. illus. (U.S. represented by Gottlieb, Guston, Hofmann, De Kooning, Motherwell,

Newman; brief individual bibliographies; 'Documentation' includes reprints of *bibls.* 450, 474, 543.)

1311 ALLOWAY, LAWRENCE. 'Introduction,' *American Drawings*, Solomon R. Guggenheim Museum, New York, September–October 1964, pp. 4–9; 'Quotations,' p. 54; bibliography pp. 55–59. (Includes Gorky, Gottlieb, Guston, Kline, De Kooning, Motherwell, Newman, Pollock.)

Recent Writings 1965–69 (chronologically)

1312 TUCHMAN, MAURICE. *New York School. The First Generation*, Los Angeles County Museum of Art, 16 June–1 August 1965, 252-p. cat. illus.; with reprinted statements by artists and critics; bibliography.

1313 SELDIS, HENRY J. 'Exhibition Features Art of 15 Pioneer Abstract Painters,' *Los Angeles Times Calendar;* 27 June 1965, p. 13 illus.

1314 SELDIS, HARRY J. 'New York School a Tribute to Independence,' *Los Angeles Times Calendar*, 14 July 1965, p. 3 illus.

1315 LEIDER, PHILIP. 'The First Generation,' *Frontier*, vol. 16, no. 10, August 1965, pp. 22–23.

1316 LEIDER, PHILIP. 'The New York School in Los Angeles,' *Artforum*, vol. 4, no. 1, September 1965, pp. 3–13 illus.

1317 *American Painting 1945–1965*, Museum of Modern Art, New York, circulating exhibition (Japan, India), 1966; texts by Lucy R. Lippard, Irving H. Sandler, G. R. Swenson.

1318 *Contemporary Americans*, The Winnipeg Art Gallery, February 1966, 6-p. cat. illus. (Includes among others, Gottlieb, Guston, Hofmann, Motherwell.)

1319 *Six Painters*, University of St Thomas, Houston, Texas, February–April 1967: organized by Morton Feldman; Preface by Thomas Hess. (Includes De Kooning, Guston, Kline, Pollock, Rothko, and Mondrian.)

1320 *Six peintres américains: Gorky, Kline, de Kooning, Newman, Pollock, Rothko*, M. Knoedler, Paris, October 1967.

1321 RUBIN, WILLIAM S. *Dada, Surrealism and*

Their Heritage, Museum of Modern Art, New York, 27 March–9 June 1968, 231–p. cat. illus. (Includes Baziotes, Gorky, Gottlieb, Newman, Pollock, Rothko, among others.)

1322 RUBIN, WILLIAM S. AND AGEE, WILLIAM. *The New American Painting and Sculpture: The First Generation,* Museum of Modern Art, 18 June–5 October 1969; catalogue is forthcoming.

1323 LICHTBLAU, CHARLOTTE. 'The First Generation,' *Arts Magazine*, vol. 43, no. 8, Summer 1969, pp. 37–39 illus.

1324 SHIREY, DAVID L. 'New York Painting and Sculpture 1940–1970,' *Arts Magazine*, vol. 44, no. 1, September–October 1969, pp. 35–39 illus; of Still, Gottlieb.

1325 *De Kooning, Newman, Gorky*, M. Knoedler Gallery, New York, 26 June–20 September 1969.

1326 GELDZAHLER, HENRY. *New York Painting and Sculpture 1940–1970*, Metropolitan Museum of Art, New York, 15 October 1969–11 February 1970: Introduction by Geldzahler; reprinted contemporary criticism by Harold Rosenberg, Robert Rosenblum, Clement Greenberg, William Rubin, and Michael Fried; biographical data on individual artists, pp. 429–54; selected bibliography, pp. 455–88; 494–p. cat. illus.

1327 KRAMER, HILTON, '30 Years of the New York School,' *The New York Times Magazine*, 12 October 1969, pp. 29–31, 89–90, 92–94, 97, 99–100, 102, 109–10, 117, 119–20.

1328 KRAMER, HILTON. 'A Modish Revision of History,' *New York Times*, 19 October 1969, sec. 2, pp. 29–30 illus.

1329 SHIREY, DAVID. 'Super Show,' *Newsweek*, 20 October 1969, p. 80 illus, pp. 81–84.

1330 'From the Brink, Something Grand,' *Time*, 24 October 1969, pp. 78–81 illus.

LIST OF ILLUSTRATIONS

List of Illustrations

ARSHILE GORKY

ADOLPH GOTTLIEB

PHILIP GUSTON

ROBERT MOTHERWELL

64 *Blue with China Ink – Homage to John Cage*. 1946. Gouache and oil with collage on cardboard. 104.1 × 78.7 cm, 40 × 31 in. Collection Richard Brown Baker, New York 100

65 *Pancho Villa, Dead and Alive*. 1943. Gouache and oil with collage on cardboard. 71.1 × 91.1 cm, 28 × 35⅞ in. Museum of Modern Art, New York 101

66 *Still Life, Ochre and Red*. 1947. Oil on canvas. 74.3 × 96.5 cm, 29¼ × 38 in. Collection Mr and Mrs Philip Gersh, Beverly Hills 101

67 *The Best Toys are Made of Paper*. 1948. Collage and mixed media on cardboard. 121.9 × 76.2 cm, 48 × 30 in. Collection Mr and Mrs Burt Kleiner, Beverly Hills 102

68 *At Five in the Afternoon*. 1950. Oil on masonite. 91.4 × 121.9 cm, 36 × 48 in. Collection Mr and Mrs Wright Morris, Mill Valley, California 102

69 *Jour la Maison, Nuit la Rue*. 1957. Oil on canvas. 177.2 × 227.3 cm, 69¾ × 89½ in. Collection Mr and Mrs William C. Janss, Palm Desert, California 103

70 *Elegy to the Spanish Republic XXXVB*. 1953. Oil on board. 50.8 × 76.2 cm, 20 × 30 in. Collection Mrs Henry Epstein, New York 104

71 *A Sculptor's Picture with Blue*. 1958. Oil on canvas. 177.8 × 193.0 cm, 70 × 76 in. Collection Mrs Stanley Sheinbaum, Santa Barbara, California 104

BARNETT NEWMAN

72 *Tundra*. 1950. Oil on canvas. 182.9 × 226.1 cm, 72 × 89 in. Collection Mr and Mrs Robert C. Scull, New York 106

73 *Onement No. 6*. 1953. Oil on canvas. 259.1 × 304.8 cm, 102 × 120 in. Collection Mr and Mrs Frederick R. Weisman, Beverly Hills 107

74 *Genesis – the Break*. 1946. Oil on canvas. 63.5 × 71.1 cm, 25 × 28 in. Collection Dr Ruth Stephan, Greenwich, Connecticut 108

75 *Euclidean Abyss*. 1947. Mixed media on canvas. 71.1 × 55.9 cm, 28 × 22 in. Collection Mr and Mrs Burton Tremaine, New York 108

76 *Abraham*. 1949. Oil on canvas. 210.2 × 87.6 cm, 82¾ × 34½ in. The Museum of Modern Art, New York, Philip Johnson Fund 111

77 *Onement No. 3*. 1949. Oil on canvas. 182.9 × 86.4 cm, 72 × 34 in. Collection Mr and Mrs Joseph Slifka, New York 111

78 *Vir Heroicus Sublimis*. 1950–51. Oil on canvas. 243.2 × 541.7 cm, 95¾ × 213¼ in. The Museum of Modern Art, New York. Gift of Mr and Mrs Ben Heller 112

79 *Primordial Light*. 1954. Oil on canvas. 243.8 × 121.9 cm, 96 × 48 in. Kasmin Gallery, London 113

80 *The Word*. 1954. Oil on canvas. 228.6 × 177.8 cm, 90 × 70 in. Collection Mrs Annalee G. Newman 114

81 *Outcry*. 1958. Oil on canvas. 208.3 × 15.2 cm, 82 × 6 in. Collection Mrs Annalee G. Newman 114

JACKSON POLLOCK

82 *Pasiphae*. 1943. Oil on canvas. 142.6 × 243.8 cm, 56⅜ × 96 in. Marlborough-Gerson Gallery, New York 116

83 *Night Dancer (Green)*. 1944. Oil on canvas. 109.2 × 86.4 cm, 43 × 34 in. Marlborough-Gerson Gallery, New York 117

84 *The Key*. 1946. Oil on canvas. 149.9 × 213.0 cm, 59 × 83⅞ in. Marlborough-Gerson Gallery, New York 118

226

Mr and Mrs Wright Morris, Mill Valley, California 138

109 *No. 26, 1947.* 1947. Oil on canvas. 85.1 × 114.3 cm, 33½ × 45 in. Collection Mrs Betty Parsons, New York 138

110 *Mauve Intersection (No. 12).* 1948. Oil on canvas. 147.3 × 162.6 cm, 58 × 64 in. The Phillips Collection, Washington, D.C. 140

111 *Untitled.* 1948. Oil on canvas. 170.2 × 86.4 cm, 67 × 34 in. Collection Mr and Mrs Wright Morris, Mill Valley, California 141

112 *No. 24, 1949.* 1949. Oil on canvas. 224.8 × 146.0 cm, 88½ × 57½ in. Collection Joseph H. Hirshhorn, New York 143

113 *Untitled.* 1951. Oil on canvas. 237.5 × 144.1 cm, 93½ × 56¾ in. Collection Mr and Mrs Gifford Phillips, Washington, D.C. 144

114 *Green on Blue.* 1956. Oil on canvas. 228.3 × 135.9 cm, 89⅞ × 63½ in. University of Arizona Art Gallery. Edward Joseph Gallagher III, Memorial Collection 145

115 *White Center.* 1957. Oil on canvas. 213.4 × 182.9 cm, 84 × 72 in. Collection Mr and Mrs David E. Bright, Beverly Hills 145

116 *Light Cloud, Dark Cloud.* 1957. Oil on canvas. 167.6 × 157.5 cm, 66 × 62 in. Collection Edwin Janss Jr, Thousand Oaks, California 146

CLYFFORD STILL

117 *1944-N No. 1.* 1944. Oil on canvas. 266.7 × 234.9 cm, 105 × 92½ in. Collection the artist 148

118 *1946-H.* 1946. Oil on canvas. 198.1 × 172.7 cm, 78 × 68 in. Collection Mr and Mrs Frederick R. Weisman, Beverly Hills 149

119 *1950-A No. 2.* 1950. Oil on canvas. 274.3 × 233.7 cm, 108 × 92 in. Collection the artist 149

120 *1950-1.* 1950. Oil on canvas. 299.7 × 234.9 cm, 118 × 92½ in. Collection the artist 150

121 *1947-M.* 1947. Oil on canvas. 266.7 × 233.7 cm, 105 × 92 in. Collection Mr and Mrs Frederick R. Weisman, Beverly Hills 151

122 *1955-K.* 1955. Oil on canvas. 287.0 × 264.2 cm, 113 × 104 in. Collection the artist 152

123 *1955-6.* 1955. Oil on canvas. 289.6 × 264.2 cm, 114 × 104 in. Collection the artist 152

124 *1957-K.* 1957. Oil on canvas. 287.0 × 393.7 cm, 113 × 155 in. Collection the artist 153

BRADLEY WALKER TOMLIN

125 *No. 5, 1949.* 1949. Oil on canvas. 177.8 × 96.5 cm, 70 × 38 in. Private collection, New York 154

126 *Tension by Moonlight.* 1948. Oil on canvas. 81.3 × 111.8 cm, 32 × 44 in. Betty Parsons Gallery, New York 156

127 *All Souls Night.* 1948. Oil on canvas. 107.9 × 162.6 cm, 42½ × 64 in. Betty Parsons Gallery, New York 156

128 *No. 9: In Praise of Gertrude Stein.* 1950. Oil on canvas. 124.5 × 259.7 cm, 49 × 102¼ in. Museum of Modern Art, New York. Gift of Mrs John D. Rockefeller III 157

129 *No. 12.* 1952. Oil on canvas. 167.6 × 121.9 cm, 66 × 48 in. Albright-Knox Art Gallery, Buffalo 157

130 *No. 1.* 1952–53. Oil on canvas. 200.7 × 116.8 cm, 79 × 46 in. Betty Parsons Gallery, New York 158

131 *No. 10.* 1952–53. Oil on canvas. 182.9 × 260.3 cm, 72 × 102½ in. Munson-Williams-Proctor Institute, Utica, New York 158